Three Rivers

THE YUKON'S GREAT BOREAL WILDERNESS

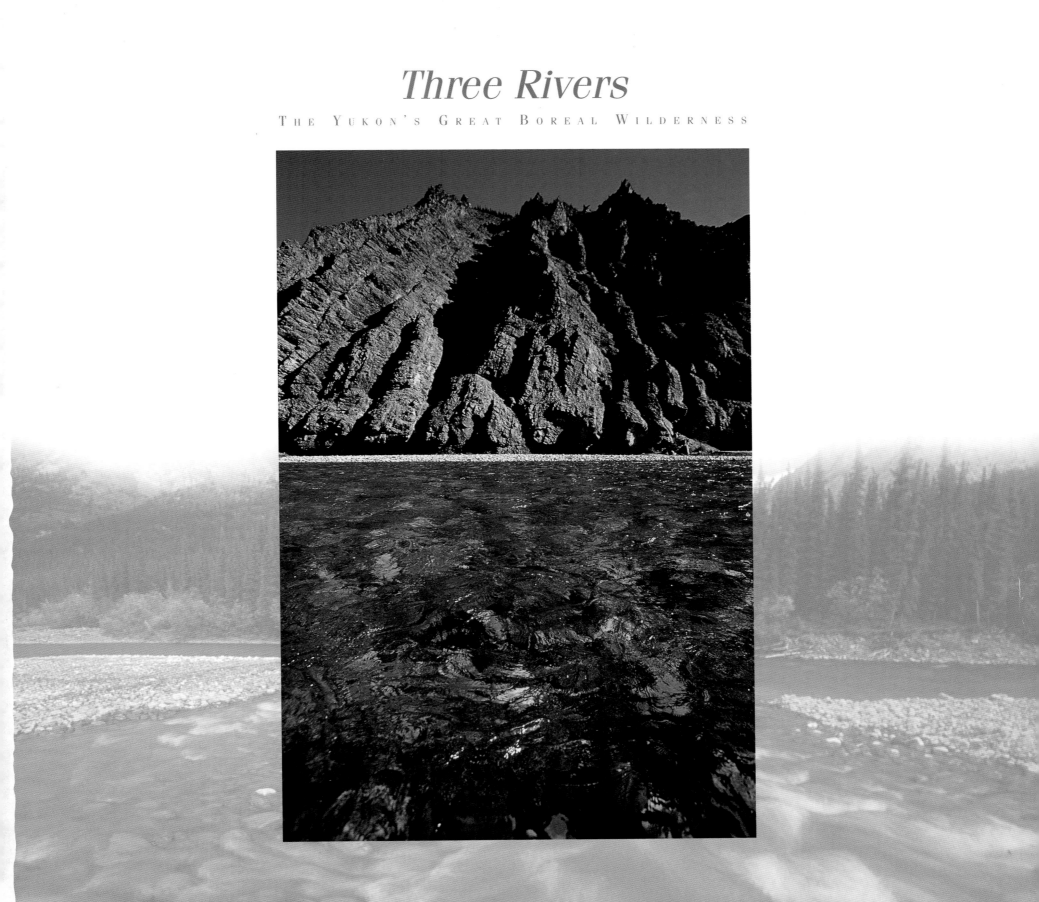

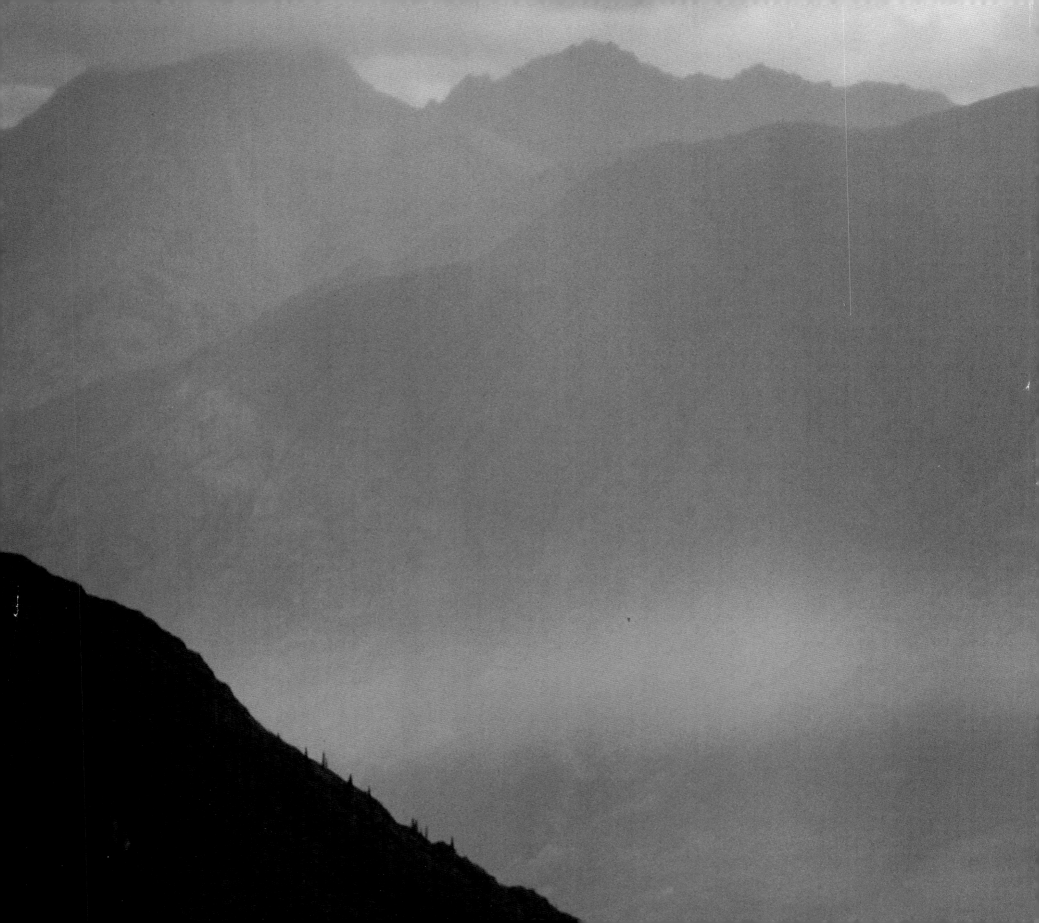

Three Rivers

THE YUKON'S GREAT BOREAL WILDERNESS

Text by
Juri Peepre, Margaret Atwood, John Ralston Saul,
Richard Nelson, Sarah Locke, Brian Brett and others

Photography by
Courtney Milne, Juri Peepre, Fritz Mueller, Jannik Schou,
Marten Berkman, Peter Mather and others

HARBOUR PUBLISHING

Page 1:
Westernmost of the Yukon's pristine Three Rivers, the Wind is known for its craggy cliffs and pure, crystal waters.

Previous pages:
A rainbow accents a moody sky over the Yukon's turbulent Bonnet Plume River, a favourite of whitewater canoeists.

Evenings are a magic time in the Yukon's Three Rivers country.

TABLE OF CONTENTS

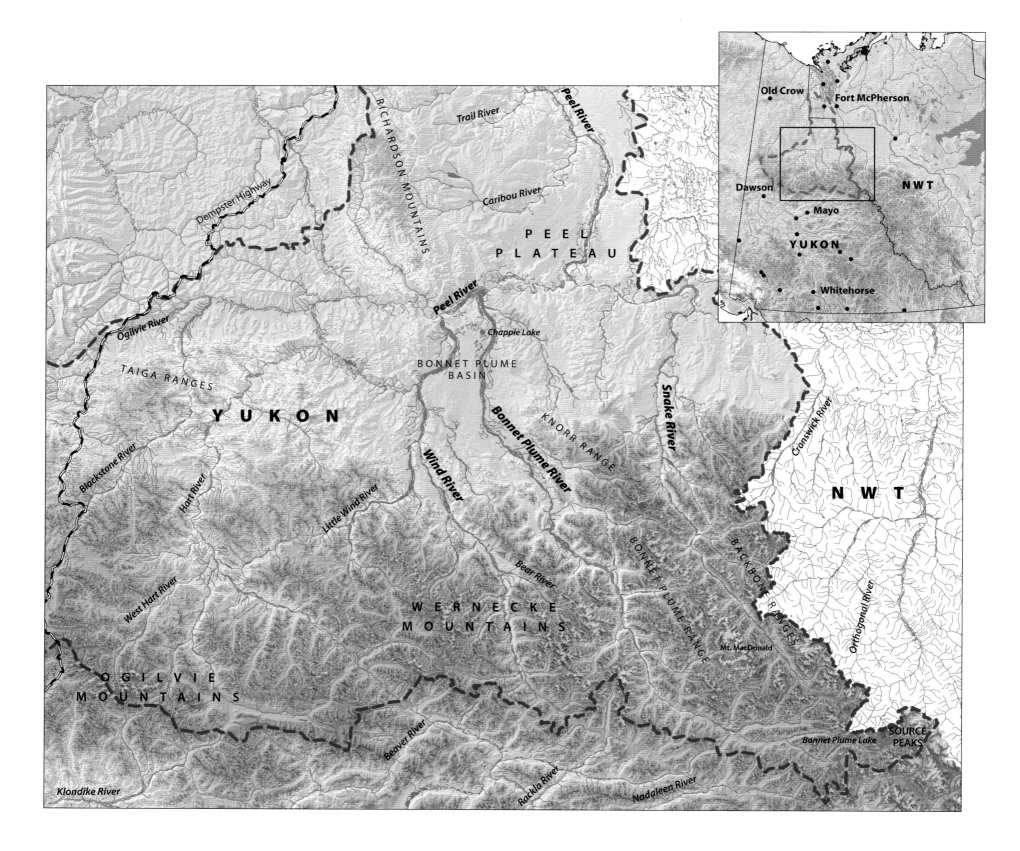

FOREWORD

By Juri Peepre

How does one celebrate and protect an immense boreal mountain wilderness that is unknown even to most Canadians? The Yukon Chapter of the Canadian Parks and Wilderness Society (CPAWS) took on this challenge by bringing to life the ambitious Three Rivers Journey Project in the summer of 2003, when we invited eighteen nationally prominent artists, writers, journalists, and photographers to join people from the Yukon and Northwest Territories in simultaneous journeys along the remote Wind, Snake, and Bonnet Plume rivers.

These three rivers, along with their sister tributaries the Hart, Blackstone and Ogilvie, rise in the stunning Selwyn and Wernecke Mountains and flow through the vast Peel River Basin on the Yukon's northeastern border, an area that accounts for 14 percent of the Yukon. Perched at the apex of Canada's boreal forest and the northern end of the Rocky Mountain chain, the Peel Watershed also touches on the unglaciated area known as Beringia and the Subarctic. A blend of all these biomes, it is a distinct and varied land of plateaus and mountains, rivers and wetlands, not yet fully revealed to science. Here, unbounded and colourful mountain ranges frame pristine taiga forests and subarctic watersheds. Robust woodland and barren ground caribou, free-ranging wolverine and grizzly bear, the vulnerable peregrine falcon, unspoiled aquatic habitat, and thousands upon thousands of boreal songbirds and migratory waterfowl occupy an ancient and unfettered landscape that is the essence of wildness.

This is the traditional territory of the Nacho Nyak Dun and Tetl'it Gwich'in First Nations; for generations they were sustained by the plants, fish and wildlife of this region as they traversed its valleys and mountains on a network of travel and trade routes. Today the wilderness of the Peel Basin serves as a vital benchmark of untamed nature; ancient and complex ecological processes continue to evolve freely, and the full complement of native predators and prey range across the landscape. Although fishing, hunting and trapping are still important to the way of life in the region, Yukon people and visitors from around the world also value the watershed as a premier destination for canoeing, backcountry travel, photography, education and scientific research.

However, just as this vast area slowly begins to gain the recognition that it deserves, plans for development are already compromising its future. The Peel Watershed, like much of Canada's North, is vulnerable to the continental thirst for hydrocarbon energy, including new development schemes for oil and natural gas, pipelines, coal and coal-bed methane. Others dream of building roads and rails to extract iron ore, copper, and other metals from the remote

Top: The Three Rivers is one of a dwindling number of places where woodland caribou thrive undisturbed by outside influences.

Above: Canoeist Juri Peepre relaxes between whitewater chutes on the Bonnet Plume River.

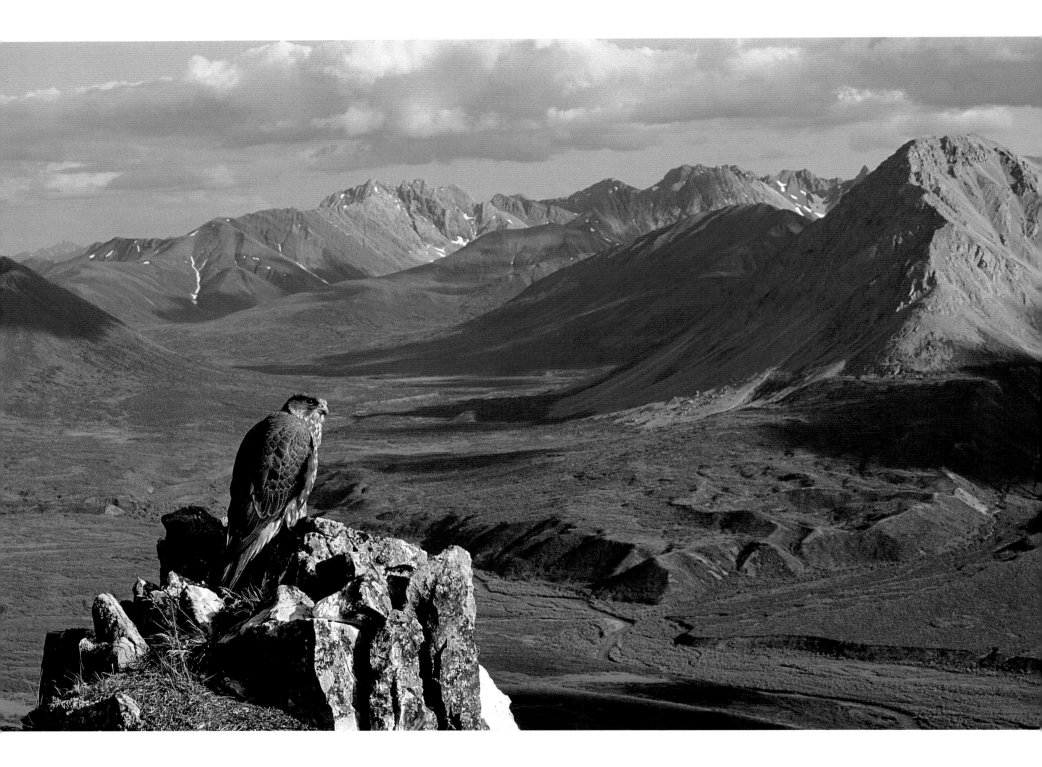

mountains. And the Yukon government is promoting all of this activity before citizens have had a chance to consider the watershed's future through land use planning. Our governments seem especially eager to industrialize the Peel before setting aside conservation lands, even though pre-emptive resource development would have an overwhelming impact on the Peel Watershed and the ecological health of its major tributaries. After the heavy machinery is gone and tracts of land laid waste, what future would be left for the people and communities in the North?

In August 2003, after eighteen exhilarating and arduous days, the Three Rivers Journey ended at the confluence of the Snake and Peel rivers. Here, members of the Tetl'it Gwich'in First Nation greeted the thirty-seven paddlers—artists, writers, filmmakers, scientists, conservationists and First Nation community members—with traditional gun salutes and a chorus of cheers, welcoming them to an elders' feast held on the banks of the Peel. More than one hundred people participated in this gathering, the majority having travelled upstream by riverboat from Fort McPherson—a trip of at least eight hours. We feasted on fresh moose meat and grayling and listened to elders and First Nation members speak eloquently about the importance of the land, wildlife and waters of the Peel Basin. Elaine Alexie, on behalf of Gwich'in youth, said:

> "We, the youth of the Tetl'it Gwich'in, a generation of tomorrow, are here today to express our profound concern for the well-being of our sacred and ancestral lands within the Peel River Watershed and our right to maintain our cultural way of life."

Later, in return for sharing in the Three Rivers Journey, many of the participants created art and literary works that responded to this wild and mystic landscape. These artistic explorations of northern Canada's primeval origins and cultural heritage were then embodied in a national touring art exhibit as well as in this literary anthology. *Three Rivers: The Yukon's Great Boreal Wilderness* honours one of the world's finest wild mountain river systems and highlights the threats to its integrity. Through visual art, imagery, essays, stories and poems, this book aims to present conservation essentials that will help safeguard this vital wilderness. It poses questions and sets out an alternative vision to the imminent decline of the North's wild heart.

Opposite: A gyrfalcon, the North's largest and most powerful falcon, scans its hunting grounds in the headwaters of the Snake River.

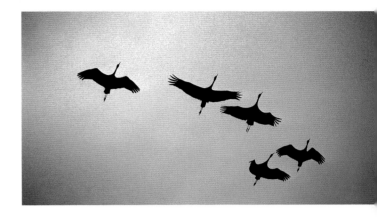

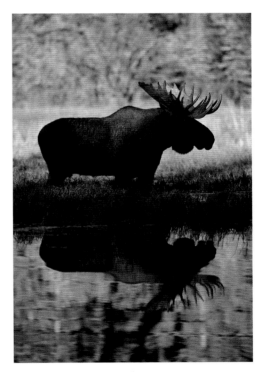

Top: The Yukon provides nesting grounds for global populations of countless birds like these sandhill cranes.

Above: The Alaska Yukon moose, which lives in the northern Yukon, is the largest moose sub-species in the world.

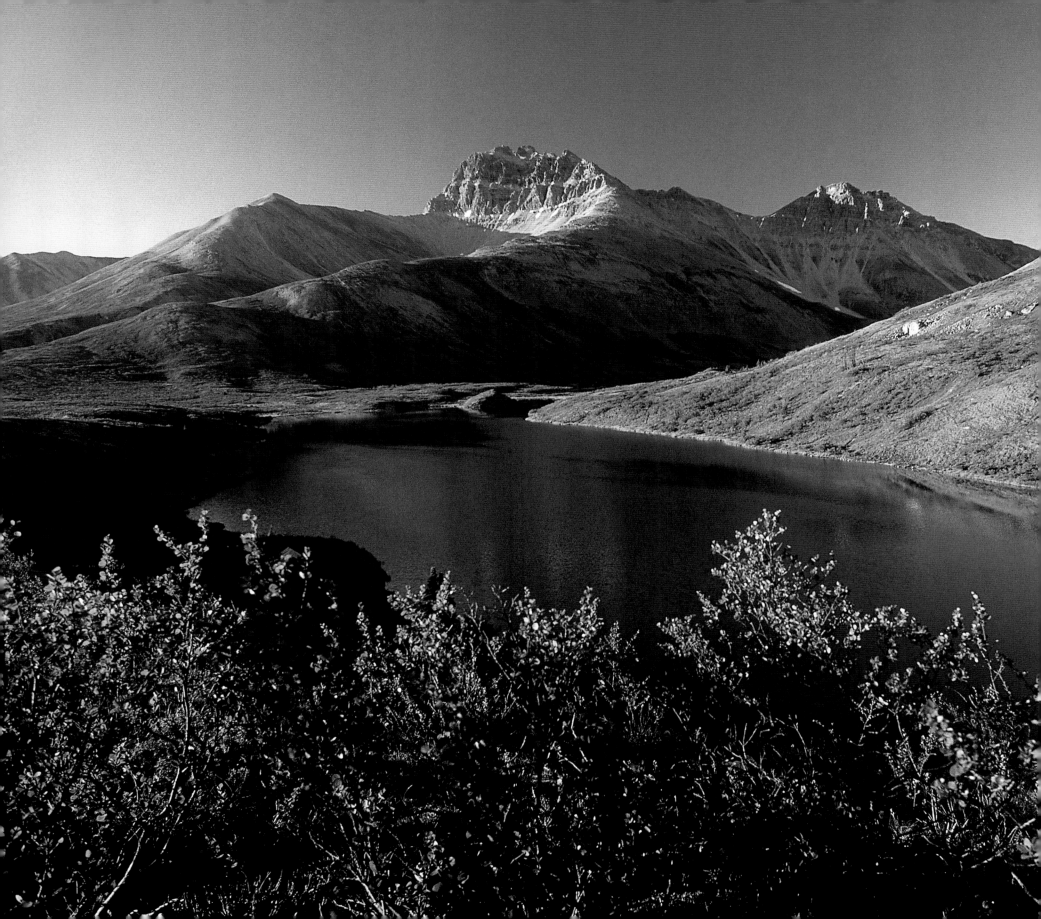

TRAVELLING THROUGH THE BODY

By Margaret Atwood

The Yukon is immense in every way. I've travelled a little in it, and even that little took a long time. Any territory that huge, that mountainous, that cold, that rocky, is bound to be dangerous to the unwary or the unlucky. "Here's the seatbelt, here's how you open the door, here are the earphones," said the Whitehorse bush pilot, "and the survival equipment is in the nose of the plane, unless of course it's scattered all over the ground." This is Yukon humour, but like all humour there's some truth in it. I've walked the tundra of the Mackenzie Mountain Plateau, just over the Yukon border in the Northwest Territories: every so often you'll come across a rusting plane part embedded in the moss. One false turn in the fog or rain or sleet or snow and that's the end of it. Or, as another bush pilot said, "I don't like to fly over anything I can't see." Some do. Some die.

We measure everything by its size in relation to our own bodies. Quite a few bodies could disappear without trace in the Yukon, and quite a few have. It's a land that inspires respect; in fact, it requires it: you won't be rewarded for absent-mindedness, or allowed many mistakes. This land isn't cuddly, any more than grizzly bears are cuddly. You can love it passionately, but not with condescending affection. You can't take it for granted. It's not cute.

Left: At Duo Lakes, near the headwaters of the Snake River, the late night sun brings out the rich hues of the northern mountains.

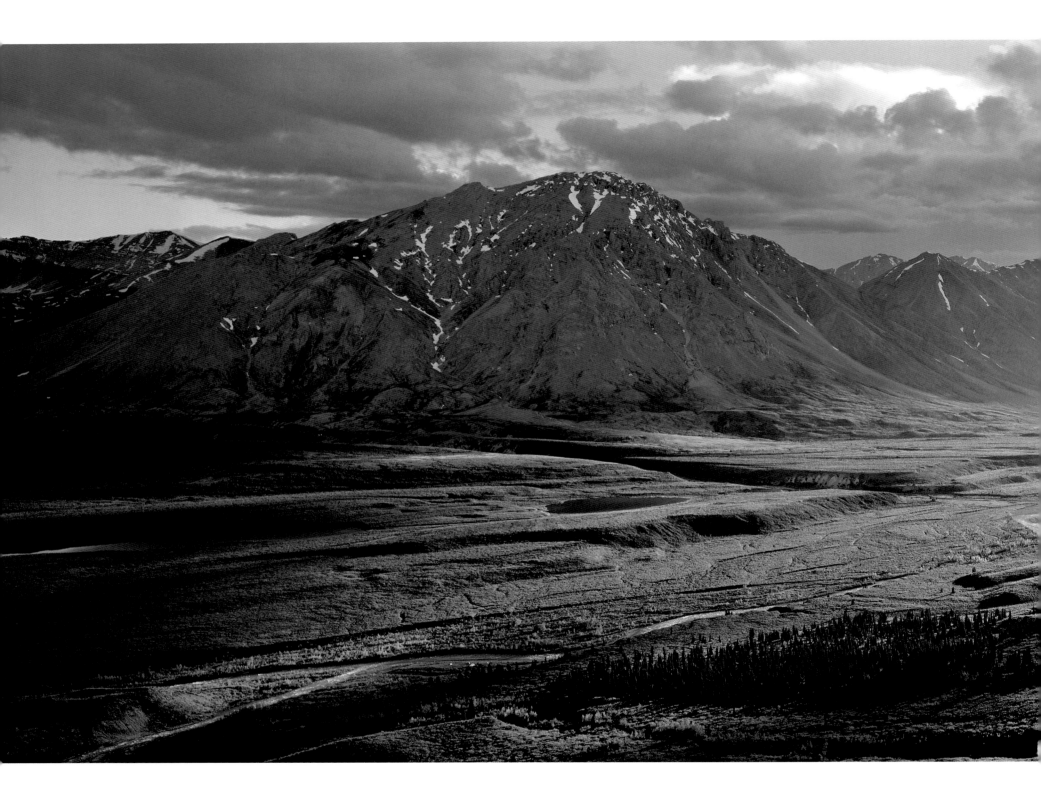

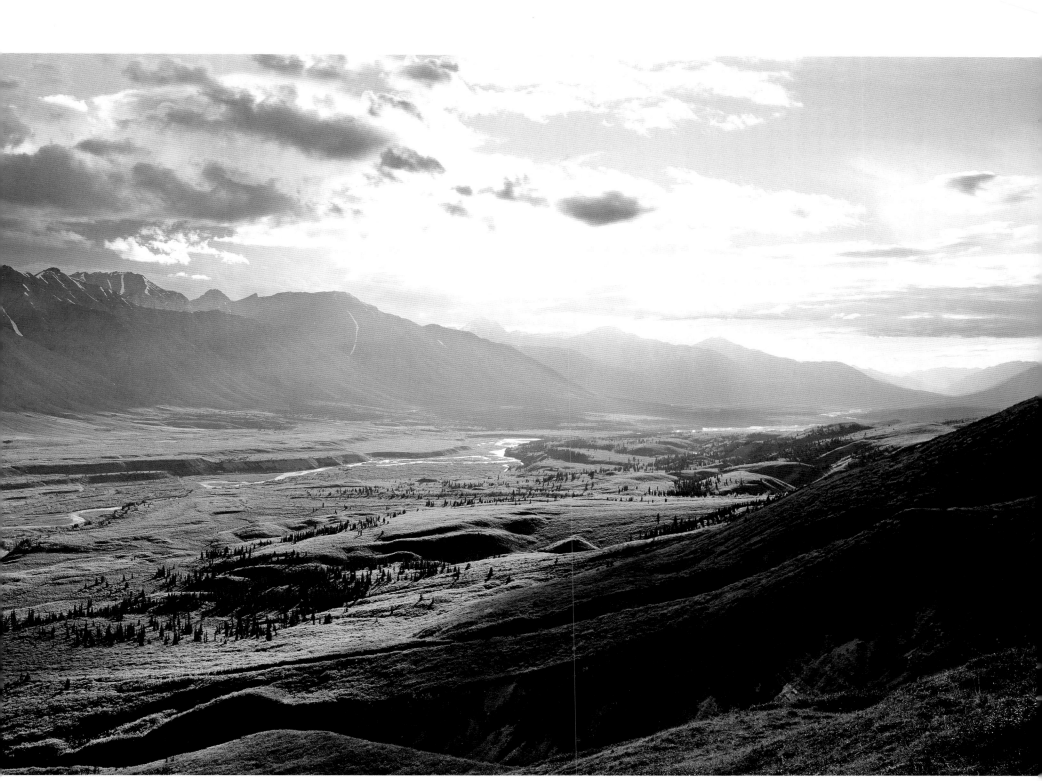

Flowing through one of Canada's largest intact mountain ecosystems, the Snake River
is renowned as a premier North American paddling river.

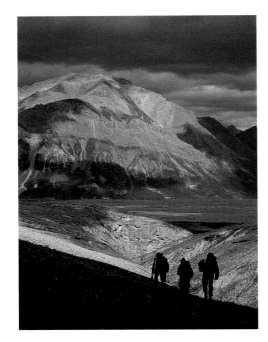

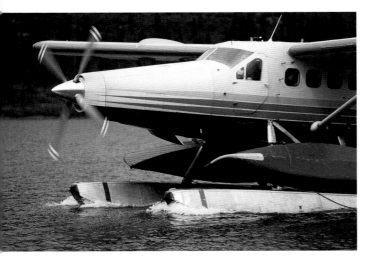

Top: Hikers high above the Wind River valley enjoy the endless vistas.

Bottom: A Black Sheep Aviation Otter lands on Bonnet Plume Lake laden with canoes. Bush planes provide the only ready access to the road-free Three Rivers area.

Some people would rather stay in their condos. "I don't do cottages," one friend said to me recently. Even the front lawn can be a challenge to those on poor terms with organic life: there might be a worm. These folk would agree with Alexander Pope's dictum that the proper study of Mankind is Man, as long as that man is equipped with a microwave, a cell phone, a car, and the other bells and whistles we use to transcend space and time while cocooning ourselves from the raw materials. A lot of children these days think meat comes from the supermarket. But you can't really study Man (nor Woman either) apart from his habitat; and, air conditioning or not, we all breathe air; and the air is undivided. Even in the midst of the city, you are—in that respect—also in the wilderness. And in the wilderness you're getting the fallout from cities, whether you can see it or not.

In the Yukon where the Three Rivers Journey mostly took place, you feel you're closer to the essence of air—air the way it used to be thousands of years ago. You can stand beside one of the chilly, pebbly rivers, looking up at one of the wrinkled mountains, and see more or less what the first travellers through this region must have seen. Those travellers came only with what they could carry or make; they ate only what they could pick or kill; and they arrived with the knowledge they already had from living in similar conditions for a long time. In imagination, shed everything you have that's nylon, cotton, steel, wool, plastic, rubber, or glass, and you'll begin to understand how ingenious and resourceful these people were, and how ill-equipped you'd be if you suddenly had to fend for yourself without benefit of twenty-first century technology. If you don't get a little humility this way, you'll probably never get it any other way either.

To journey through this land is to journey in time. You can almost touch the human past—the sense of a primordial homeland is very strong. And you witness the infinitely longer and older geological past as well. Rocks and stones are time in slow motion; they're the unliving backbone of everything alive, and here they're in plain but startling view. The green world we take for granted further south is revealed for what it is: a thin, fragile, but tenacious coating, doing what it can with rock and stone. It's life *in extremis.*

You journey through time in another way here as well because time itself is rearranged. It's no longer divided into minutes and seconds as it is when you're driving a car or catching a subway train or sitting through a boring meeting. Instead, it becomes two other kinds of time. First, the time of the seasons, more intense here than in other places: the summers shorter but more brilliant, the days long, the sunsets vivid, luscious, but with the shadow of the hard icy winter to come falling across them. Second, the time measured by the body: how long it takes you to make your way down a stretch of river or clamber up a hill with your sore arms and aching legs and sharpened heartbeat.

At first thought, there's something a little comical in the idea of dropping a clutch of artists

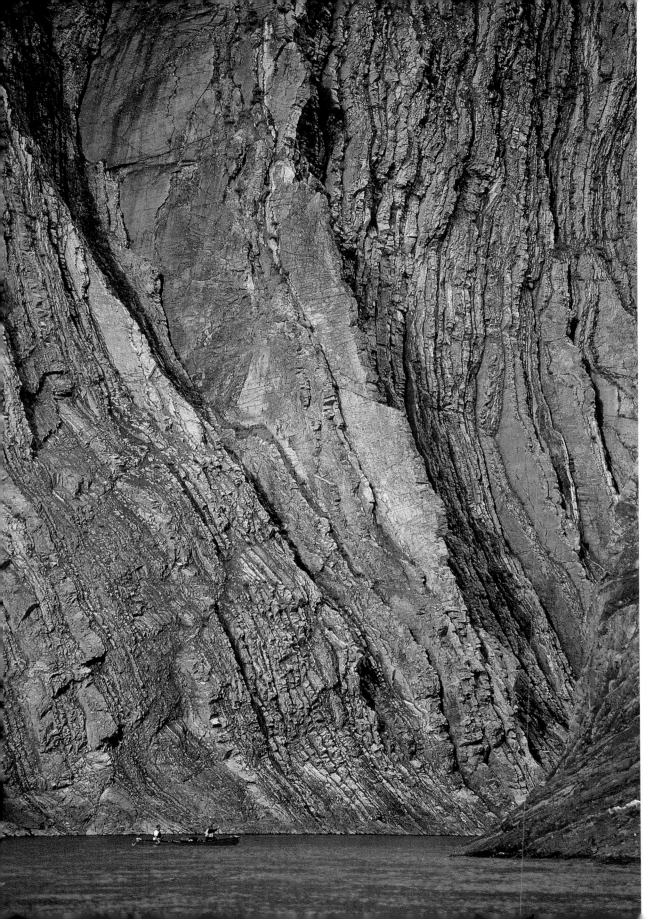

Above: The sun sets over Mt. Royal, a dominant landmark along the the Wind River valley.

Left: "In the Yukon, you're smaller," writes Margaret Atwood. But you're bigger for having experienced it. Here paddlers navigate Peel Canyon.

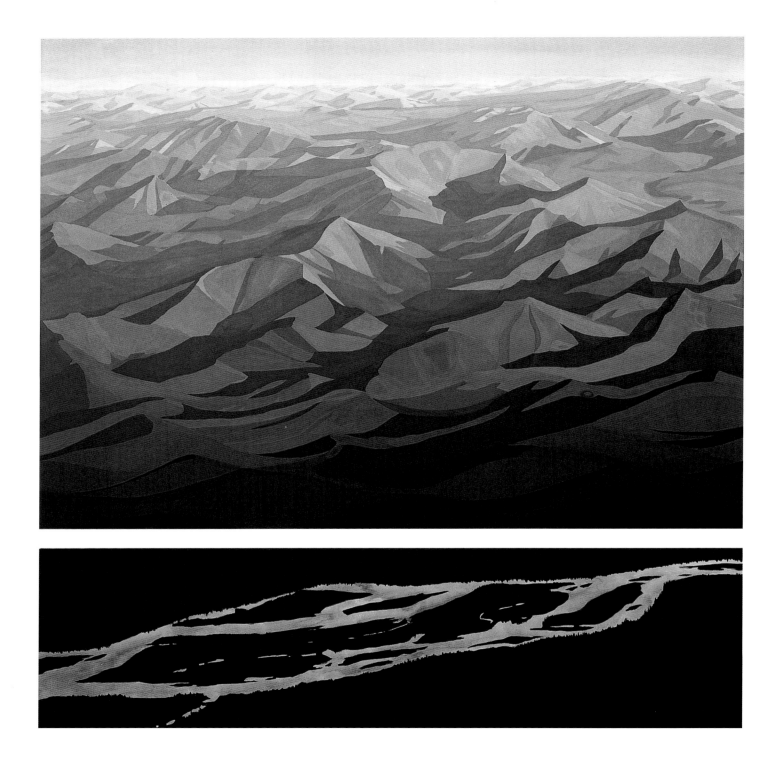

into such a place. Artists, with their freeze-dried supplies and windproof tents and rain hats and zippers and toilet paper and paraphernalia, and their ideas about art. What are they doing here? The land doesn't need them. Remove the artists—in fact, remove any people at all—and it would go on perfectly well by itself. Why do people make art, anyway? Why are they always turning what is into what-does-it-mean? Looked at from the point of view of a mountain, an artist is tiny and brief, a sort of bubble.

But perhaps this terrain does need the artists after all. It needs them to tell the rest of us about itself because, at the stage we've now reached in the saga of ever-expanding, ever-voracious humanity, anything or anyone that isn't understood, valued, and defended—made real to the hearts of others—is likely to be exploited and obliterated. A person you see and know and love is harder to kill than one that is merely a target. And so it is with natural areas.

I've said that we measure everything by its size in relation to our own bodies, but the reverse is also true: we measure our own bodies by the size they are in relation to everything else. In the Yukon, you're smaller. But you're bigger as well, because we all have two bodies—our physical body and our body image. Our physical body is unlikely to be at the most more than seven feet tall, but our body image is as large as our emotional claims make it. Sometimes we're as large as our room, or our car, or our city, or our province, or our country. Sometimes we're as large as the earth. As with the physical body, pain is a symptom of life: you can tell how big your imagined body is by what hurts. When two hundred thousand people on the other side of the globe are killed in a tidal wave and it hurts, you're that big.

For many Canadians, the North is part of the imagined body. It's an extension of the self, not the rational self but the self that feels. When the North is damaged and we hear about it, we hurt. The twenty-first century will tell us—once and for all, I suspect—how much of ourselves we're prepared to destroy.

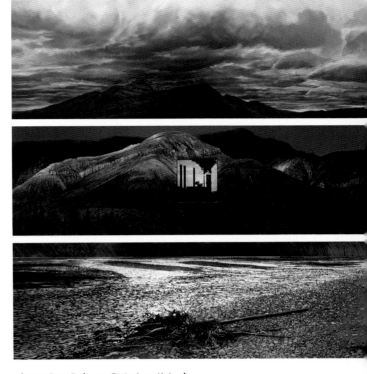

Above: Ron Bolt, an Ontario artist who participated in the Three Rivers expedition, painted detailed, subtly coloured works. In "Imagine This," Bolt subverts the traditional landscape by placing an industrial site—a steel smelter—within a wilderness portrait. "It's inevitable that the world will change, but it's important that we understand what we will lose in that process, not just what we will gain materially," he says.

Opposite: In "Wernecke Mountains: Free Flow", Whitehorse artist Jane Isakson presents the land in all its diversity and forms. "Nature is where I go to seek a sense of connection, where I look for answers, where I go in search of myself; it is the spark for a conversation in paint," says Isakson.

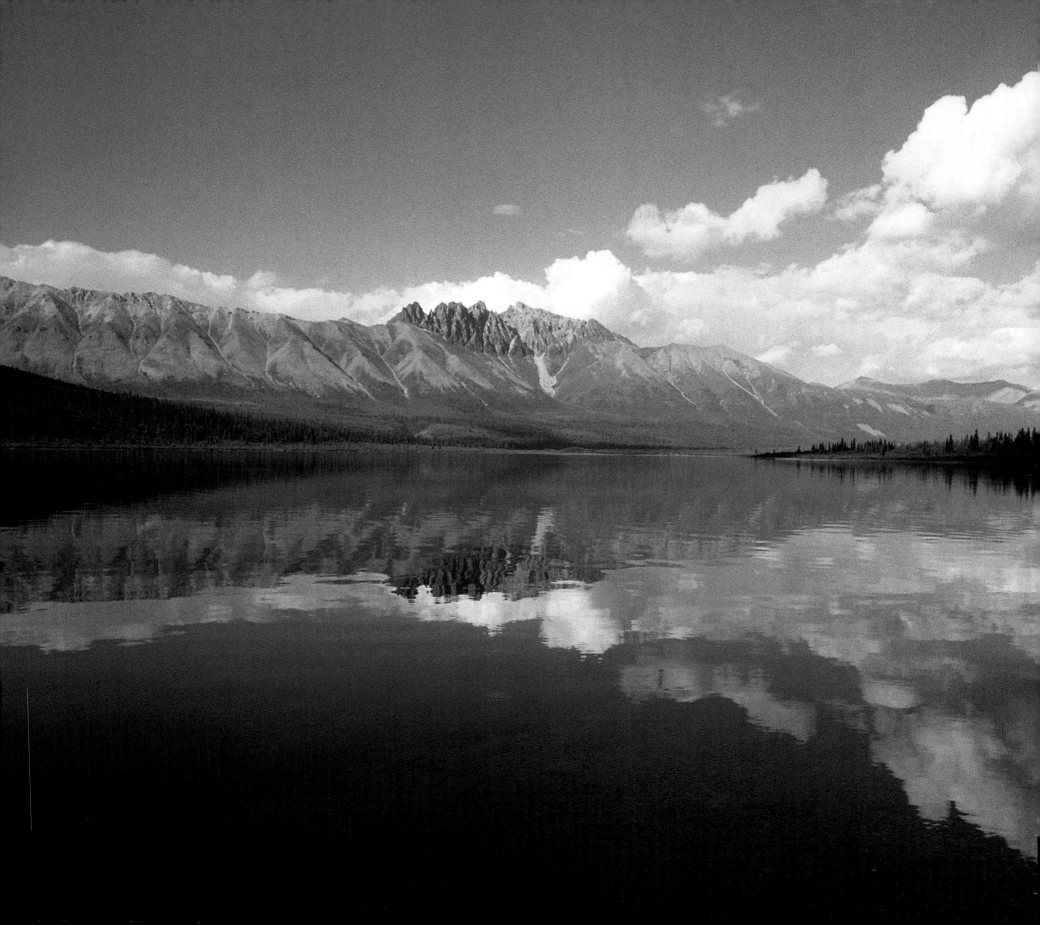

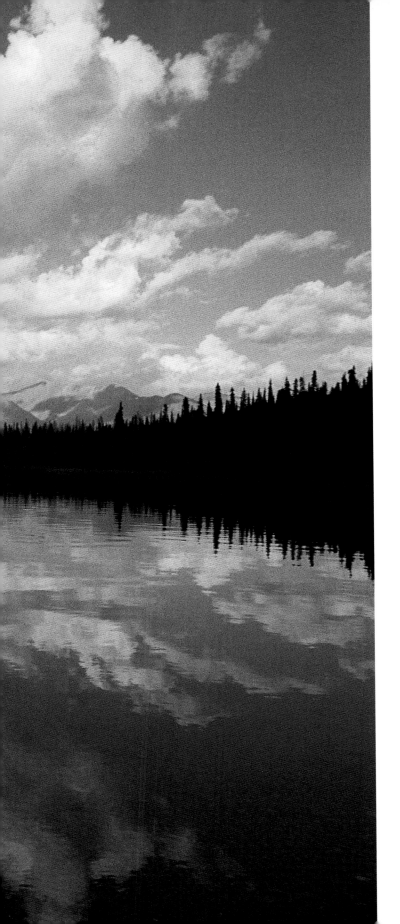

THE WORLD OF THE THREE RIVERS

T he area known as the "Three Rivers" is in the heart of the greater Peel River Watershed, within the traditional territory of two First Nations. The area is biologically rich, wonderfully pristine, and it is acutely threatened. If, as many scientists feel, development of the northern boreal is a clear danger to planetary health, that is doubly true of the "Three Rivers" region.

FINDING HOPE IN THE CANADIAN BOREAL

By Richard Nelson

A late summer evening in the unbounded wild of northern Canada—low sun obscured by the mountain's shoulder, the nearby forest exhaling cool moist air, riffles softly chanting in the river. Imbedded in the descending hush, I feel elated by the palpable abundance of secrets.

In a moment of stark and beautiful suddenness, a wolf steps into an open place among the nearby willows. He must have come from the darkening woods and walked silently toward us over the dry riverside rocks, weaving through ribbons of scent so utterly strange they triggered no fear. Almost certainly, he has never before heard the singsong murmur of human voices, the crackle of a campfire, the tinkling of spoons in coffee cups.

The wolf halts in mid-step, showing his full profile, turns his head toward us, and holds us in a protracted, unflinching stare. I am struck by the pure blackness of his fur, the

Left: Shimmering waters of Bonnet Plume Lake reflect the Wernecke Mountains.

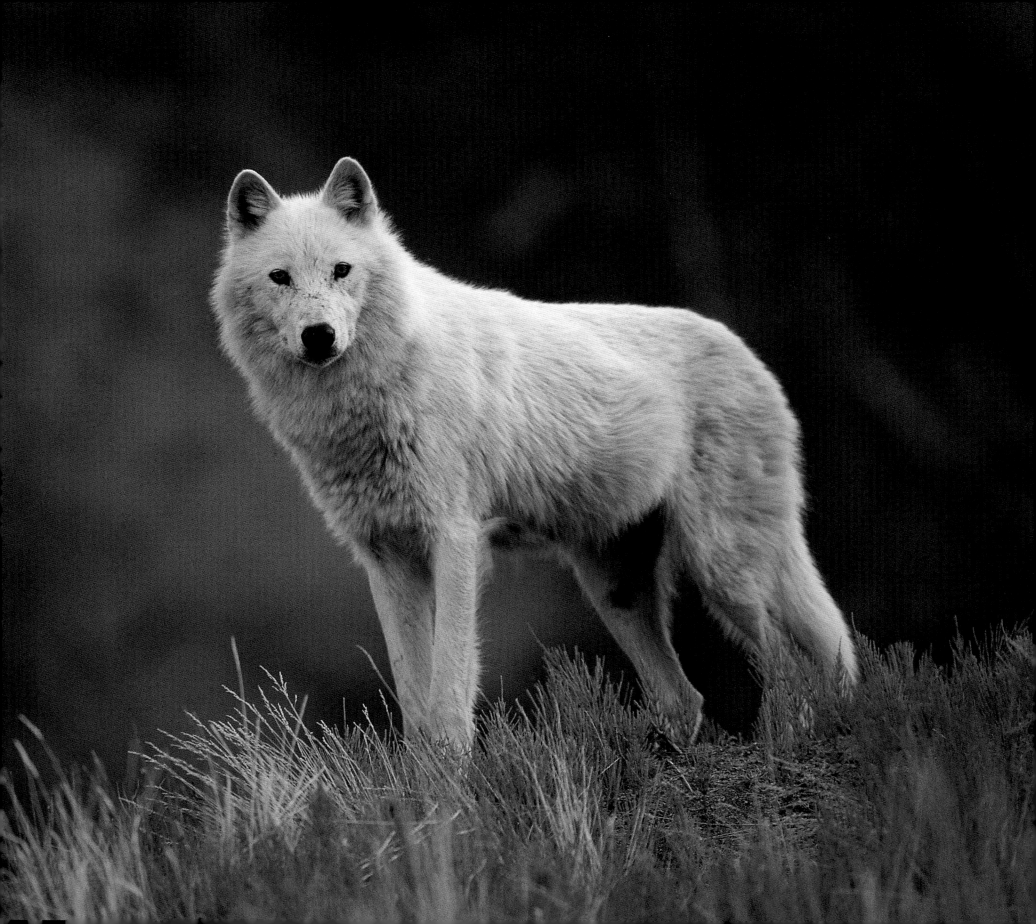

lankiness of his legs, and the sinewy brawn of his youthful body, which must weigh sixty or seventy pounds.

At this close range, I can look directly into the wolf's eyes, shining like flakes of mica against the midnight of his face. I feel as if I'm staring directly at the sun, as if the bright corona of those eyes will burn in the core of my mind long after I've turned away.

The wolf lifts his snout to the faint, furling breeze. I imagine his nostrils flaring and narrowing, his chest rising and falling. During these moments, his presence seems to pervade our entire surrounding world—the steep-sided valley, the high glinting peaks, the brightly overarching summer sky that never fades fully into night. Finally, his curiosity yielding to apprehension, the wolf turns and lopes back toward the forest, flouncing like an overgrown puppy.

Amid a flurry of whispered exclamations, I ease with my camp mates toward the place where the wolf had stood, hoping to catch another glimpse, perhaps even to spot the more cautious members of his pack who are almost certainly nearby. But we see only the empty field of river-smoothed stones and the brow of forest beyond.

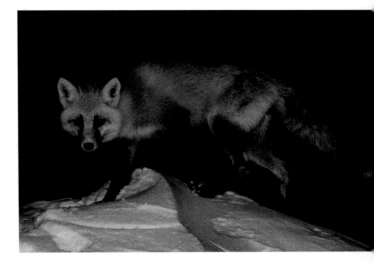

❧

For me, this startling encounter with a wolf in the northern Yukon Territory was the defining moment of a three-week journey down the Bonnet Plume River, a journey which took us into one of the largest, most spectacular, pristine wildlands remaining on earth—the boreal forest of Canada. I was the lucky Alaskan in an otherwise all-Canadian group that included a photographer, a wildlife biologist, several artists and writers, river guides, conservation advocates and representatives of First Nations communities—thirteen of us in all. Our goal was to produce art, images and writing that would help to raise public awareness of the great northern forest.

Even after forty years of travel into the remotest parts of Alaska, I was astonished by the magnitude of wildness and beauty along the Bonnet Plume. For most Americans, Alaska is the purest icon of wilderness. What they know of Canada is shaped almost entirely by the narrow sliver of tamed, cultivated, urbanized land just above the Canadian border. In the American psyche, what lies beyond that settled ribbon is vaguely perceived as "the northwoods," a land entirely without dimension, like peering into the edge of a forest without troubling to consider whether it goes on for one kilometre or a thousand. Even in these days of growing environmental awareness, few Americans have any comprehension that they live adjacent to the largest expanse of untrodden, uncut, undiminished forest anywhere on earth.

As a new perspective opened around each bend of the Bonnet Plume, I gradually realized that the Canadian boreal is to Alaska what Alaska is to New Jersey. I say this not to disparage my

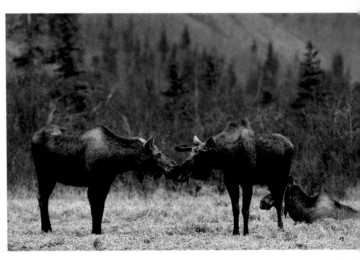

Top: The common red fox adapts well to life in the high north.

Bottom: Moose, emblematic of the boreal forest, are increasing in number in the northern Yukon.

Opposite: Personifying the spirit of the wild, the elusive grey wolf is integral to the boreal ecosystem.

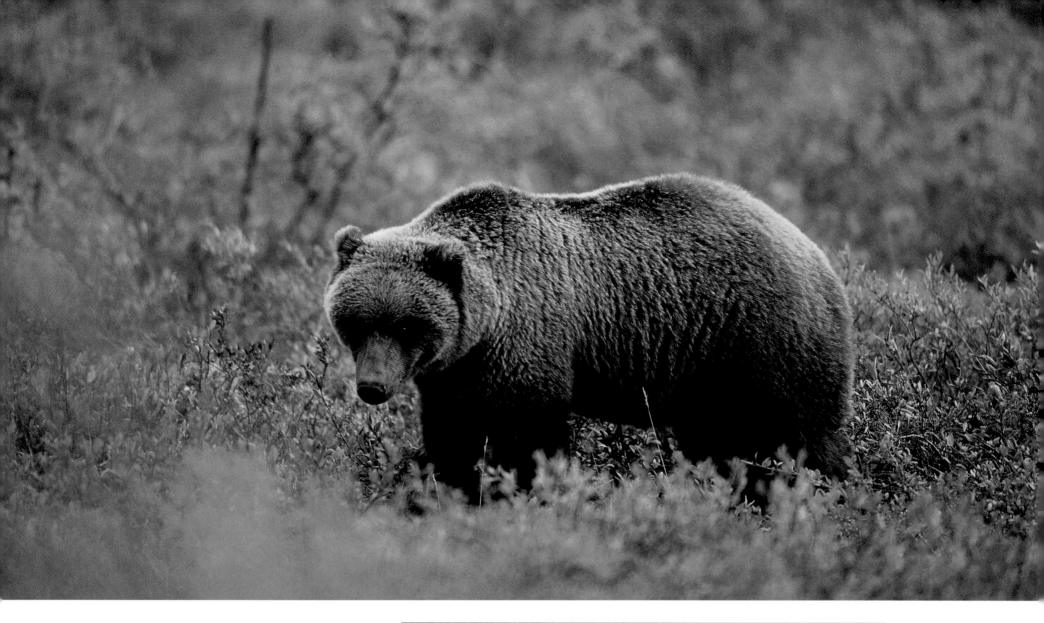

Above: The western Canadian boreal is one of the remaining strongholds of the grizzly bear, now extirpated in many parts of North America.

Right: Synonymous with the northern wilderness, the wolverine can only survive in vast wild spaces like the Three Rivers.

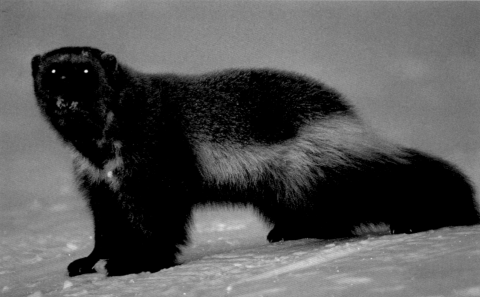

chosen home but to celebrate one of the great remaining natural marvels of our planet. In the northern Yukon, I felt as if I had entered a world of dreams, bearing witness to the continent before humankind, standing awash in the dawn of creation itself.

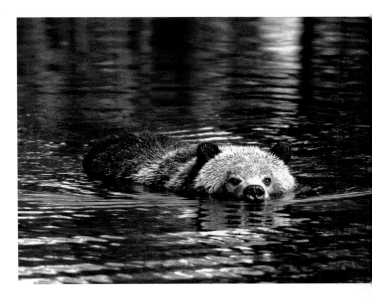

The morning after the wolf's visit, a small group of us trekked off to climb one of the mountains that rise steeply from the riverside. Labouring our way up, we paused to identify fast-blooming arctic flowers and relish the sweet, low-growing blueberries. On the summit a couple of hours later, we looked out over a massive fretwork of stony peaks, sheer vertiginous walls, narrow tributary valleys and tier beyond tier of jagged ridges standing into the far distance. I left the others and wandered along a grassy slope, followed the tracks of Dall sheep into a narrow cul-de-sac gorge, watched a golden eagle veer and circle in the updrafts, and found a colony of rabbit-like, collared pikas living amid the rocks and tundra. I had never felt a more complete absence of visible human impact and had never been more vividly aware of the earth's inherent capacity for perfection.

From our high vantage, we could trace a long, shimmering stretch of the Bonnet Plume River, which runs almost 275 kilometres from its mountain headwaters northward to a confluence with the Peel River. The Peel eventually flows into the Mackenzie River not far from its broad, braided mouth on the shore of the Arctic Ocean. In the 77,000-square-kilometre watershed of the Peel and its tributaries, there is just one settlement, the Gwich'in community of Fort McPherson. Few would imagine that at the opening of the twenty-first millennium such an unfettered, unhewn, uncompromised landscape still exists on this continent.

This brings to mind another way to measure the wildness of the Canadian boreal. From where we stood, just below the Arctic Circle, the nearest permanent road—the Dempster Highway—is about 200 miles west. For comparison, in the entire continental US, the farthest you can get from a road is less than 25 miles, and that is in the southeast corner of Yellowstone National Park. And imagine this: if you go straight east from the Bonnet Plume River, you will not find a permanent, interconnecting road across the entire 2,000-mile breadth of boreal Canada. The next road at this latitude? Beyond the Atlantic in Norway.

A more tangible vision of wildness appeared near our camp that same afternoon when a grizzly bear swam across the river a hundred yards away, shook himself dry, and lumbered off without troubling to investigate our little cluster of tents. The next morning, I found his flat-footed, long-clawed tracks punched deep into the sandbar, weaving among the prints of a female grizzly and her tiny cub, four wolves with paws so large that an imprint would barely fit under my outstretched hand, and an enormous bull moose with hooves like those of a dairy cow, measuring about 11 inches from their pointed tips to the trailing dew claws. Even more

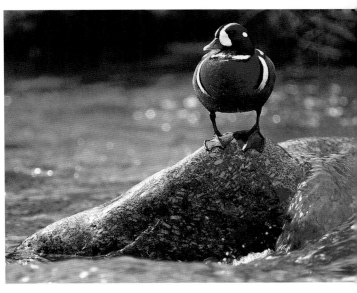

Top: Young grizzly takes to the water.

Bottom: The uncommon harlequin duck is at home in the clear and fast-moving waters of the Three Rivers.

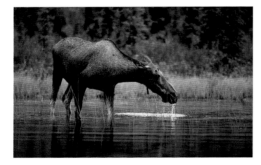

Top: Two young woodland caribou from the Bonnet Plume herd move up a ridge trail, seeking relief from mosquitoes and the summer heat.

Bottom: Cow moose forages at McClusky Lake. Moose take to the water both to feed on aquatic vegetation and to escape predators.

impressive were the metabolic signs left by a grizzly that had been feasting on the prolific, bitter soapberries—heaps literally as big around as a bushel basket and almost a foot deep, filled with seeds and scarlet-coloured like the berries themselves. Definitely not for the squeamish, but these organic calling cards can reveal much about the animals' sequestered lives.

Each day the Bonnet Plume carried us past dozens of sandbars, most of them similarly inscribed with animal tracks. But often we were too busy to notice; the clear, cold, brawling river demanded our full attention as we pitched through whitewater canyons, slalomed between giant boulders and scraped along shallow interwoven channels. Only a few groups float the Bonnet Plume each summer, and we rarely saw traces of their visits. But a fractured canoe, half buried in gravel, reminded us of the tenuous balance between exhilarating play and serious risk, where the only rescue possibility is a very long flight by helicopter or float plane.

Most of the Yukon Territory is blissfully removed from industrial civilization. At 186,000 square miles, it's a bit larger than California, but the total population is just 31,000 people, 21,000 of whom live in the city of Whitehorse. The rest are scattered among a dozen small towns and villages, remote homesteads and roadside outposts. East of the Yukon, in the vast Northwest Territories and Nunavut, the human population is even sparser; these three territories, with a combined area larger than India, are home to slightly over 100,000 people.

This leaves plenty of room for trees. Billions of trees—white spruce, black spruce, tamarack, Jack pine, lodgepole pine, trembling aspen, white birch, balsam poplar—a sweep of billowing, sighing trees, pelagic in dimensions. In North America, the boreal forest stretches across all of subarctic Canada and interior Alaska. In Eurasia it spans Norway, Sweden, Finland and Russia, where it is known as the taiga. Taken as a whole, the boreal forest is like a green banner draped around the entire northern hemisphere. It is the world's largest expanse of intact forest, covering nearly 11 percent of our planet's surface, far larger than the Amazonian rainforest and equally significant as an environmental treasure.

Along with the ubiquitous moose, woodland caribou may be the quintessential wild animal of the Canadian boreal. We saw them at scattered points along the Bonnet Plume, always in small numbers, always moving toward the edge of sight. One evening, a mother caribou and her calf emerged from the woods close by, peered at us for a long moment, then swam powerfully across the river. After lunging up onto the bank opposite our camp, they trotted along the gravel bar with swift, smooth, effortless grace, straight-backed, heads high and eyes wide, the rhythm of their hoofbeats ringing back to us across the water. Like all caribou, they seemed compelled to run, even without a visible reason, as if they love to feel the strength of their legs, the wind against their flanks, the chill air huffing in their throats.

Earlier we had spotted a skein of woodland caribou trekking up a mountain ridge—all prime adult bulls weighing perhaps 400 pounds, dark chocolate with sharply contrasting white on their necks and shoulders, carrying intricately tined antlers that curved several feet above their heads. They made their way toward the peak, stopping often to graze, dwindling higher and higher until they vanished beyond a ridge. As always, they seemed absolutely self-contained, unreachable, wholly taken up in a world beyond the touch of humankind.

Less known than the highly migratory barren ground caribou, which favour tundra regions farther north, these woodland caribou are forest animals. At most there are 184,000 of them scattered across the Canadian boreal today, living in small, dispersed groups, feeding mainly on lichens that thrive only in unbroken tracts of old-growth forest. They are animals of the deep wilderness, easily disrupted by mining, oil and gas development, logging and the roads that spider increasingly into remote woodlands. Endangered or threatened in almost all of Canada, extinct in the northeastern US, and down to about fifty animals in the Selkirk Mountains of Idaho, Montana and Washington, they are a key indicator of environmental integrity—and perhaps of human integrity as well.

Sarah Locke and Juri Peepre paddle a rock garden in the canyons of the Bonnet Plume.

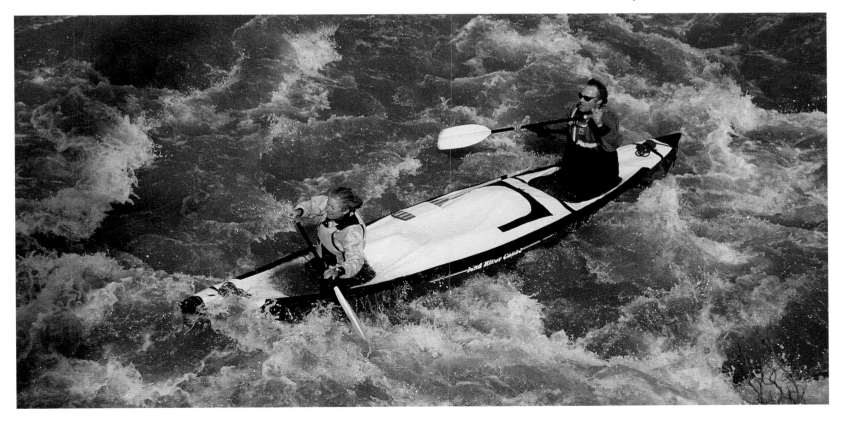

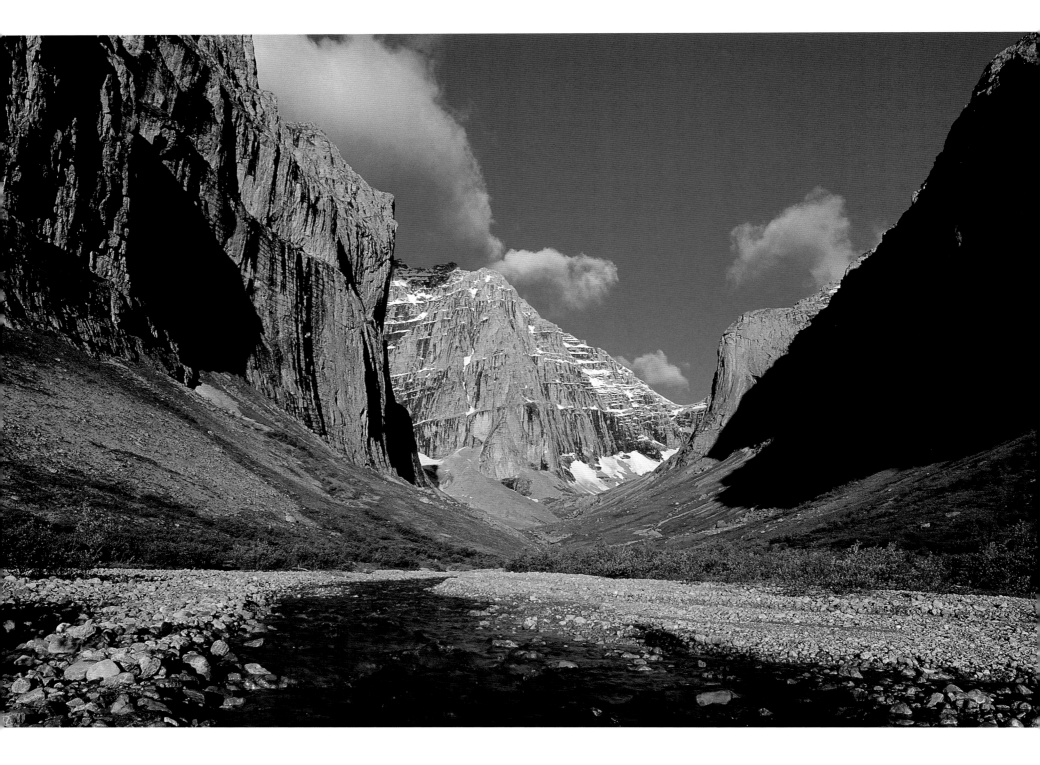

First Nations people have long depended on caribou for meat and hides. Where the caribou have become rare or extinct, remote indigenous communities have lost a major subsistence resource, while their cultural traditions have been undermined and their spiritually empowered world diminished. But throughout boreal North America, Native people who have limited access to imported groceries still take their staple foods from the land and waters. In addition to caribou, they hunt moose, Dall sheep, mountain goat, black bear, snowshoe hare, geese, ptarmigan; they trap beaver, muskrat, lynx, marten; they catch whitefish, salmon, pike; they gather berries and edible greens; they cut logs for houses, boats, sleds. Small wonder that strong voices for protecting the forest have come from the First Nations people who live in more than six hundred communities across the Canadian boreal.

Near one of our camps, I stumbled onto the ruins of a small cabin, probably built by a Nacho Nyak Dun trapper. I found a huge crosscut saw, enamel cook pots, a rusty cast iron stove and oversized Hills Brothers coffee cans strewn among the mouldering logs. Yukon law strictly protects historic remains, and it looked as if nothing had been taken away, but the relics would slowly vanish under the moss, leaving no visible evidence of the lives carried out here. I imagined the trapper standing in his cabin doorway, looking out over the forested valley and the high ragged peaks. It was a powerful reminder that indigenous people have used the boreal land for thousands of years without substantially diminishing its richness and beauty.

Now, however, throughout the North they have shifted away from nomadic camps and far-flung traplines to gather in frontier communities like Fort McPherson. Swept into an era of accelerated social and economic change, they are challenged to find a balance between the old subsistence traditions and the newer cash economy—wage labour, arts and crafts, guiding and tourism. Nestled among enormous tracts of forest, these communities are well situated for large-scale timber enterprises, but this presents a special challenge to First Nations communities who are so intimately connected to the land.

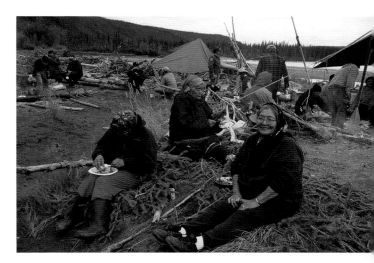

Top: Gwich'in elders from Ft. McPherson enjoy a meal of fresh moose, whitefish, beaver and goose.

Bottom: Glenda Clarke of the Nacho Nyak Dun, one of two First Nations that share the Three Rivers.

Opposite: The Mt. MacDonald massif matches the splendour of renowned Rocky Mountain landmarks such as Mt. Robson or Mt. Assiniboine.

In this north country we have the chance to accomplish what has eluded us elsewhere on the continent—to live on the land and draw from its resources while assuring that the entire living community remains intact. This often came to mind as I scanned the mountainsides, yearning to see one of this country's most elusive creatures—the wolverine. A legendary animal of the boreal forest, a predator and scavenger belonging to the weasel family, it is squat and thickset, weighing up to 20 kilograms, dark brown with paler strips along both flanks, and known for its physical power and sharp temper. Wolverines live throughout the North, but they are widely scattered, reclusive to the point of being ghostlike, and incapable of adapting to habitat loss or industrial development. Among all the native animals of our continent, the wolverine is

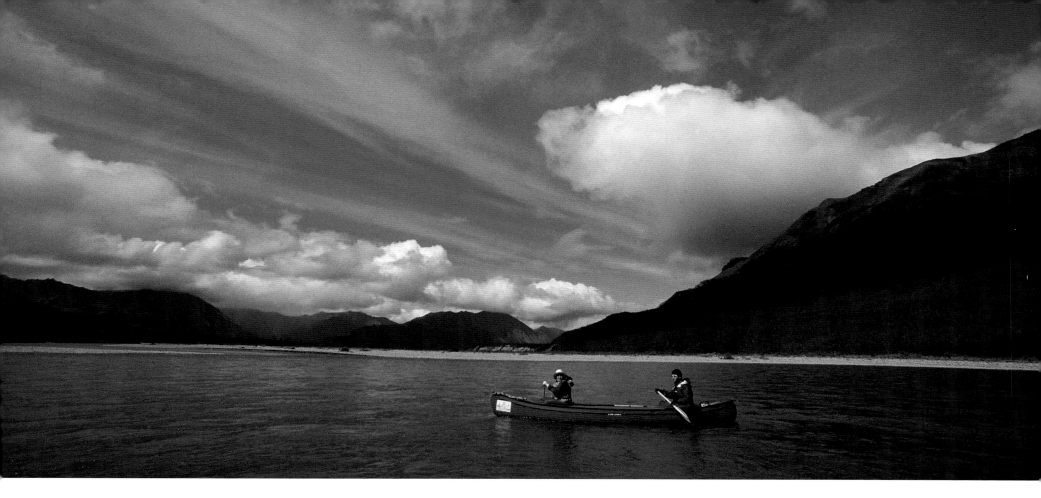

Top: Big skies and braided reaches typify lower sections of the Bonnet Plume River.

Bottom: Alaska author Richard Nelson was astonished by "the magnitude of wildness and beauty along the Bonnet Plume."

most emblematic of expansive, unmarred wilderness, holding to its farthest edge, shunning all contact with humankind, like an old mystic who chooses to die with his secrets rather than reveal them. In the long run, our most important gauge of successful habitation in the northern forest may be the continuing presence of wolverines; their disappearance would be a tragic signal of failure. And, as we drifted down the Bonnet Plume, I was comforted to think that wolverines may have watched us from the concealing forest—but we saw no trace of them.

During one of our stops, I hiked up an easy ridge and came onto a sprawling view of mountains cloaked in velvety green tundra. Glassing the nearest peak, I saw four pure white female Dall sheep and two half-grown lambs, all peering down from a bedrock precipice as if there might be a wolf or bear somewhere below. Making my way back to the river, I heard a lovely, garrulous chatter and amid the boughs of a tall white spruce I picked out a northern shrike—robin-sized, slate grey, with a conspicuous black mask and a long, hooked bill. Dave Mossop, the Yukon biologist who carefully logged our bird sightings, was pleased when I told him about this bird because he fears shrikes may be declining here.

Northern shrikes often winter in the boreal forest, along with a fairly small number of other bird species tough enough to endure temperatures of minus fifty or colder. But the great majority of birds head for warmer climates each fall, returning in spring to nest and raise their young, taking advantage of the protracted daylight, lush summer growth and abundant insects. Almost 30 percent of all North America's land birds and 40 percent of our waterfowl nest in the Canadian boreal—over 230 species in all, including warblers, sparrows, thrushes, woodpeckers, flycatchers, longspurs, vireos, swallows, juncos, kinglets, hawks, loons, grebes, ducks, geese. The total population of land birds in Canada's boreal forest each summer is over five billion, a number so large it is completely beyond our comprehension.

In recent years, much attention has focused on habitat destruction in the tropical areas where many northern birds winter. But now there are equally important concerns about their nesting grounds, which are the source for every new generation of these bright and beautiful creatures. A report by Bird Studies Canada indicates that the populations of forty species nesting in the boreal forest are declining. Almost certainly there are multiple causes, but protection of the birds' nesting habitat is crucial at a time of growing pressure from petrochemical development, hydroelectric dams, mines, agriculture, roads and logging. In Ontario alone, up to 85,000 migratory bird nests were destroyed by timber harvests in 2001, according to a report to the North American Agreement on Environmental Cooperation.

Every spring, flocks of birds fly enormous distances across the continents and oceans to reach their home grounds in the northern forest. During their annual passage they bring flashes of dazzling colour to our backyards. They weave a chorus of song through our mornings and evenings. They reveal to us the lavishness and splendour of evolution. And they remind us about the tenuousness of life in a time of global change. One evening we watched a pair of loons perform an ecstatic mating dance on the waters of Bonnet Plume Lake. Their protracted, tremulous, wailing voices drifted through the forest and rang up against the mountainsides as if the whole northern world were singing to itself.

The boreal forest is also one of the few places where every species known to exist before Europeans landed on North American shores is still present, where we need not feel the heartbreaking emptiness of extinction. And the forest contributes importantly to the well-being of our own species. Every breath we take is in part a gift from this immense, earth-circling ecosystem, which exhales massive amounts of oxygen each day. The boreal regions also hold and filter 80 percent of the world's fresh water. And by locking up huge quantities of carbon in living vegetation, the subarctic forest helps to limit the amount of carbon dioxide in the atmosphere, mitigating a major cause of global warming.

The Canadian boreal is like an elephant in the living room—we ignore it at our peril. Few people are aware of its existence, yet the far-flung, thinly populated northern lands may be our

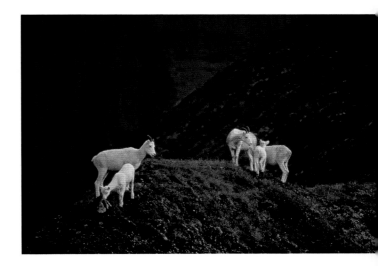

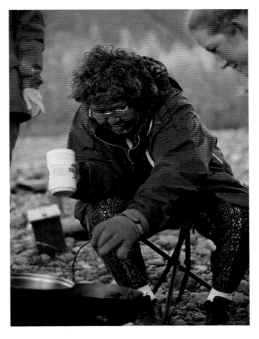

Top: Dall sheep, believed to have evolved in the unglaciated region known as Beringia, are often seen at mineral licks along the rivers.

Bottom: Elder Liz Hansen tends to the brewing of campfire coffee.

best remaining chance to protect our natural heritage on a grand scale. We can do it while also recognizing the place of indigenous cultures, nourishing healthy land-based communities, and shaping a balance between preservation and utilization of the environment.

This is exactly what the Canadian Boreal Initiative proposes to do. Supported by a coalition of conservation organizations, this initiative would protect the world's largest tract of virgin forest through an unprecedented collaboration between First Nations people, environmental interests, scientists and industries. These groups have shaped the boldest, most ambitious, most visionary conservation plan ever created anywhere: it is called The Canadian Boreal Conservation Framework. It would establish a network of strictly protected, interconnecting parks encompassing about half of the 1.3-billion-acre northern forest, an area almost ten times the combined size of all US national parks. The other half of the boreal region would be open for development under ecologically sustainable guidelines yet to be defined. This extraordinary plan avoids the divisiveness typical of many debates over land and resources because it was developed collaboratively by the stakeholders and because it assures that people will remain intricately engaged with the land as residents, workers and stewards. Northern Canada may be the only place in the world where conservation on such a magnitude could still be achieved, first because Canada's political, economic and cultural circumstances open conservation opportunities that wouldn't be possible in the Amazon or Siberia and second and most importantly because over 90 percent of Canada's boreal land is publicly owned.

Many northern communities are witnessing an unplanned but dramatic economic change. Travellers are coming here from throughout the world, not to create extractive industries, not to build factories or cities, not to see museums or theme parks or monuments, but to absorb themselves in precisely the opposite. They are drawn by what is rapidly becoming one of the scarcest, most desired and most valuable resources of all—wild lands, wild waters, wild forests, wild animals and the peace of wildness itself. Nearly all of the Bonnet Plume River is incredibly rich in these qualities, but along the lower reaches we came upon stark evidence that change may be impending. A short distance from the riverbanks was a huge air strip—the only visible indication of a highly speculative development that could include a coal mine, coal-fired electrical generating plant, power line, coal-bed methane and conventional oil and gas projects and an enormous iron mine near the adjoining Snake River, with all the accompanying road systems and settlements. It's a staggering possibility in the midst of such an enormous unblemished land. This is why many northern conservationists and First Nations people are working to gain formal, lasting protective status for this remarkable place. Opinions are divided about the future of Canada's boreal country, and the pressure for a wide array of developments will intensify in coming years. At the same time large tracts of unsettled land, abundant wildlife and spectacular scenery are attracting more and more visitors. With the exponential growth

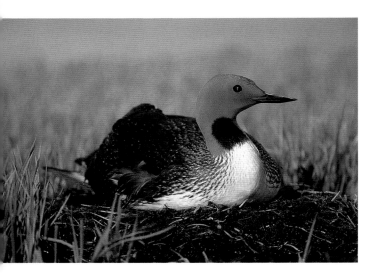

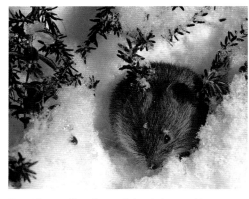

Top: The small and graceful red-throated loon is common in the far North, but rare elsewhere.

Bottom: The red-backed vole, a small forest rodent, stays active all winter underneath the snow.

Opposite: The crimson and rust of dwarf birch in the Three Rivers autumn.

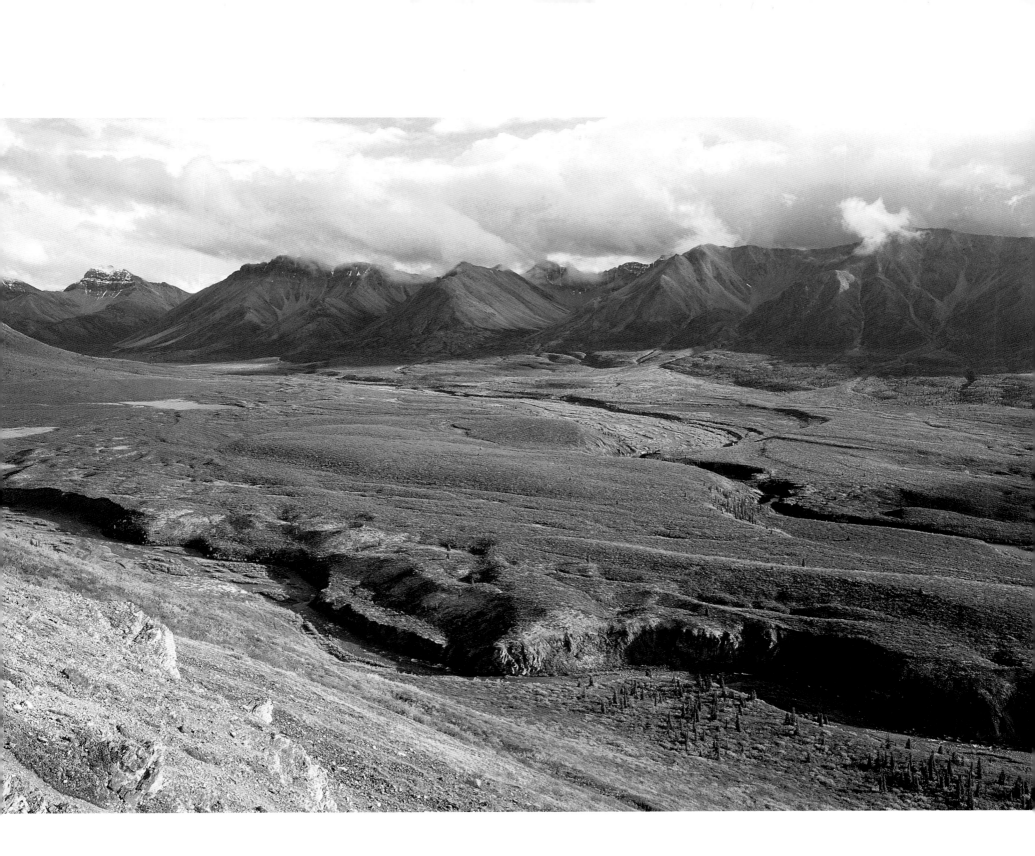

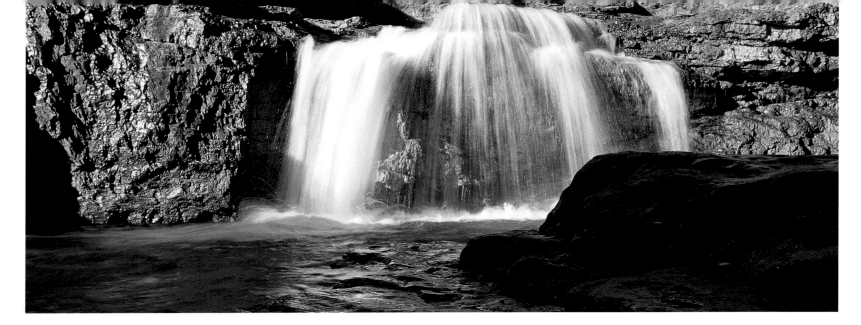

Top: One of many hundreds of cascades and pools along side creeks of the Three Rivers.

Bottom: Moose tracks along the river valleys are often accompanied by wolf and bear signs.

of recreation and tourism, wilderness qualities are likely to become the single most valuable economic asset for northern communities. In the Yukon and throughout the Canadian North, older industries based on resource exploitation should be balanced against the young, vigorous industry based on wildness. So, as we drifted past the airfield, with its bright orange windsock dancing in the breeze, I felt the burden of a responsibility as enormous as the boreal land itself. Even if developments like this could be accomplished without displacing wildlife, without polluting the ice-clear waters, without widespread deforestation and wholesale changes in the natural environment, the fragile condition of wildness would irretrievably disappear. It would create a vast darkness at the centre of the Gwich'in and Nacho Nyak Dun homeland, and it would empty the hearts of people everywhere who love the splendour of wild places.

When our trip ended, we flew back over the Bonnet Plume in a float plane stuffed with gear. Peering down at the land from this radically different perspective, I traced each bend of the river, remembered the excitement of thrashing whitewater chutes, felt again the sweaty exhaustion of high mountain hiking, reflected on the pleasures of travelling in good company and savoured the comforting silence of an immeasurably vast, forested land. Then I imagined once more the transfixing gaze of a young black wolf. And it was as if all the wildness at the heart of the North American continent had been revealed; as if the entire history of a human presence on this land were set before us; as if we were challenged to find the humility that makes us deserving of a place here; as if this animal had emerged from the forest to confront us with a prodigious, impending, massively consequential question.

And I would trust the wolf's answer far more than I would trust my own.

Adapted from a story that first appeared in the magazine *Trust*.

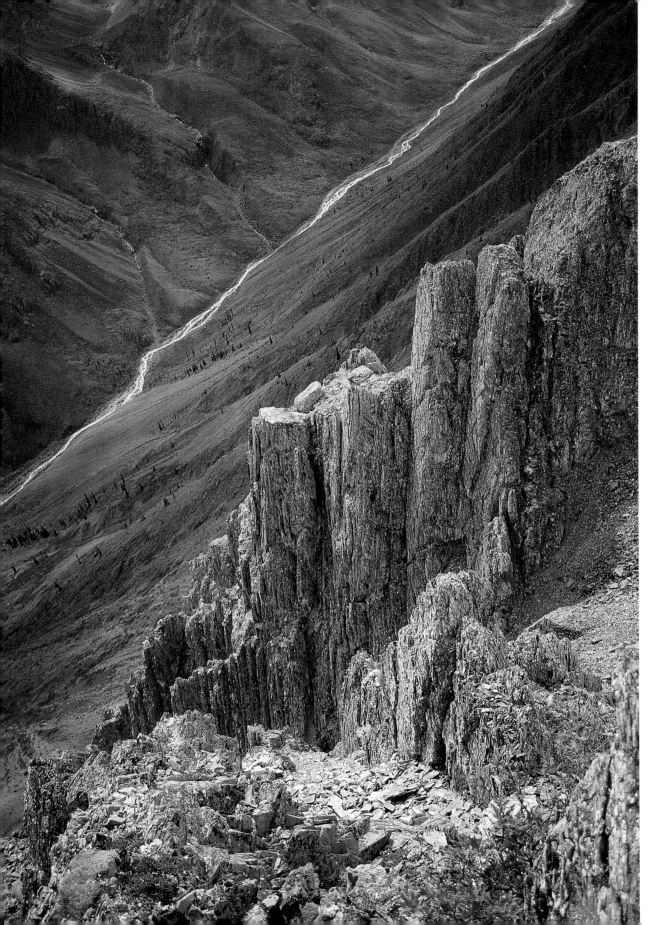

Above: The hardy beaver is ever-present in swamps and muskeg throughout the boreal forest.

Left: A side creek incises a V-shaped canyon on its way to join the Bonnet Plume.

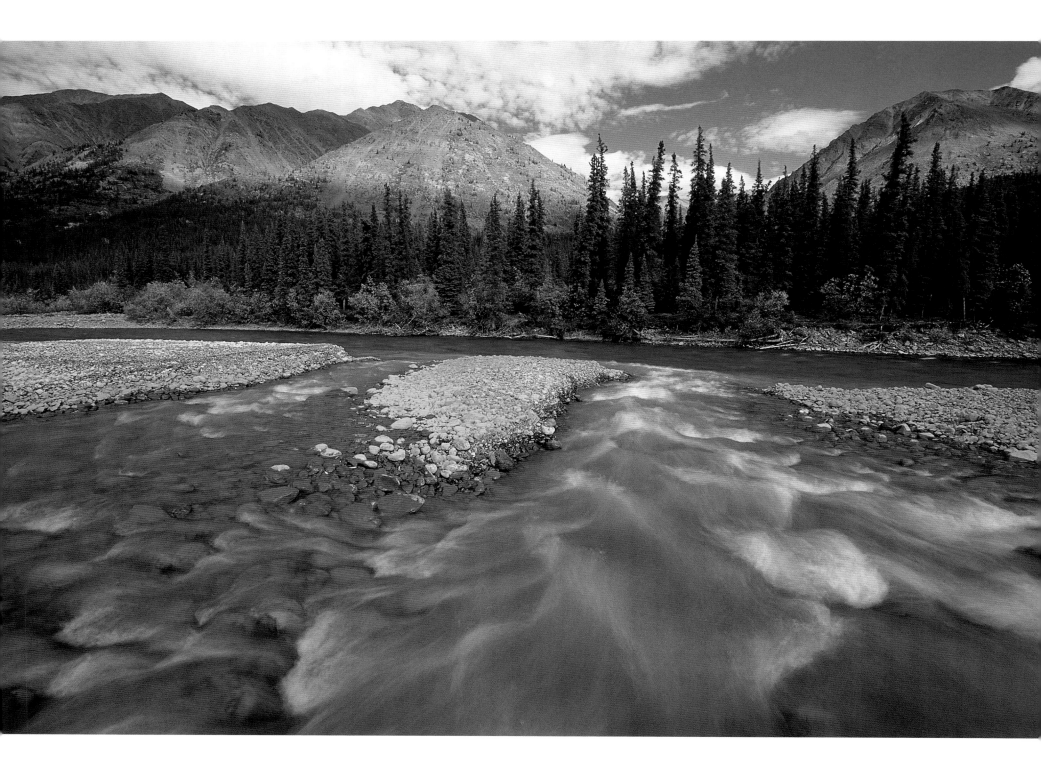

WILD WATERS, SACRED PLACES

By Juri Peepre

In 1992 when I walked into a small Vancouver courtroom as the representative of the Canadian Parks and Wilderness Society (CPAWS), the odds did not look good for the Bonnet Plume River. Facing the judge was a battery of stern-faced lawyers, ready to make the case for the federal government and the company that wanted to develop a mine beside the river. Our own legal team consisted of one lawyer, Stewart Elgie, who was with the Sierra Legal Defence Fund. He told me that our group had only a fifty-fifty chance of winning this particular fight, a case that revolved around a 60-kilometre-long winter road that had been bulldozed in to a large block of mining claims on the Bonnet Plume River. We had challenged the federal government's environmental review of the project.

Ironically, the Bonnet Plume was soon to be honoured as a Canadian Heritage River, thanks in large measure to the land claims negotiations of the Nacho Nyak Dun people, yet the future of its clear waters and free-ranging caribou would be decided in this courtroom 2,500 kilometres away. Surely, I thought, we can't delegate judgment on thousands of years of biological evolution and the destiny of a wild mountain river to a legal game of chance.

I had journeyed down many remote rivers before canoeing the Bonnet Plume in the summer of 1988, but I had never experienced a watershed like this one. This aquamarine stream and its sister rivers, the Wind and Snake, carried in their crystal waters all the fascination of the Yukon wilderness. The space, the infinite light, the escape from time itself, the never-ending gnarled and saw-toothed mountains opened a new window on the meaning of wild. Looking back now, I can see how that two-week journey changed my life. Growing up in a quiet town on the edge of the woods, I had always felt a kinship with nature, but there on the Bonnet Plume I realized that without help, extraordinary places like this river would soon disappear, even in the Yukon.

It was just a few years later that prospectors for Westmin Mining Corporation, exploring for copper, staked the flanks of the Bonnet Plume valley. They did so armed with the historic privileges afforded by the Yukon's free-entry mining law, which grants powerful rights to those who first lay claim to the land. Far from public scrutiny, they knew they could knock down trees, bulldoze roads, dynamite and utterly transform the land on their claims. When CPAWS wanted to take a closer look at Westmin's operation, a generous local pilot donated the use of his two-seater Piper Cub, and I was soon up in the air, photographing the flattened spruce trees along the winter road leading to the new airstrip and mining camp. After seeing the giant scar on the landscape, I understood that this one corporation was on the verge of setting the entire future for the Bonnet Plume valley, and I knew we could not accept surrendering this wild

Top: Wildflowers along the Bonnet Plume include yellow arnica and pink licorice root, a favoured spring food of grizzly bears.

Bottom: Brilliant red birch and yellow willow shrubs create a dazzling autumn display in the subalpine.

Opposite: Milky glacial melt waters from Mt. MacDonald mix with the clear currents of the Snake River.

Top: Orange lichens are a telltale sign of carbonate-rich rocks.

Bottom: Autumn bunchberry, feather moss and cranberry carpet the boreal in bright colours.

river to a money play in the southern penny market. If this northern wilderness were to be diminished, where would we draw the next boundary for nature? It was time to confront the belief that mining exploration was exempt from environmental safeguards; the only place we could do that was in the courts.

In the end, we lost our case under the weight of legal minutia, but we did win an important point: the judge conceded that the federal government was obliged to consider how mining could affect a Canadian Heritage River. In the meantime the company had found less copper than anticipated and, when metal prices dropped, they packed up and left, abandoning their airstrip, drill pads and mining camp. The promised jobs and bright future for the Village of Mayo evaporated as quickly as the claims had been posted. For its part, the federal government realized its antiquated mining regulations—which allowed for extensive exploration work without any environmental review—were no longer tenable, and it dusted off long-awaited new rules to improve the way mining companies carry out exploration work in the Yukon.

∽

While our court case had been pending, CPAWS had joined a government-led planning group to work out the Bonnet Plume land use puzzle. At the first meeting, I thought the nervous bureaucrat at the front of the room had made a mistake when he said, "Wilderness is not an option for the Bonnet Plume Heritage River." But in uncharacteristically plain language he was actually expressing the government policy of the day: a fresh articulation of the persistent frontier myth that the North's only purpose was to provide raw materials for the South. What had become of our northern reverence for nature, our celebration of boreal wilderness? Was wilderness not an enduring part of Canada?

We didn't accept that "no wilderness" edict for the Bonnet Plume; instead, we embarked on a long journey to learn the rhythms of the Peel Watershed and to persuade people in the Yukon and Canada that here was a place worthy of leaving alone. Having heard too many voices over the years lamenting the wild places lost because too few people knew about them, we were determined to avoid that mistake, and we gathered wildlife biologists, botanists and First Nations youth and elders to join our conservation crews to survey the heart of the Peel Watershed. Since the proponents of industry were charting a course for resource extraction, it was obvious we had to draw maps for nature, too. But when I asked one of the staff in a community lands office to point out the First Nation's traditional lands along the Bonnet Plume, I realized the young man wasn't sure where that distant river flowed. Although their ancestors travelled the headwaters of the Peel for generations, the aboriginal youth of today rarely have a chance to visit these places. So it became clear that the scientific value of our research trips would be outweighed by the chance for community members to renew their acquaintance with ancestral lands.

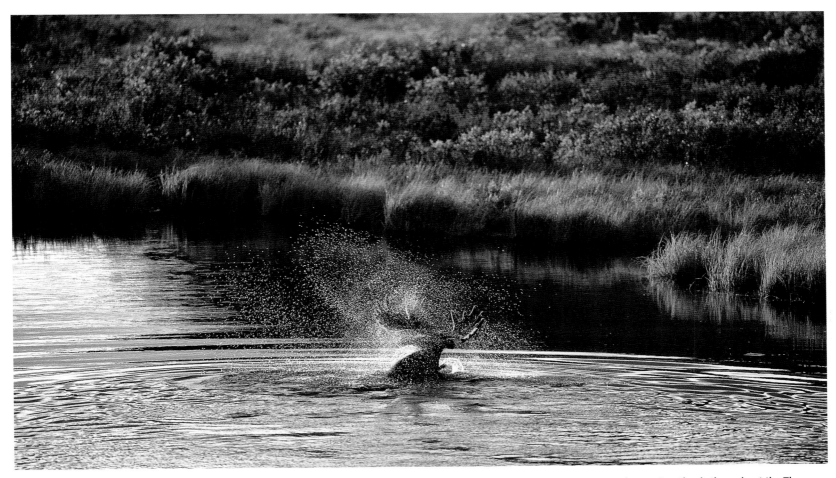

Moose frequent wetlands throughout the Three Rivers country. These large mammals can swim as fast as two people can paddle a canoe.

At first it was hard to find community folks willing to paddle for two weeks with strangers. Then Gladys Netro, a Vuntut Gwitchin woman from Old Crow, used her family connections across the western Arctic to reach out to northern communities and bring them together on the work to save the Peel Watershed. She brought an acute sense of purpose to this work from her years of campaigning for the protection of the Porcupine caribou herd calving grounds in the Arctic National Wildlife Refuge in Alaska. As a result of her leadership, for close to ten years Gwich'in and Nacho Nyak Dun people joined the CPAWS river trips, enriching these experiences for all of us.

We learned much from each other. Peter Kay, a Gwich'in from Fort McPherson who travelled with us on the Snake River, spoke of his long family history in the Peel Basin and explained the lay of the land around his traplines. But he could not conceal his amusement over where we liked to camp—windswept gravel bars, free of bugs but short on shelter and food.

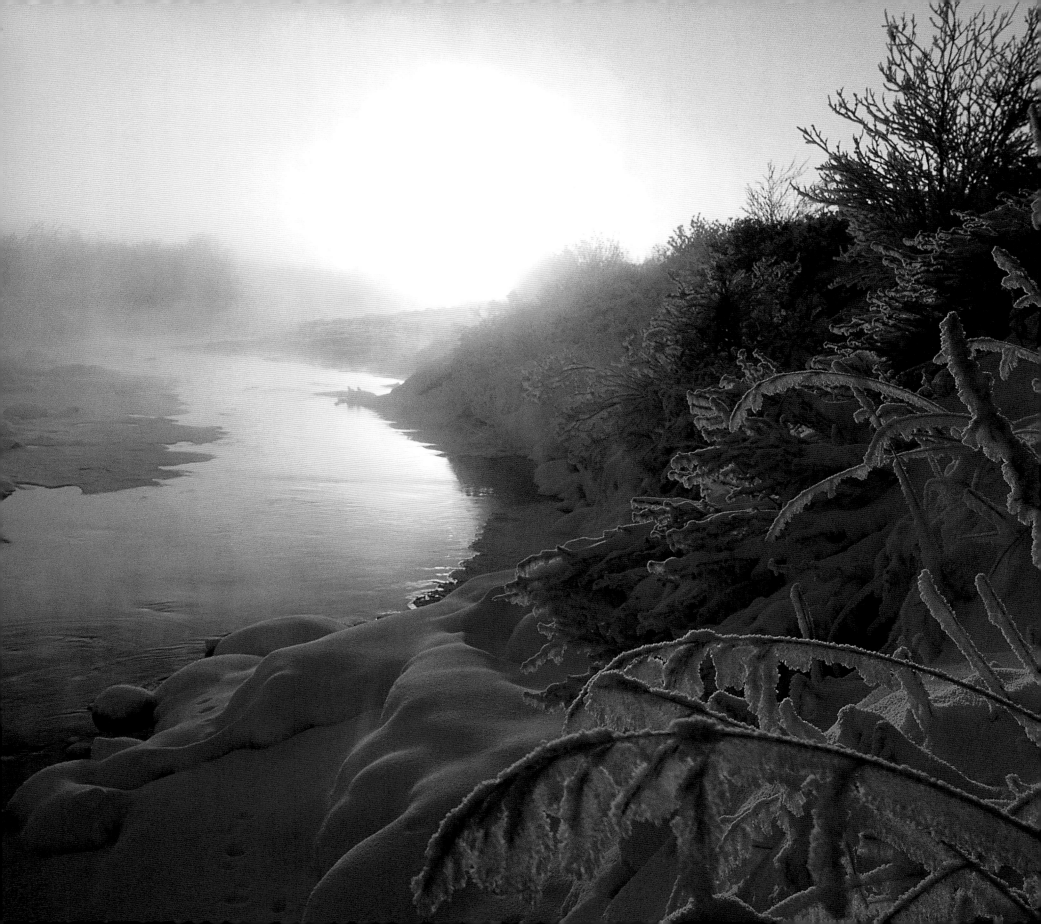

Elder Jimmy Johnny, who knows the headwaters country better than anyone, pointed out big herds of sheep and caribou high on mountain slopes where we could see only scenery. For Jimmy, a Nacho Nyak Dun and long-time hunting guide in the Wind, Snake and Bonnet Plume valleys, this place is home.

Those river surveys and the scientific data and maps we gathered helped make a strong case for conservation in the Peel Watershed, but staking claims for nature also seemed like a good idea. Our "Stake the Snake" campaign was born at midnight around a campfire. The plan was simple: stake mineral claims on crucial grizzly bear and Dall sheep habitat in the Snake valley and manage the properties for wildlife instead of bulldozers. It was all perfectly legal, but it was damn hard work, and one day, hauling four heavy spruce logs up a narrow ridge, I wondered if the resident sheep appreciated the irony of the moment. We posted our claims in long-time activist Ken Madsen's name, and sure enough, as soon as news of our venture got out, the response was indignation—we had dared to use mining laws in symbolic defence of wilderness! Ken took our Peel Watershed slide show across the country, and hundreds of people bought Snake River mining claim certificates to show their support for protecting the Yukon's northern wild rivers.

Dave Foreman, a passionate advocate for conservation in the United States, came north to paddle with us on the Snake River. Flying to our starting point at Duo Lakes, he gazed down from the windows of the vintage Otter aircraft onto range upon range of layered and nameless mountains. He had never seen such wilderness, he said. Wilderness without beginning or end. Wild spaces big enough for a journey of discovery almost beyond the imagination of most Canadians—that's the country of the Wind, Snake and Bonnet Plume rivers.

"Wilderness," wrote Canadian author Bruce Littlejohn in 1989, "with all its diversity, mystery, space, freedom, challenge and beauty, remains a vital component of our heritage as Canadians. It has marked our history and helped to form our national identity. . . . Nature, after all, is much more than a stage for human concerns. It's more than a stock or inventory for our manipulation and use. It has its own meaning and order." Several decades earlier, Aldo Leopold, one of America's most influential conservation thinkers, had observed, "We abuse land because we regard it as a commodity belonging to us. When we begin to see land as a community to which we belong, we may begin to use it with love and respect." These words mirrored what was already long understood by many aboriginal peoples.

For the First Nations people who live in the lands of the Peel Watershed, their value is not in question. To Elaine Alexie, a young filmmaker and conservation activist from the Peel River community of Fort McPherson, these are the storied ancestral lands of her Gwich'in nation. In 2003, while on the Three Rivers Journey, she said, "Going through these lands, I think about the old people going through the Wind River area and remember the stories my father told me

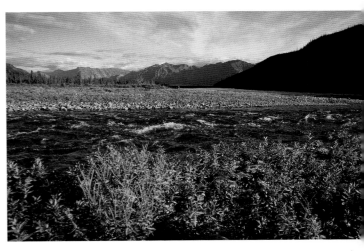

Above: Abundant pure water is one of the most precious features of the Peel Watershed—dip your cup and drink straight from any of its mountain tributaries.

Bottom: The Bonnet Plume valley near the mine site proposed by Westmin in the 1990s.

Opposite: Winter arrives early in the Peel Watershed, with snow lingering through mid-June in the mountains.

Top: Lush alpine meadows in the Snake River headwaters. The Peel Watershed offers one of Canada's best and last places for conservation on a scale large enough for restless animals like the wolverine, falcon and caribou.

Bottom: Gladys Netro from Old Crow, Yukon, a veteran of the fight to protect the calving grounds of the Arctic National Wildlife Refuge, has also worked tirelessly to conserve the Peel River.

about how our people used to travel. We need to ensure clean waters keep flowing out of these mountains."

❧

I once believed that the heart of the Peel River was safe because tentacles of roads and industry would never reach so far north. But the Peel Watershed has become another frontier for oil and gas development, another area to be sacrificed for North America's thirst for energy. Three consecutive Yukon governments have offered these lands to industry at bargain sale prices, ignoring the calls from First Nations and conservation groups to finish land use plans first. Now you need to phone Houston, Texas, to learn the latest news on what is going on in the Peel River country. Schemes to drill for coal-bed methane, extract coal and iron ore, and build steel mills are also topics of animated discussion. Although these plans seem far-fetched, any large development (perhaps made easier with government largesse) could have a profound effect on the Peel Watershed and the ecological health of its pristine tributaries. And as the continental energy and natural resources debate heats up, promoters with their eyes on the Peel are already at work, and the supporting machinery of governments is in motion.

Most of Canada's remaining wilderness has no legal protection, yet it is recognized worldwide as an indispensable though dwindling reservoir of biological wealth. This country has about 20 percent of the planet's remaining intact landscapes, and a good portion of that lies within the Yukon. However, across Canada as a whole, only about 6 percent of our lands and waters have been set aside in protected areas, and many of these are too small to sustain vigorous ecosystems. Conservation biologists have shown us the dangers of leaving only fragments of original landscapes for species other than our own; Yellowstone National Park in Wyoming, for example, is one of the very few places on the continent where grizzly bears can still survive within diminished natural boundaries. We cannot ignore these lessons in the Canadian North; we must be mindful of the cascade of change that usually follows the first deep cut in the landscape.

The Peel Watershed offers one of Canada's best and last places for conservation on a scale large enough for restless animals like the wolverine, falcon and caribou. It's a landscape worthy of international recognition for its mountain forests, unspoiled wildlands and human history and it has inspired hope among the people working on the Yellowstone to Yukon Conservation Initiative. This organization, focusing on the mountain landscapes along the spine of the continent, has developed a bold and visionary plan that calls for a network of protected lands and habitat links from Yellowstone to the northern Yukon, where free-ranging wild species can evolve and coexist with human endeavours. In the northern reaches of the region—in the Peel Watershed—this is not an impossible dream. The lands are whole and the array of life is still in place. For how long is the only question.

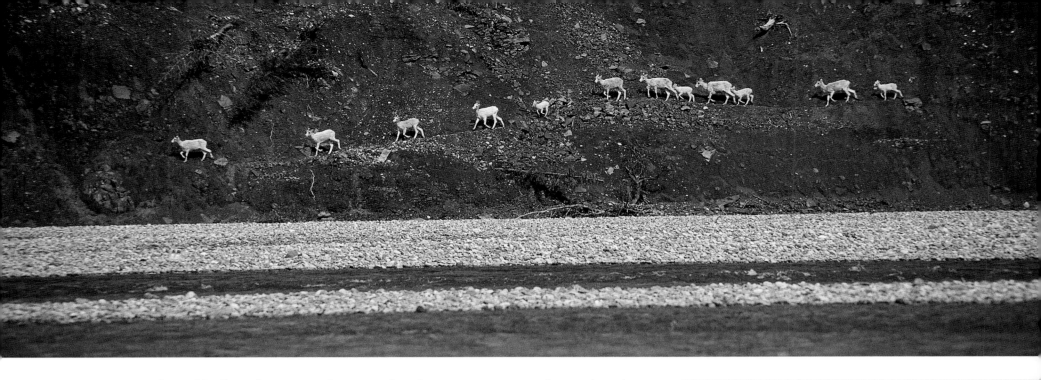

Canada, as if finally awakening to its history, is also asking urgent questions about its boreal forest—the northern land of spruce, pine, myriad lakes and rivers, the root of so much of our country's story. Even though industrial development is outpacing conservation in many southern parts of the region, our boreal forest is still one of the largest intact ecosystems left on the planet. About 70 percent remains in a natural state, 30 percent is tenured for industrial uses, and 10 percent is protected. In the Yukon the amount protected roughly matches the 10 percent national average, but is far short of the 50 percent protection goal established by scientists and conservation organizations such as the Canadian Boreal Initiative and CPAWS. Underlining the importance of the boreal region on a global scale, in 2004 the World Conservation Union called on Canada and Russia to do more to protect the health of their boreal forests. Do we as a nation have the foresight and courage to protect this ancient circumpolar forest?

For this river system to endure—both as an anchor for the Yellowstone to Yukon region and as a benchmark for Canada's boreal forest—we need to convey the value of the watershed from fresh and compelling perspectives. Northerners sometimes take for granted how exceedingly rare such places have become in the rest of the world. Before we contemplate plunder, the Peel deserves the utmost precaution. Continental economic forces leaning on the future of its watershed call for a counterweight to aid the local conservation effort.

I wonder about the future of these wild rivers that are so deeply etched in my life. I ask myself, why is it so difficult for us to leave alone what is so rich, vital and beautiful? What should we ask for? How much protection is enough? On the river, around the fire circle, and with all senses open to the mystery of the forests and meadows, it's an easy answer. All of it. We have to dream as big as the Three Rivers, as far as the Peel River flows.

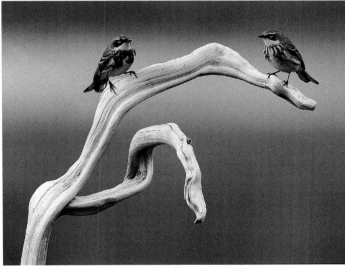

Top: Dall sheep ewes and lambs visit a mineral lick along the Snake River.

Bottom: Yellow-rumped warblers are part of the myrtle population that ranges north of British Columbia. Efforts to save southern bird habitat may be in vain if northern nesting grounds like the Peel Watershed remain unprotected.

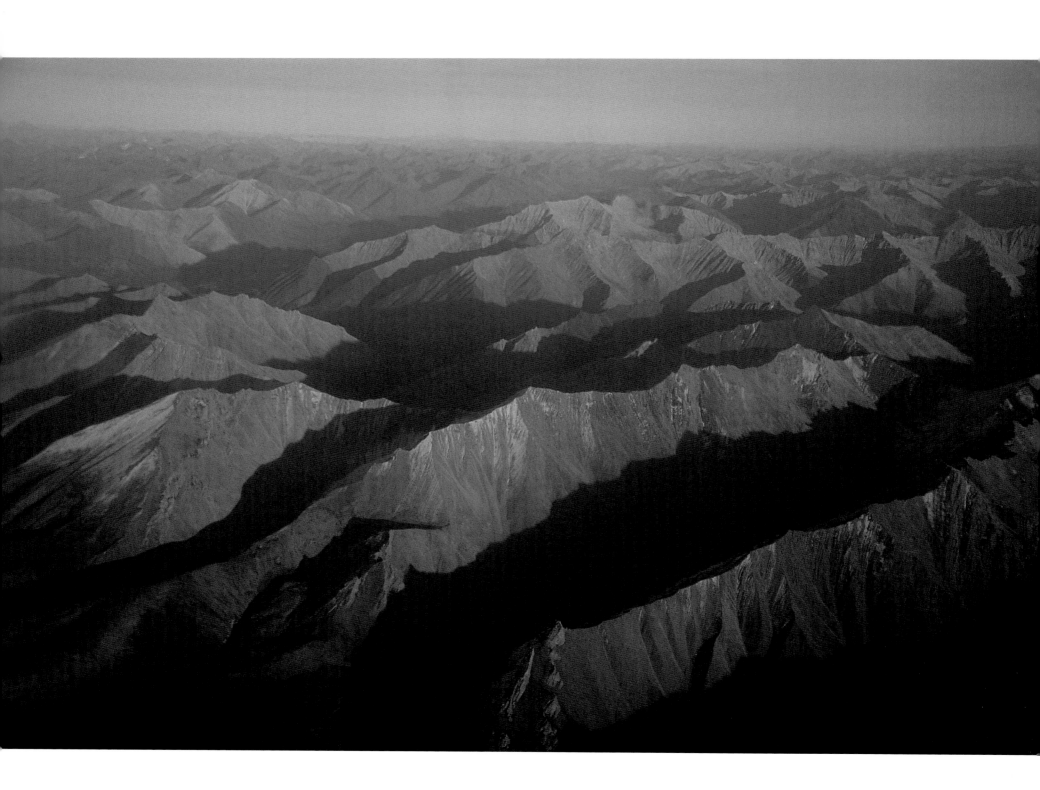

LAY OF THE LAND

By Sarah Locke

Frozen for much of the year, the Wind, Snake and Bonnet Plume rivers return to life each spring among melting snowfields high in the northern Yukon. Running north through the Mackenzie and Wernecke Mountains, they flow first into the Peel River, then on to the Mackenzie River and the Arctic Ocean

Known as the Three Rivers, the Wind, Snake and Bonnet Plume race side by side like wild siblings, and are part of a larger family of rivers in the Peel Watershed. The Hart, Ogilvie and Blackstone rivers, which flow north out of the Ogilvie Mountains, join the Peel upstream of the Three Rivers.

The wild expanse of mountains of the Peel Watershed, sometimes known as the Arctic Rockies, have much in common with other ranges along the 5,000 kilometre length of the continental divide. Farther south, celebrated mountain landscapes have been set aside in some of the world's best loved national parks, places like Banff, Jasper, Yoho and Kootenay in Canada and Yellowstone and Yosemite in the United States. All of these parks would fit into the watershed of the Three Rivers, which takes in about 32,000 square kilometres. The entire watershed, which includes the Hart, Ogilvie and Blackstone rivers, covers more than 77,000 square kilometres, a land mass equal to the size of Scotland. But few people know these wild mountains and rivers as, in this whole vast area, the only road is the two-lane, gravel Dempster Highway that skirts its western edge.

In these northern mountains, the mantle of green life can be thin, and geologic features stand out in stark relief: wind-blasted outwash plains, ridges encrusted with hoodoos and spires, mountainsides blushing with mineral colour. Rock is always close to the surface. On the gravel bars lining the rivers and creeks, multi-hued stones create intricate mosaics and distill this landscape to its rocky essence. Red jasper. Umber chunks of sandstone. Pale grey carbonate. Speckled green diorite. Blond quartzite. These tumbled beauties dazzle with the sheer lavish variety of their forms. They also hint at complex origins.

❧

The Yukon is home to some of the planet's most convoluted geology, but the history of the rocks in the northeastern Yukon begins simply. Two billion years ago, this region was covered by a clear shallow sea that lapped at the edges of the ancient North American continent. Rivers as large as the modern-day Mackenzie carried sand, silt and clay west onto this broad continental shelf. As the shoreline receded and advanced, tangled mats of algae grew in the warm waters; the muddy bottom supported trilobites and snails, brachiopods and clams, an abundance of

Top: The glowing reds of hematite and jasper in Snake River rocks are clues to a convoluted geological past.

Bottom: Author Sarah Locke.

Opposite: The sprawling Wernecke and Mackenzie Mountains in the Peel Watershed are sometimes known as the Arctic Rockies. Some of the oldest sedimentary rock in the Yukon, they were formed from an ancient seabed.

marine life that later formed limestone reefs and thick layers of dolostone. Fine sediments washed out to deeper water, where over time they were transformed by heat and pressure into shale, chert and siltstone.

If left undisturbed, these sedimentary deposits might have remained a vast coastal plain. Instead terranes—large, fault-bounded chunks of land—crashed this peaceful scene, throwing everything into disarray and making mountains out of the chaos. These terranes were a mixed lot—fragments of ocean floor, pieces of island arcs, chunks of ancient continents. The first one bumped into the northwestern shores of the ancestral continent about 190 million years ago, crumpling and folding the smooth layer of sediments in its path. More terranes drifted in later, a series of sideswipes and rear-end collisions, plastering themselves together, and eventually fusing and melding to form the southern Yukon. Then, carried along on plates of heavy oceanic crust, the terranes began wedging themselves underneath the sediments, pushing them up toward the northeast and sometimes thrusting older layers overtop of younger sediments. In some places the two-billion-year-old sediments of the Wernecke Supergroup—the Yukon's oldest rocks—have come to rest near the summits of the peaks.

Most of the terranes had thudded into place by the Cretaceous Period, when dinosaurs roamed much of the planet. At least one hadrosaur, or duck-billed dinosaur, trundled along on its hind legs through this region. In the 1970s three of its bones were found near the confluence of the Peel and Bonnet Plume rivers, the only place in the territory where dinosaur bones have been discovered. Gregarious hadrosaurs usually travelled in herds, so this beast likely had company as it feasted on the riot of green growth in the warm and swampy lowlands. In fact, so many dawn redwoods, giant ferns, cycads and other plants rotted here that 660 million tons of coal now fill the Bonnet Plume Basin, the lowest of all the lowlands in these mountains. By the time the dinosaurs became extinct, the terranes and continental plates had finished their main work, deforming the sediments and uplifting the mountains. These processes continue at a slower rate today, sometimes kicking off large earthquakes in the Richardson Mountains, one of the most tectonically active parts of the Yukon. Now erosion is the main force at work in the sedimentary mountains of the northern Yukon.

However, it was ice that sculpted many of the most dramatic features in the Werneckes—the knife-edged arêtes and dagger-shaped horns, the high mountain cirques and wide river valleys. For three million years most of the Peel Watershed was scrubbed, scoured and thoroughly rearranged by Pleistocene glaciers. The massive Laurentide Ice Sheet, which entombed the northern reaches of the continent, came to a grinding halt at the ramparts of the Mackenzie Mountains. Probing at this barrier, a tendril of ice found one last opening and pushed out to its westernmost limit, creating a huge glacial lake in the Peel River Basin. The smaller Cordilleran Ice Sheet was centred over the continental divide. Its icy fingers also clawed towards the Peel.

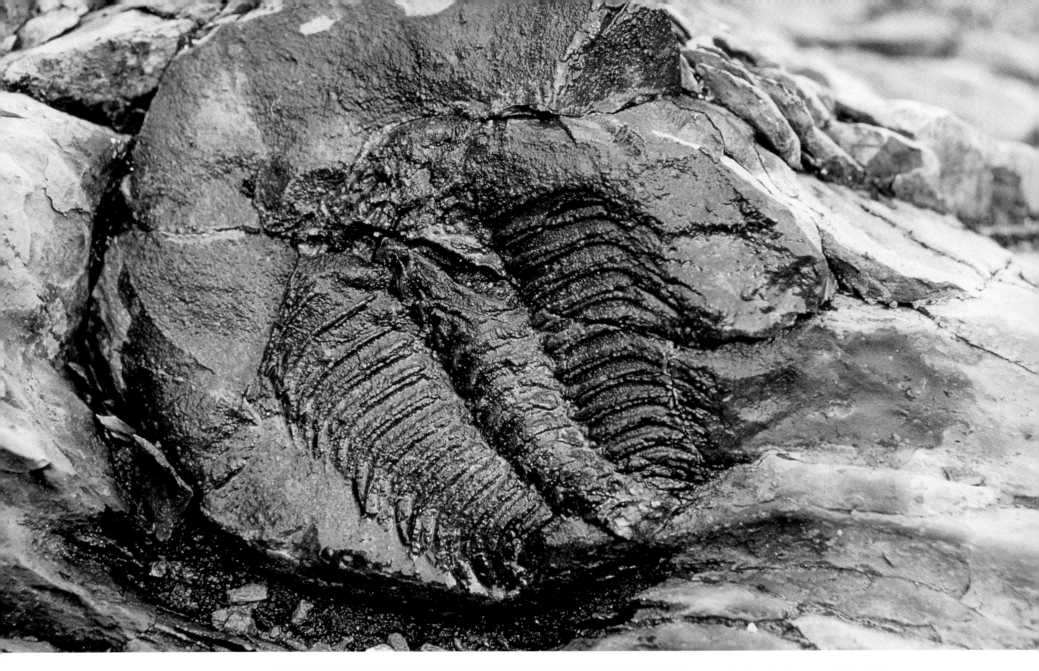

Opposite: Gwen Curry, a British Columbia artist on the expedition, recreates the diverse forms, patterns and shapes found in the stones of the Bonnet Plume River in her wall piece, "Yukon Sampler." "For me," Curry notes, "this work is playful and personal. The inventory relates to me as much as it does the North. I like that connection."

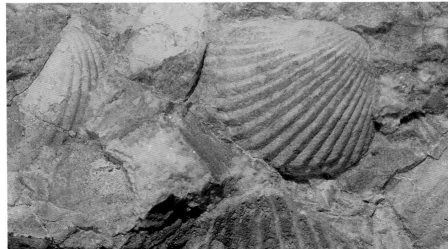

Top: The fossilized remains of this trilobite, a common seabed organism in the Paleozoic, is embedded in rock next to the Snake River.

Left: Bivalve fossils, found along the Wind River are evidence of the shallow seas that covered this region hundreds of millions of years ago.

45

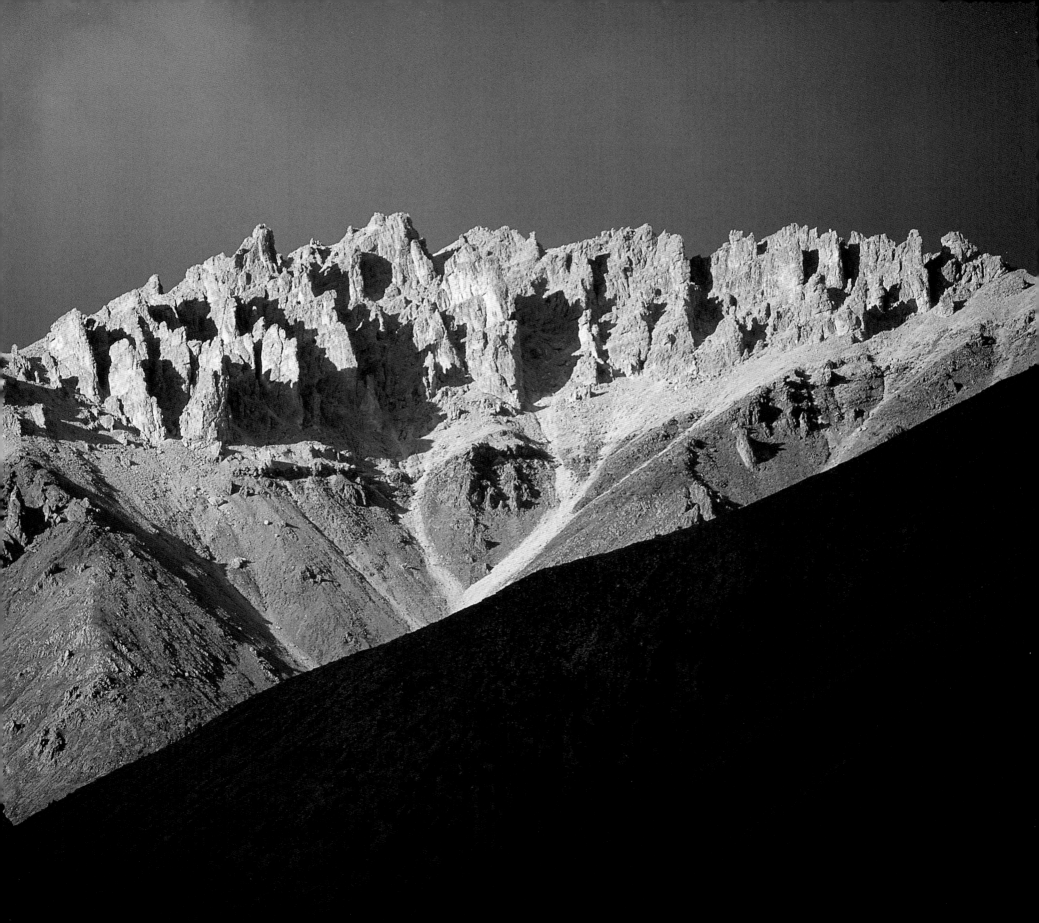

To the east the two ice sheets ground into one another, creating an uninterrupted glittering prismatic dead zone.

But north and west of the Peel Watershed, a vast arid region known as Beringia served as a refuge from the ice. Stretching from the Mackenzie Valley west into Siberia, a distance of 3,200 kilometres, Beringia was its own subcontinent, with its own geology, climate and life forms. Now divided by the waters of the Bering Strait, it existed during glacial periods when so much of the planet's water was tied up in massive sheets of ice that water levels in the North Pacific Ocean dropped, exposing the floors of the Bering and Chukchi Seas. This land bridge was a conduit of life for animals, plants and insects, and has long been recognized as the first entry point for humans into the New World. Most of the traffic was from the Old World to the New, but there was also movement the other way. Here, one of the most fantastical assemblages of life ever seen on the planet roamed and grazed on productive grasslands. Woolly mammoths,

Opposite: Sawtooth ridge along the Wind River. Erosion is the main force at work in the sedimentary mountains of the northern Yukon today.

Below: Artist George Teichmann's interpretation of Beringia, an ice-free plain between the Mackenzie River and Siberia that supported a fantastical assemblage of life during the ice age.

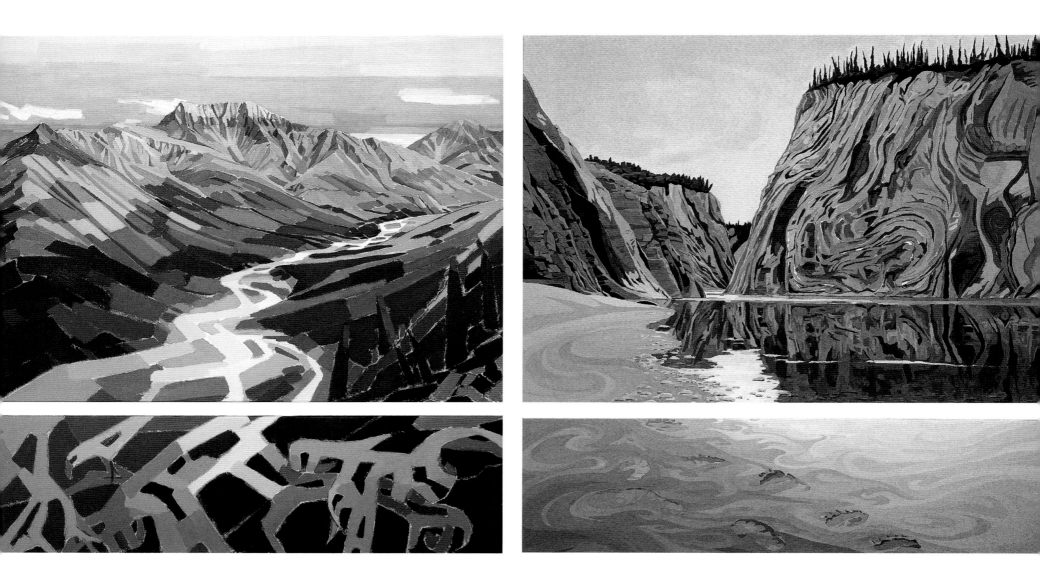

Jane Isakson's paintings project the ageless
character of the Yukon landscape and the richness
of its topography, life forms, and colours. On the
left: "Bonnet Plume Range: Fragments;" on the
right, "Peel River Canyon: Marking Time."

mastodons, saiga antelopes, horses and camels were hunted by ferocious short-faced bears, saber-toothed cats, lions, tigers and wolves. Giant beavers grew to the size of black bears. Ground sloths were as large as oxen. Many of these exotic beasts went extinct after the glaciers melted, but other plants, animals and insects hung on to their niches in Beringia and only exist there today.

Beringia continues to fascinate experts who energetically debate everything from the vegetation that grew there to why the mammoths disappeared. For decades, most of them had agreed on at least one set of ideas: as the glaciers started to melt and human hunters left Beringia, they travelled south along an ice-free corridor on the east side of the Mackenzie Mountains. However, this theory is a bit shakier these days. The first blow came when artefacts found in southern Chile were radiocarbon dated at 12,500 years old. No one dreamed that people were in the southern hemisphere at such an early date. Then glacial research, some from the Peel Watershed, showed that the corridor was probably still closed at this time. Early peoples must have found their way to South America via some other route.

Now that the ice-free corridor theory is no longer sacrosanct, many of those looking for answers have been scrutinizing the glacial mapping work of geologist Alejandra Duk-Rodkin. She spent almost twenty summers in northwestern Canada, studying the moraines left behind by retreating sheets of ice and mapping the locations of glacial erratics—rocks that have been transported by glaciers. On the Snake River, she collected rocks that were very similar to ones found on another river 300 kilometres to the east. When she found chunks of pink granite that had somehow been transported west more than 700 kilometres, she began to question the very flow of the rivers. Had the Mackenzie River always emptied into the Beaufort Sea? Eventually Duk-Rodkin and her colleagues at the Geological Survey of Canada put the whole complicated picture together: the Mackenzie River had once flowed southeast into Hudson Bay and on to the Atlantic. Both the Peel and the Porcupine rivers had flowed north, emptying directly into the Arctic Ocean. The Laurentide Ice Sheet erased these original drainages, and—as the climate warmed and the glaciers retreated—formed new ones. One river after another was created in the meltwater channels along its western margin: first the Peel and Snake, then the Arctic Red and the Mountain, and finally the great Mackenzie itself. These rivers form the world's largest glacially diverted river system, a testament to the power of ice.

This coal seam along the Wind River reveals part of an industrial grade coal-bed which has fuelled dreams of development in the Peel Basin.

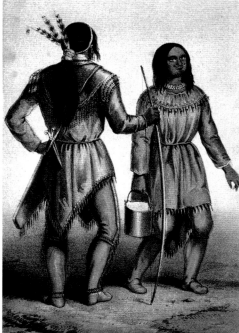

Some of the earliest representations of the Yukon's aboriginal peoples were these drawings fur trader Alexander Murray made of the Gwich'in while working at Fort Yukon in the 1840s.

THE PEOPLE OF THE THREE RIVERS

By Sarah Locke

It's 1908 and early winter in the northern Yukon. Up near the continental divide, the shores of Bonnet Plume Lake are silver with ice. A mantle of white covers the mountains slopes, the boughs of the spruce trees, the floor of the valley. Most winters there is little to break the absolute quiet, but now many tents are pitched near the shores of the lake. People gather in the dim winter light and share their stories of the day's hunt. Great herds of barren ground caribou are wintering in the valleys of the Peel Watershed, and both the Nacho Nyak Dun and the Tetl'it Gwich'in will hunt here this winter. The two Athapaskan peoples speak different languages, but they find ways to communicate, particularly when they want to trade.

When the Nacho Nyak Dun travelled north into the mountains to hunt, they welcomed chances to exchange their dried salmon for sacred red ochre. In their legends, the Bonnet Plume country was called "the place of shining rocks" as treasure troves of red ochre could be found glinting among the peaks. Giant birds with shaggy manes stood sentry over these valuable deposits, never leaving their posts, sending smaller birds out to hunt for them.

In their Northern Tutchone language, Nacho Nyak Dun means "big river people." They live in Mayo, Yukon, along the broad reaches of the Stewart River, which flows into the Yukon River and on to the North Pacific Ocean. In the lakes and rivers at the heart of their homeland, a thousand metres and more below the summits of the peaks, they can fish year-round. In late summer, their drying racks are lined with salmon.

The Gwich'in live on Fort McPherson, NWT, on the lower Peel River, which they call *Teetl'it njik,* "along the head of the waters." Tetl'it Gwich'in translates as "people who live at the head of the waters." Before they settled down among the stunted black spruce and wetlands of the Peel Plateau, the Gwich'in were mountain people, and lived in the upper Peel Watershed.

First known by Europeans as the Kutchin and then as Loucheux, the Gwich'in belong to the same language group as the Navajo and Apache of the southwestern United States. Their small communities are spread across Alaska, the Yukon and the Northwest Territories, a diverse world of river flats, mountains and wetland plateaus united by the sweeping green belt of the taiga and the extremes of latitude. Much of this traditional territory lies above the Arctic Circle; only the Inuit live further north.

When they lived out on the land, the Tetl'it Gwich'in were travellers on a grand scale, expert at moving quickly and lightly across the mountains and valleys of their traditional territory. On land they travelled by dog team, on snowshoes and on foot; on the opaque waters

of the Peel they poled upstream in birchbark canoes or floated downstream in mooseskin boats. These craft measured up to 15 metres in length and carried as many as ten families. To build them they used only axes, knives and awls.

The voyages by skin boat remain cultural touchstones for the Gwich'in, particularly the passage through Peel River canyon. On an earlier Canadian Parks and Wilderness Society trip down the Wind River, Gwich'in elder Neil Colin described the last of these voyages and pointed out the portage trail on top of the cliffs. The women, children and dogs would walk through the ragged fringe of spruce forest high above the water while the men braved the dangers in the canyon. A quick, lively man who constantly told stories and jokes, Neil became serious as he said, "1927 was the last time. That was the last time they made the skin boats. One boat they say was fourteen skins or sixteen skins sewed together. The women sewed them. When they got to Fort McPherson, they pull it up and turn it over and everybody help, and they take their own skin back because they got to use it for their shoes, their mukluks."

Living this way, they could not haul all their worldly goods along with them and often fashioned what was needed—snares, snowshoes, even entire boats—on the spot. They built temporary shelters out of moss or brush or skins.

Gwich'in elder Mary Teya speaks admiringly of the toughness of her ancestors, but she doesn't paint an idyllic picture of life on the land; this singularly hard existence required skill

"Ode to the Wind" by Joyce Majiski. Using imagery drawn from maps, photos and drawings, the Yukon artist created a moving environment of silk. A tactile layering of images and patterns captures nature's apparent chaos, as well as its underlying order and capacity to regenerate itself. 'Ode to the Wind' reflects my perspective on journey and connection to place," says Majiski. "I felt the need to make a large piece of work that would invite viewers to move through the space to experience a journey of their own."

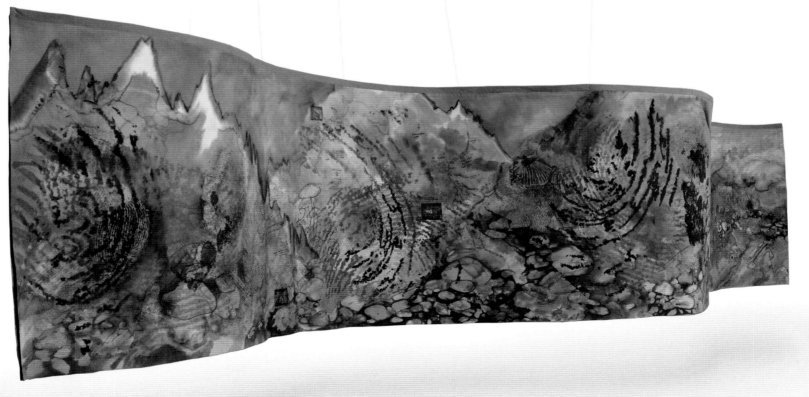

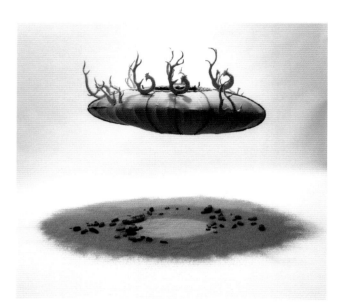

and hard work and at times a healthy dose of luck. "Our ancestors lived up here for years and years, and they lived off the land," she says. "They were just a part of this land and a lot of them went through really hard times. Maybe other times they had good times, but I remember my grandparents and other elders who said they had to go through a rough, rough time because sometimes it was hard to get caribou, and it was hard to get moose. And it was cold, cold. It was forty, fifty, sixty below, sometimes seventy below. But they are the last of that kind of life."

Traditionally *vadzaih* or caribou was the most important animal for the Tetl'it Gwich'in. They preferred its taste and considered it more nutritious than *dinjik* or moose. Before they had accurate rifles, they herded caribou into "surrounds," which they built in the high valleys of the northern Ogilvie and western Richardson Mountains. Many families gathered for this work, piling brush and hauling logs to build two long fences that funnelled into an opening in a corral. Once the animals were trapped inside, it was easier to spear or shoot them. The Gwich'in also hunted and trapped many other animals, including moose, sheep, black bear, porcupine, beaver and rabbit, as well as ptarmigan and various waterfowl. Summer was the time of plenty, the season for feasting and celebrating. Gathering at favourite fishing spots such as Fish-Trap Head, they caught whitefish, inconnu and ling cod and dried them on large wooden racks, preparing for the next winter.

But above all, they depended on caribou, and these unpredictable animals seemed to

Above and opposite: Expedition artist Haruko Okano created three boat-shaped pods, suspended in mid-air, suggesting both a journey by water and something that contains life, like a seed pod. "It is my intention to bring the audience into reflecting on our relationship with a land that is both fragile and sustainable," explains Okana. Suggesting a mythological voyage, her installation includes real elements such as sand scattered on the floor, tracked with the prints of wolf, caribou and sheep. This work explores how someone from one culture journeys towards another culture's worldview.

Right: The Tetl'it Gwich'in travelled on the Peel River in mooseskin boats until the 1920s.

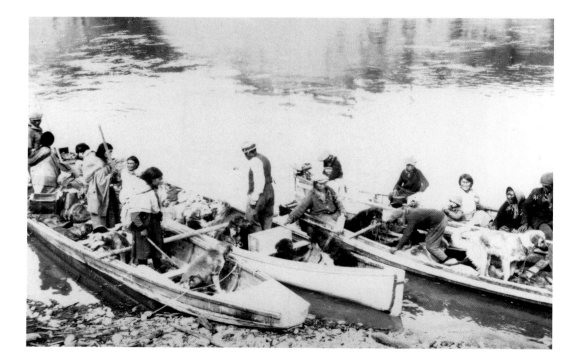

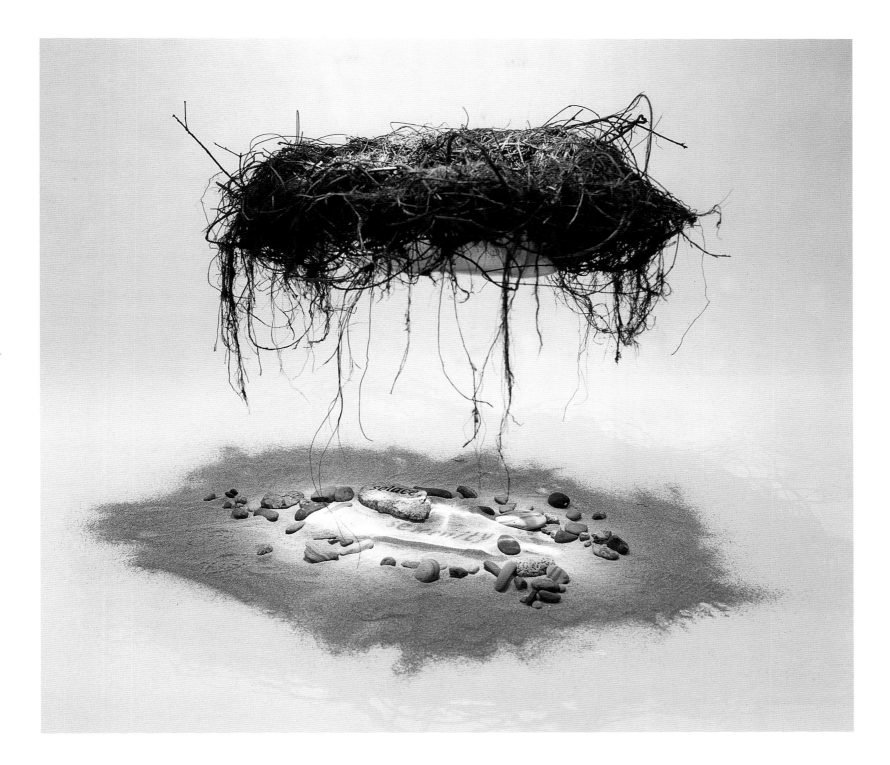

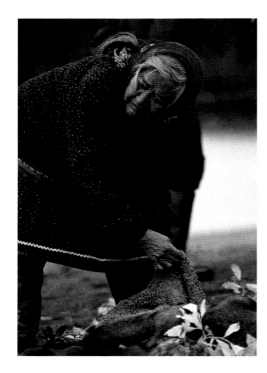

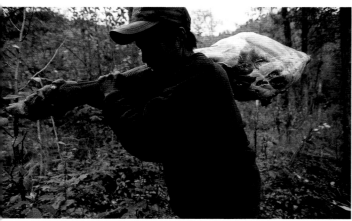

Top: Elder Tabitha Nerysoo strips hide from a freshly-killed moose in preparation for a feast. After caribou, moose were the most important game animal in the Three Rivers.

Bottom: Robert Mantla shoulders a moose drumstick at the Peel River gathering.

vanish into thin air at times, leaving entire groups of Gwich'in to starve. George M. Mitchell, a Canadian on his way to the Klondike in 1898, survived a famine with the Gwich'in, and decades later told his story to Angus Graham, author of *The Golden Grindstone*. Mitchell travelled down the Mackenzie then up the Peel and Wind rivers where he became friends with Francis Tsik, the chief of the Tetl'it Gwich'in, who had himself nearly died of hunger as a child:

> Once, while Francis was still a baby, the band to which his mother belonged missed the caribou herd and all died of starvation. A party of hunters who were travelling light happened to come upon the lodges and found everyone dead inside them except this baby, who was still at his mother's breast. (Francis's Indian name was *Tuttha Thsuga*, "one little suck," on this account.)

Mitchell broke his kneecap with an axe while on the Wind River, and Francis's band, a group of about two hundred men, women and children, took care of him while his knee healed, pulling him from camp to camp on a toboggan as they followed the caribou. When at one point the hunters could not track the caribou, famine set in.

> The children began to die first, then the women, and then the weaker men; the two larger children in Mitchell's lodge died and he thinks that there were probably two or three deaths in every lodge. The biggest eaters seemed to suffer the most.

Eventually they found caribou again and continued their seasonal round, descending to the Peel and building a mooseskin boat. After the tragic rigours of the winter, Mitchell described his journey along the Peel as a time of laughter and excitement:

> You must imagine us all stuffed into the boat with dogs and fur packs and all the squaws' paraphernalia—the men working their sweeps in leather loops, Francis in the stern with his long steering sweep, and an emergency man with a pole standing in the bow. The bottom of the boat was well lined with furs and skins to prevent any damage, and I made myself very comfortable in spite of the children and puppies. I tell you I enjoyed every minute of that trip! There was a tremendous racket all the time, with the Indians and squaws whooping with delight at the rushing water, dogs howling and children squealing and fighting. And in stretches of easy water we used to have great boat races, like Noah's Ark racing, that occasioned the wildest excitement.

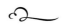

Some of the most famous names in arctic exploration passed by the mouth of the Peel while travelling "down north" on the Mackenzie, searching for the elusive Northwest Passage. In 1789

Alexander Mackenzie explored the full length of the river named after him. He is credited with being the first European to meet the eastern Gwich'in—most likely the Gwichya Gwich'in—but it is quite possible that they had met other fur traders before him. The Gwich'in already had trading networks extending west down the Porcupine and Yukon rivers to the Russian traders working in Alaska and southwest to the Tlingit living on the coast.

In 1826 John Franklin—also searching for the Northwest Passage—took a wrong turn amid the maze of wetlands in the Mackenzie Delta and "discovered" the mouth of the Peel. He named it after Sir Robert Peel, the British home secretary, and encouraged the Hudson's Bay Company (HBC) to investigate the area further as a rich source of furs. The Russians controlled the fur trade in Alaska, so the British company—looking for its own opportunities—hoped that the Peel would link the Mackenzie and Yukon rivers. In 1839 John Bell and a crew of HBC men explored the Peel to its confluence with the Snake River and then, mistaking it for the main stem of the Peel, continued up the tributary. The next year Bell established Peel River Post on the lower river. As this site proved to be prone to flooding, the fort was moved 6 kilometres downriver a few years later and named for the HBC's chief trader, Murdoch McPherson. By this time the fort had become a springboard for the westward expansion of the fur trade into the Yukon River basin. Sponsored by the Smithsonian Institution, naturalist Robert Kennicott explored this area in the winter of 1861-62. He enlisted the help of many fur traders, who contributed to the extensive collection of flora and fauna he sent back to the Smithsonian.

For decades, the comings and goings of fur traders and the occasional scientist had little effect on the lives of the Tetl'it Gwich'in. They seldom visited the fort during the first twenty years of its existence as it was located too far downstream of their hunting grounds in the mountains. It was also too close to enemy terrain; the HBC, to suit its own needs, had located Fort McPherson in the dangerous neutral ground between the Gwich'in and the Inuvialuit, or western Inuit, bitter enemies who sometimes massacred each other.

Gwich'in elder Sarah Simon described her people's constant concerns about surprise attacks:

> The white men wished to build the fort on the west bank because the land was higher there, but the Indians told them that from that side it would not be possible to see the approach of Eskimo war parties, whereas the east bank commands a clear view for many miles downstream. Consequently the fort was built on the east bank of the river.

Over time the Gwich'in adapted their seasonal round to spend a month or so at Fort McPherson (*Teetl'it Zheh*) each summer, holding their feasts and celebrations there instead of upriver. Unfortunately, they would have been better off staying in isolation, out of reach of the

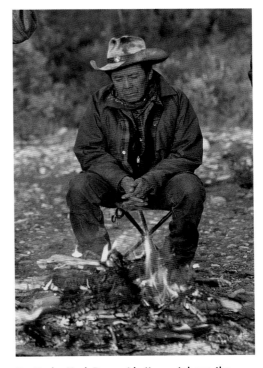

For Nacho Nyak Dun guide Jimmy Johnny, the Wind, Snake and Bonnet Plume valleys are home.

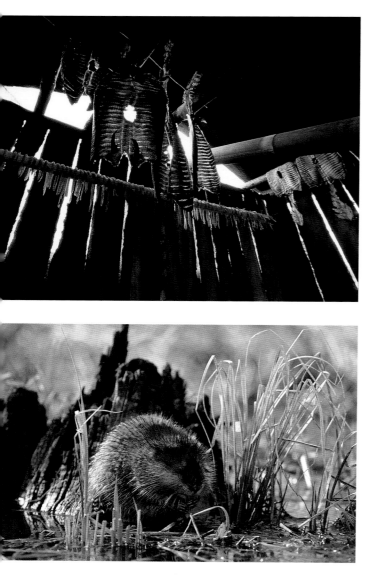

Top: Drying fish is still an important summer activity in family fish camps along the Peel River.

Bottom: Muskrat, long prized by trappers for their rich brown fur, forage on aquatic vegetation in marsh habitat.

epidemics and diseases that had killed an estimated 80 percent of the Gwich'in by the end of the nineteenth century.

In 1865, Reverend Robert McDonald travelled with one of the supply boats whose infected crew spread scarlet fever in the communities along the Mackenzie River. He spent the next few months doing little but attending to dying Gwich'in as the disease spread along trade routes throughout the North. McDonald later became an archdeacon, and—with the help of his Gwich'in wife—translated the Bible, the Book of Common Prayer, and a hymnal into Gwich'in, versions still used by some elders.

One of the more intriguing Europeans to pass through Fort McPherson during this period was a French nobleman, the Comte E.V. de Sainville, who spent more than five years mapping and exploring the Canadian North. In the summer of 1893 he worked his way up the Peel River with two Gwich'in guides, searching for gold. "Travelling in a light canoe and having surmounted incredible difficulties," the party reached the mouth of the Bonnet Plume River and walked 40 kilometres up this tributary before crossing west to the Wind River and back to the Peel. The count drew a detailed map of the Peel River and its tributaries, which, after gold was discovered in the Klondike, was widely circulated and copied.

Although the Peel was one of the lesser-known goldrush routes, it still attracted hundreds of stampeders. Starting in Edmonton, they travelled down the Mackenzie and then tracked upstream on the Peel on their way to Dawson. One group continued up the Peel to the Wind River, hoping to find gold along the way. Instead the first winter storm trapped about seventy men on the lower Wind River, and they spent the next five months in a camp they called Wind City. In their makeshift log cabins, the darkness and cold made everyday life difficult, but scurvy was the real curse; four men died and many others were seriously weakened. George Mitchell was among those who survived that winter at Wind City, and he described how the men constantly monitored each other for signs of the disease:

Every man would be secretly testing out his knees, to find out if they were beginning to give way, and every man eyed his neighbours with horror, looking for the first signs of the disease. Most of them thought that it was something catching. . . . It's ghastly to see how they go—you poke your finger into a leg, and the hole you make stays there, it doesn't fill out again like healthy flesh. Then the gums swell till the teeth drop out, and there is a most loathsome smell.

Francis Tsik and other Gwich'in brought meat to the gold rushers that winter, once arriving with seven sleighs loaded with caribou. Without this aid, no doubt many more stampeders would have died. Mitchell and his immediate group avoided scurvy by taking the Gwich'ins' advice to drink spruce tea, a source of vitamin C.

The stampeders were generally a different breed from the fur traders, who had invaded the Mackenzie region in an orderly controlled manner, always aware that their success depended on good trade relations with the local inhabitants. Most of the gold rushers had no such concerns; intent only on reaching Dawson before the gold ran out, they swept through this quiet corner of the world like a flash flood, leaving permanent change in their wake.

By the time the Wind City gold rushers arrived in the Klondike, the claims were all staked; their arduous route to the goldfields had proven to be a bust, and many went home penniless. The Gwich'in, however, had earned good money working as packers and supplying meat to the gold rushers; they liked their first tastes of the cash economy. By 1901 most of the Tetl'it Gwich'in had traded the quiet of the Peel River country for the opportunities in Dawson City. Others travelled to Herschel Island off the Yukon's north coast, where freewheeling American whalers sold goods such as alcohol and repeating rifles that were banned by the HBC.

As Canada was concerned about this American activity, the Royal Northwest Mounted Police began running winter patrols as far as Herschel to establish the Canadian brand of law and order. In 1910 Inspector F.J. Fitzgerald, the commander of the new Herschel detachment, was assigned to lead the annual winter dogsled patrol between Fort McPherson and Dawson. Travelling light, he attempted to set a speed record on the 760-kilometre route but did not hire a Gwich'in guide, as was the custom. The four patrol members lost the route after mushing a short distance up the Little Wind River. They spent a week searching for it and then encountered bad weather on the return trip to Fort McPherson. The men of the "Lost Patrol" died only 40 kilometres from the community. Starvation and exposure killed three of them; the fourth committed suicide.

A few years after this incident, the attractions of Dawson and Herschel having faded for the Gwich'in, they resumed their traditional way of life in the Peel Watershed, once again spending most of their time in the mountains. But skyrocketing muskrat prices in the period between the two world wars finally convinced the Gwich'in to settle in Fort McPherson as they needed to be closer to the Mackenzie Delta, which teems with muskrats, if they wanted to take part in the lucrative spring "ratting" season. Though their homes are now downstream of the mountains, the Peel is still the centre of the Gwich'in's annual round—in summer when they gather at family fish camps and in winter when the frozen river becomes their highway.

Graves of the Lost Patrol in Ft. McPherson bear witness to the perils of winter travel in this wild country.

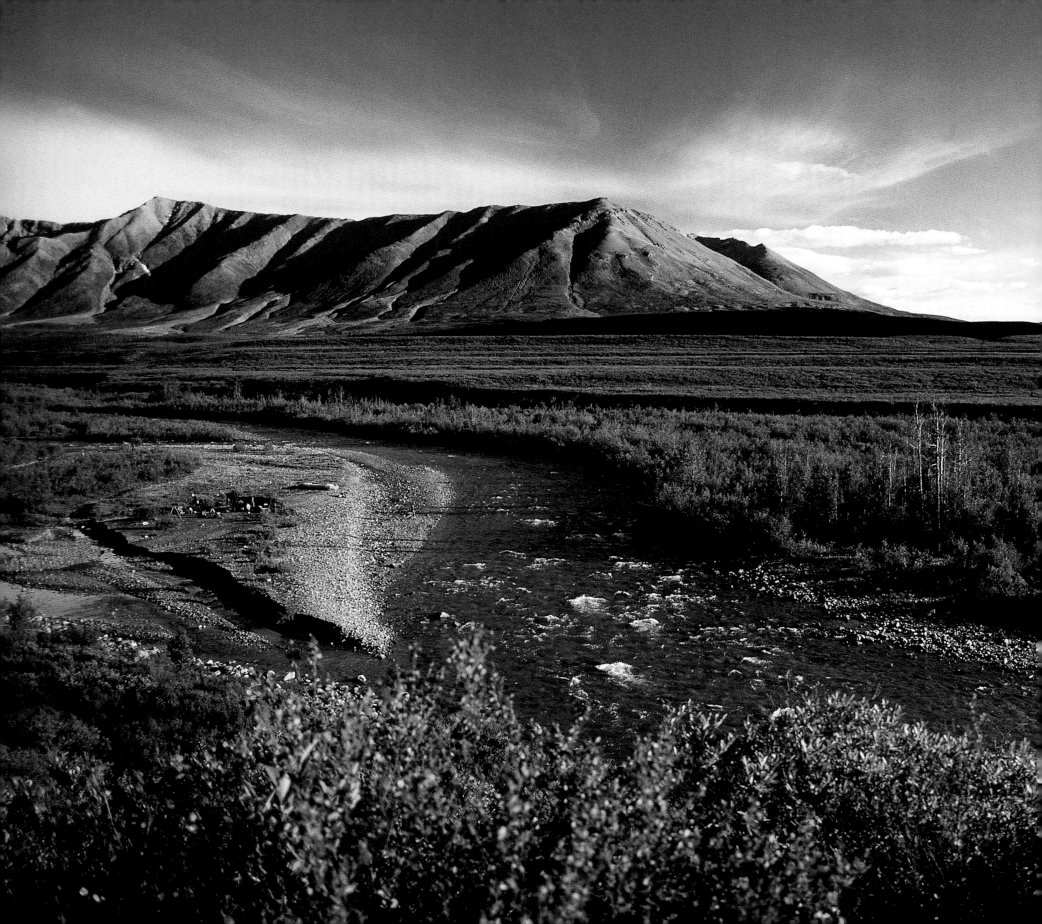

THE SNAKE RIVER

There are no reptiles in the North; *Gyûû dazhoo njik*, the Gwich'in name for the Snake River, translates literally as "worm hairy river." According to legend, in ancient times a giant worm came out of the ocean and travelled up the Mackenzie and into the Peel River, swallowing huge boulders as it went. To this day this worm remains hidden either in a riverside lake or within a mountain near the river's headwaters.

For more than 150 kilometres, the Snake River flows past layered and serrated ridges streaked with rust, ochre and maroon, while lofty glacial peaks like Mt. MacDonald tower above it. The swift-flowing upper Snake is one of the most visually stunning wild rivers in the Canadian North, and its many side valleys yield easily to exploration. Woodland caribou, Dall sheep, grizzly bear, moose and raptors live in the open forests, and the alpine meadows are profuse with arnica and arctic lupine. Where the lower Snake slows and cuts deep into the Peel Plateau, giant poplar trees and stands of tall spruce provide perches for bald eagles.

FINDING WILDERNESS

By Frank Clifford

Liz Hansen said she would walk around the rapids. "I don't have a good feeling about this place," she said, stepping out of the raft onto the stony beach. "When it comes to nature, I don't take chances."

Left: Snake River at Reptile Creek.

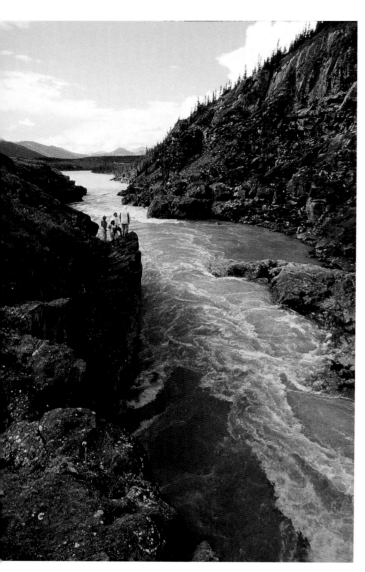

Paddlers inspect the largest rapid on the Snake River, which canoeists sometimes portage when water is high.

Liz's assessment was good enough for me. This slightly stooped Gwich'in grandmother had never run a river before—unless you counted trips on the Mackenzie River in her late husband's motor launch. No matter. For the past ten days her ability to see signs of danger— storms and grizzly bears—invisible to the rest of us had been almost infallible.

We were on the Snake River in the northern Yukon Territory, about 50 miles south of the Arctic Circle. Liz had been a paddler in one of the expedition's two rafts. I had been in a canoe. But as the others prepared to take on the rapids, she began walking slowly over the short, steep portage. I followed.

We stopped on a rocky promontory 50 feet above the river, now a frothy ribbon corkscrewing its way through a narrow passage known only as "Second-to-Last Rapids." The raft Liz had just vacated would have to enter the canyon on the far right in order to slip by a boulder in midstream. Then the six paddlers would have to manoeuvre sharply to the left to avoid being swept into a canyon wall.

They didn't make it. From above, it looked as if the raft were being drawn up the side of the canyon wall by pulleys. After it flipped, I scanned the water for six heads and saw only four. The nearest place to attempt a rescue was 100 yards downstream, below the mouth of the canyon, where the banks were level with the river and you could throw ropes to people in the water. It would be a race making it down the faint, twisting trail before the overturned rafters floated by.

⸙

Our group had assembled in Whitehorse, the Yukon's capital, and from there drove six hours to Mayo, a village on the edge of the bush. On a bright July morning, one of the last sunny days we would see, we boarded a Black Sheep Airlines float plane for the 125-mile flight to Duo Lakes, near the headwaters of the Snake. In northern parlance, the "bush" refers to places where civilization's imprint is not yet legible. The word conjures images of a boundless thicket, but what we were seeing from 5,000 feet was a tight formation of low, cone-shaped mountains reaching to the horizon like a herringbone sleeve. Down there, nearly a century earlier, a squad of Royal Northwest Mounted Police, all veterans of the bush, had become disoriented and died of starvation and exposure. The fate of the "Lost Patrol" has prompted the same kind of scholarly obsessing that has dogged Custer's Last Stand. Historians can't decide whether to view either tragedy as a fool's errand or a heroic struggle. Custer dismissed warnings by Indian scouts that the foes he was up against were too numerous and powerful; the leader of the Lost Patrol rejected the services of an accomplished native guide willing to lead him and his men across the Peel River country.

It would be just as easy to get lost there today. There are no buildings, no roads. The maps are largely devoid of place names, the map makers having chosen to ignore the original place

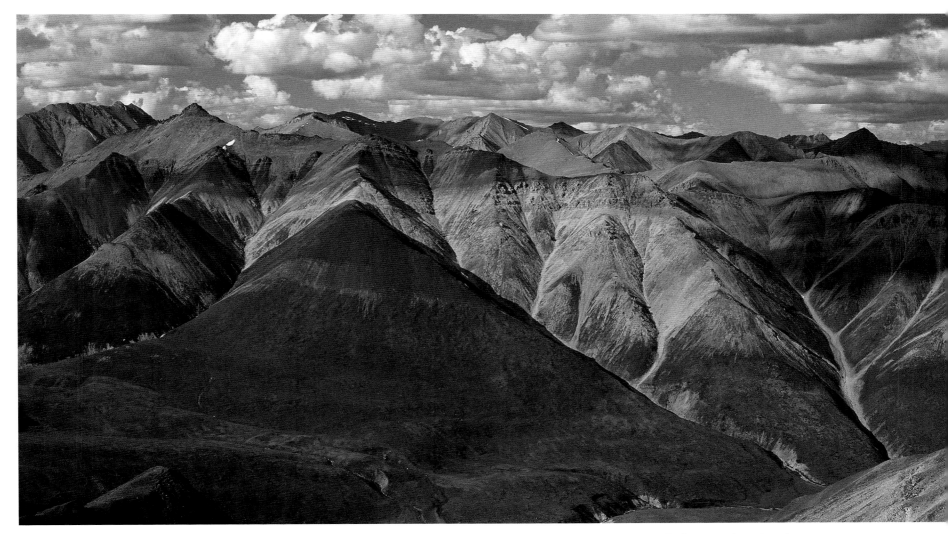

Copper, iron and other minerals produce the spectacular bands of colour in these mountains along the Snake River.

names, such as *Tshuu tr'adaonich'uu*, meaning rough, hateful waters, or *Chitr'iniinjil*, for a treacherous section of the Peel River where five members of a hunting party drowned.

As the Snake is too narrow and shallow for a float plane to land, our plane put down on a teardrop of a lake a mile from it, and we set up camp. That evening, taking stock of our gear, we discovered a serious omission: the oar frame for one of the two rafts had been left behind. There were plenty of paddles, but a single set of oars offers more leverage and drive than paddles do in rough water—especially when the paddles are in the grip of novices.

One of our guides, Kate Moylan, drew two parallel, meandering lines in the sand. Between

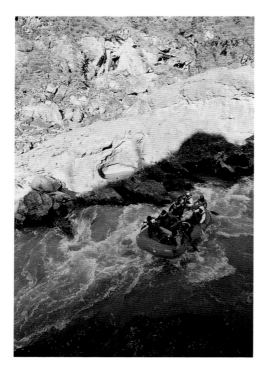

Above: Rafters run the Snake River canyon.

Opposite: Rock orange lichen encrusts a rock outcrop in the upper Snake River valley.

the lines she placed pebbles and twigs. "Tomorrow, you will be there," she said, pointing to the river of sand. "There are bigger rivers with bigger rapids, but the Snake is not to be underestimated, and you need to know how to handle it."

❧

There were twelve of us on the trip down the Snake, including four who had no previous experience in whitewater, and three of them were on the raft that capsized. We were a mixture of Yukoners, Canadians from Toronto, Ottawa and Newfoundland, and two Americans. Three were artists, one a filmmaker. There was an administrator of an environmental foundation; a lumberjack-turned-special-education-teacher; an outfitter's wife; a community organizer from Old Crow, an aboriginal settlement near the Alaskan border; and Liz, a Yukoner now living in Inuvik, a native community in the Northwest Territories. We had been chosen less for our outdoor skills than for our ability to sway public opinion in favour of preservation of this land of ferruginous mountains and emerald tundra that is fast becoming one of the most passionately contested areas in northwest Canada. We had two guides, Jill Pangman and Kate Moylan.

Only two of the twelve men and women on the trip had been down this river before— once. That didn't seem to worry the people who had organized the expedition. They seemed confident that the trip would pay off, no matter how challenging it was. From their own attachment to wild country, they knew how it can hook people. Wilderness often forges its strongest bonds with those it most sorely discomfits. From the safety of our homes, we have a way of looking back on the toughest trips as blessed ordeals.

We were not unique, as Yukon traveling parties go. There had been artists, journalists, businessmen and politicians among the thousands of fortune hunters who struggled over the Chilkoot Pass and braved the Yukon River's Whitehorse Rapids on their way to the Klondike gold fields in 1898. Most were *cheechakos*, tenderfeet, like many of us. Quite a few of them had drowned.

Explorer John Bell, the first white man to provide a description of the Snake, slogged his way to its headwaters in 1839. In his day the Yukon Territory was the object of a fierce rivalry between British and Russian fur traders, and the purpose of his expedition was to forge alliances with as many Native peoples as possible because neither side in this struggle for control of the Yukon's natural resources could prevail without their help. And the same is true today as conservationists vie with energy and mining interests for control. Both sides court the Native people; they don't own all the land, but they must consent to any plans to develop it.

❧

Liz Hansen was the last to arrive in camp. She'd flown south from Inuvik with a pilot who had never been to this place and had trouble finding it. It was after midnight when they arrived,

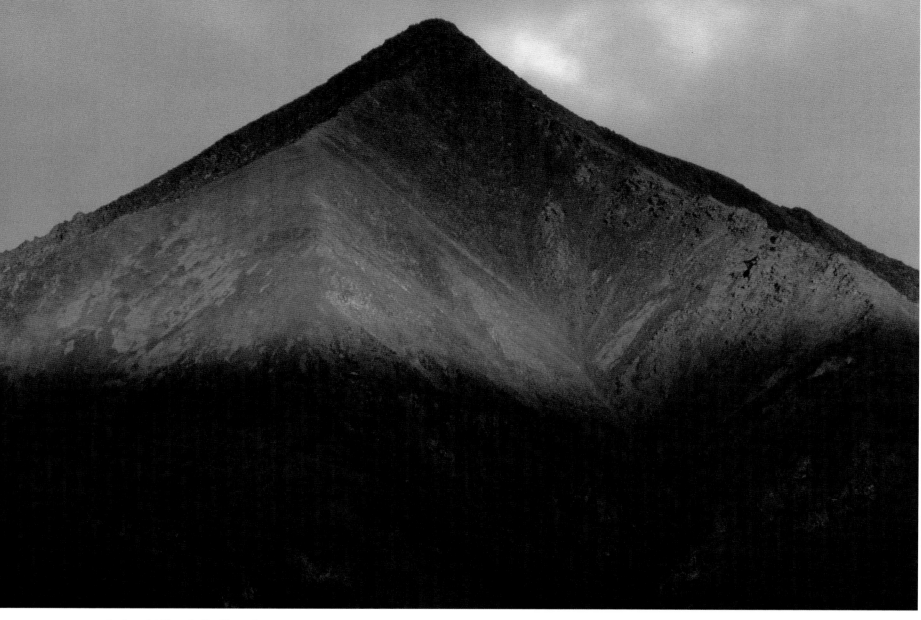

Geology laid bare in the Werneckes.

and the sound of their distant circling was like that of a mosquito probing for a hole in your tent. Liz said later she had held up a map for the pilot to read as he searched the crepuscular skies for his destination. He was beginning to fret about having enough fuel to fly home when he found the tiny lake where we were camped.

Liz stepped gingerly from the cockpit. She was wearing a polyester rain suit and a baseball cap secured to her head by a nylon scarf. "I need a cigarette," she said, stepping into a waiting canoe.

This was Liz's first visit to the Peel River country, but she is linked to it as much as any other Native person. Her grandfather, Robert George, shot game here to feed miners during the

1898 gold rush. Her great-uncle, Esau George, was the guide who offered his services to the Lost Patrol. Annie (George) Robert, Esau's mother and Liz's grandmother, was born in 1881 in a bush camp on the Wind River in the heart of the Peel Basin, not far from where the ill-fated Mountie patrol lost its way in 1910.

I came to know Liz over morning tea. She was usually up before anyone else, collecting firewood and boiling water for the first pot. "White man's axe," she said, whacking away with a dull blade at a dead willow branch. Bundled up in her rain suit, Liz was shaped like an owl, and she regarded me as warily as an owl might regard a troublesome species. In her mid-sixties and widowed twice, she had the forbearance of someone who had spent a lifetime ministering to the inept—husbands, in-laws and grandchildren. As she fingered the axe, it was evident life would be no different for her in a camp full of city-bred white folk.

She showed me how to sharpen the blade with a piece of shale. It was the first of several lessons in camp craft. From Liz, we learned to spread a layer of spruce boughs at the entrance of our tents to keep the dirt out, to keep heated rocks at the feet of our sleeping bags on the coldest nights and to use spruce gum to treat the cuts that plagued city-softened hands.

Liz Hansen was born near the Caribou River, about 300 miles north of where we were, but she said she had heard her grandparents speak fondly of their trips up the Wind, the Snake and the Peel. "It was like hearing stories of where life began." But she had another reason for taking this trip: her husband had died earlier in the year, and she wanted to travel far from the familiar places that bore the keenest memories of her marriage. "I find I have to keep going. I need the distraction of the land." As a child in the bush, she had learned how to survive on her own, and she said she had come back for a refresher course.

I was eager to ask Liz the question I had put to the rest of the group about the value of wilderness. On the flight north from Los Angeles, I had noted a passage from *The Last Wilderness* by Nicholas Luard. As he set out twenty-five years ago to explore Africa's Kalahari Desert, Luard had struggled with fundamental questions about wilderness: Why is it worth holding onto? Why would anyone put the well-being of predatory beasts and birds of prey ahead of the needs of human beings for coal or gas or heating oil? Luard admitted he didn't have an answer, and it made him angry with himself, as well it might anyone who believes that wilderness should be preserved. How can you protect such places, whether in Africa or the Subarctic, if you can't assign a value to them?

As we had assembled for our trip down the Snake, I repeated Luard's unanswered question to my travelling companions. "Maybe you can't answer until you have been lost in the wilderness," replied Kate Moylan, who would be at the helm of the raft when it flipped in the rapids. But when I quoted Luard to Liz Hansen, she looked at me quizzically. "That's a white man's word," she said. "We don't have a word for wilderness in our language."

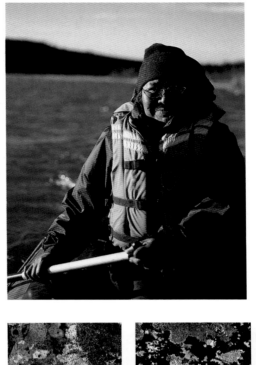

Top: Liz Hansen paddles on the Snake River.

Bottom: Artist Ron Bolt's triptych *Yukon Micro* recaptures the bright colours and fine texture of lichen-covered stone.

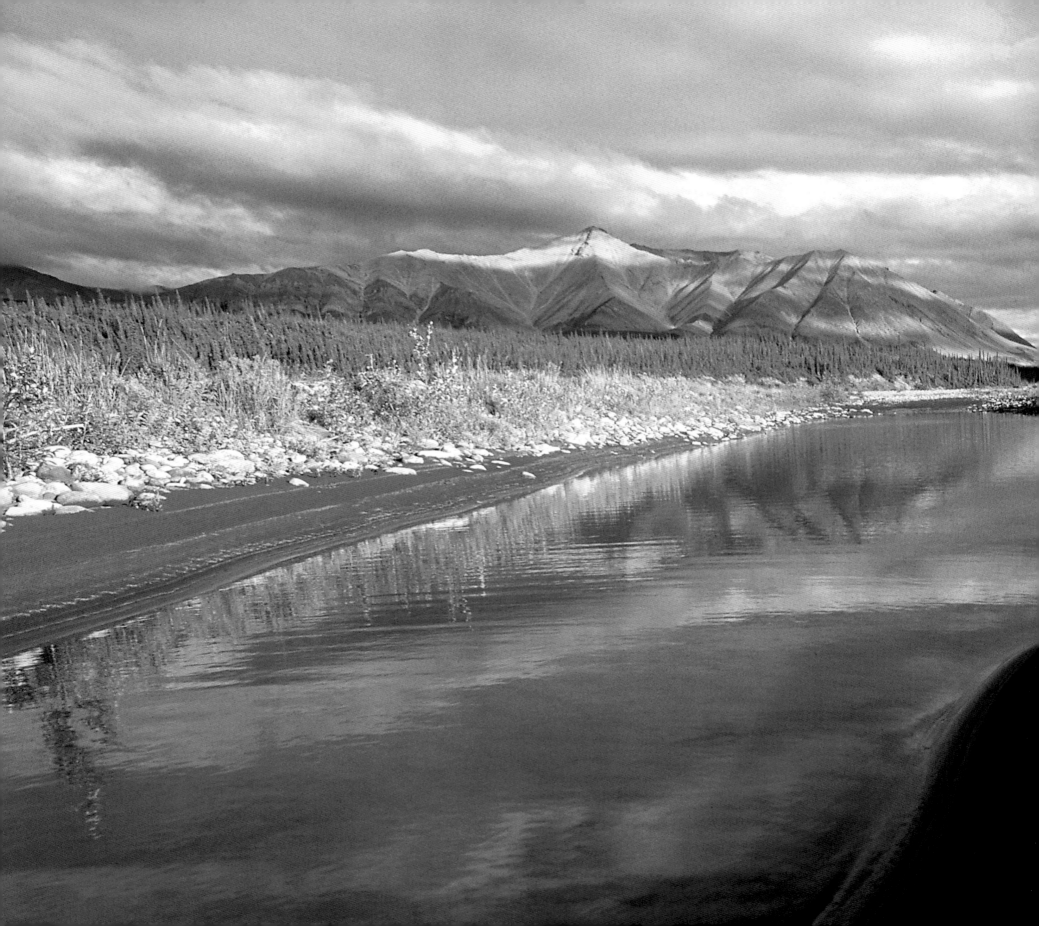

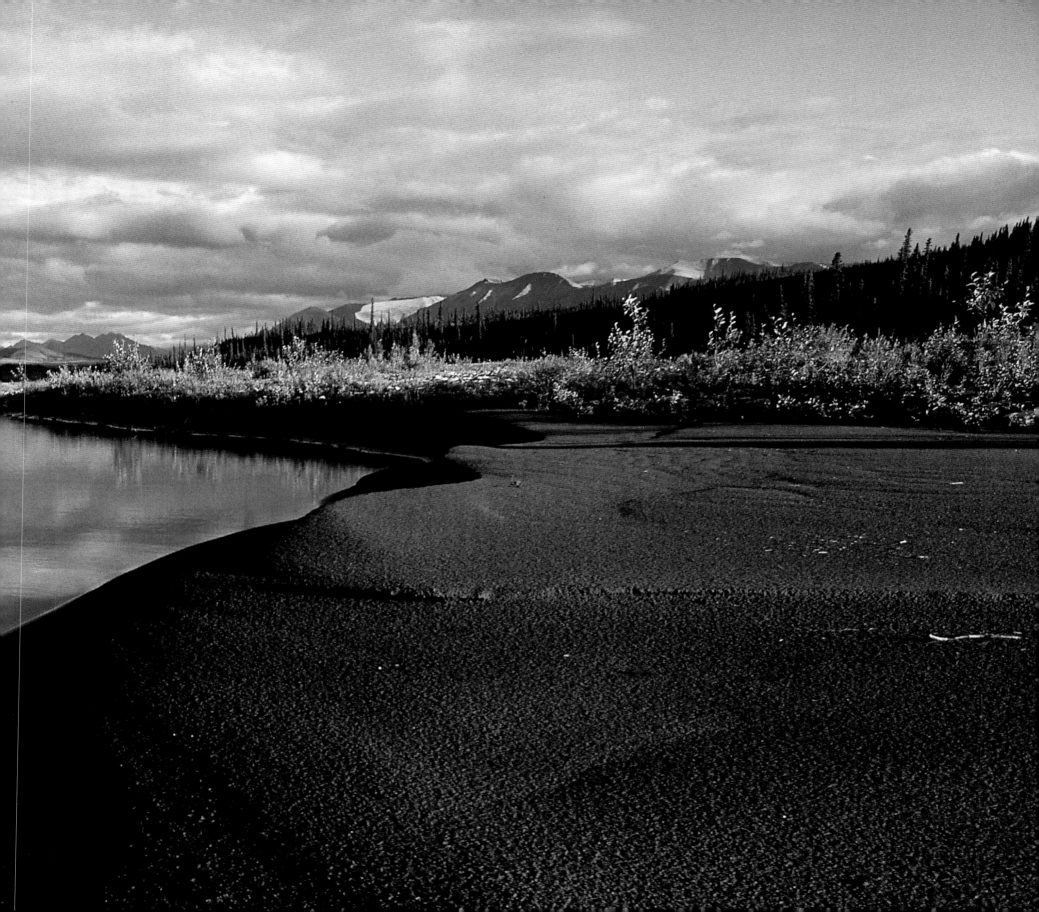

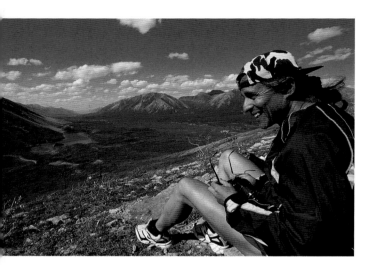

Top: Chilean-born artist José Mansilla-Miranda looks over the headwaters of the Snake River.

Bottom: Monkshood is both beautiful and poisonous.

We prepared to shove off under a gunmetal sky, a north wind rifling raindrops into our faces. In this part of the world, summer temperatures can fluctuate from near freezing to the mid-seventies, sometimes on the same day. On this trip our weather would hover at the low end of the range, and we would see snow more than once.

"I think we ought to have a prayer before our journey begins," Liz said. We formed a circle and joined hands while Liz prayed in her native language. Her friend, Gladys Netro, translated. "Heavenly Father, we ask you to guide us safely down this river. It is fast water."

The Snake splashes out of the Mackenzie Mountains to flow north in a serpentine course between the Mackenzies on the east and the Wernecke Mountains on the west. Millions of years old, the countryside looks as if it is still in the throes of adolescence. Maybe it's the stubble of spindly spruce trees or the acned tundra, grooved with frost heaves and recent avalanches, or the mercurial river itself.

Normally, there is enough water in the Snake's upper reaches to float a heavily laden raft. Not this year. As a result, we began our journey waist-deep in the river, pushing and pulling the rafts across endless rocky shoals, traveling 5 to 10 miles a day at most. We needed to average 20 a day to make the planned rendezvous at a Gwich'in encampment near the confluence of the Snake and the Peel. Black Sheep Airlines would be there to take us back to civilization, providing we weren't late.

Plunging in and out of the frigid water, then paddling furiously to stave off the shivers, we struggled against an inclement mood that hovered like the foul weather. The artists complained that they had no time to appreciate the scenes of nature they had come to paint and sculpt. Now and then, we would look up from our toil to see a moose and her calf or a line of caribou daintily picking their way across the river in front of us. Then, all too quickly, we would refocus on the work at hand, lest a misstep on the slick rocky bottom cause a headfirst tumble. By the end of each day at least one of us would be soaked through.

Bell's account of his 1839 exploration of the Snake tells of daylong struggles against the river "when the everlasting tow line was again thrown out, and the same unvarying round of tramping, tugging and wading had to be repeated. Occasionally, the monotony of the march was enlivened by a moose or a bear appearing on the river's brink." Bell was travelling upstream, but in other respects, his trip and ours, though 163 years apart, seemed eerily similar. He recounted "not a few complaints of numbness in the limbs, produced by wading in water whose temperature was scarcely above the freezing point, even though it was the middle of summer."

Despite our slow start, we decided to take a break from the river and spend a day hiking up a long, trailless valley to the base of 8,400-foot Mount MacDonald, the second-tallest mountain

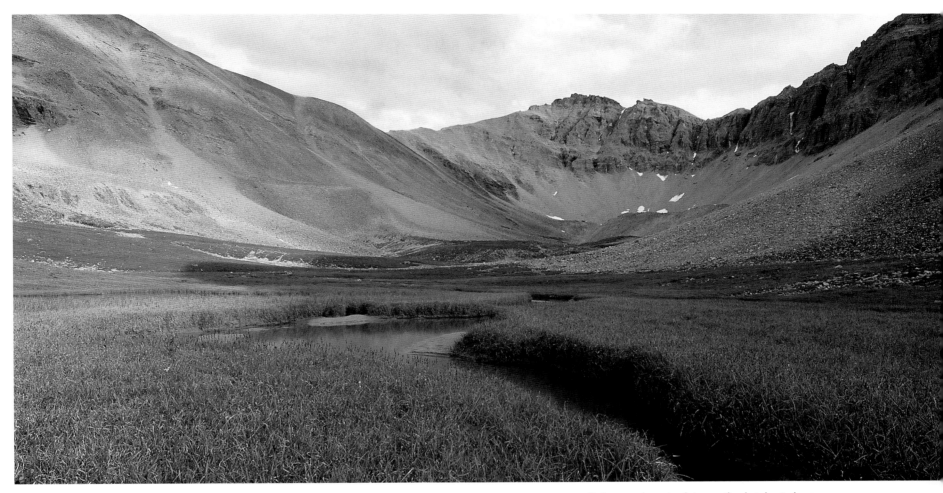

Sedge meadows in alpine wetlands tolerate long, cold winters.

in the region. We had no trouble getting there; the mountain loomed like a ghost ship in the grey morning light. Over lunch we ignored the wispy clouds lazily cocooning around the mountaintop until Liz announced she was returning to camp. Then, looking back toward the river, we could see nothing through a thick curtain of drizzle and fog. We fell in behind Liz, though like most of us, she had never been here before. She pointed out what many of us had missed on our way to the mountain—innumerable signs of grizzly bear presence, including tracks everywhere and steaming piles of fresh scat.

Liz was wryly philosophic about bears. "They say a female bear is less likely to attack a female person because she knows we bear children like she does. You take your chances with a male bear. Sometimes, if you don't act afraid, you can make him go away just by doing this." She made a shooing motion with her hands. "But I shouldn't be talking about them. There is an old

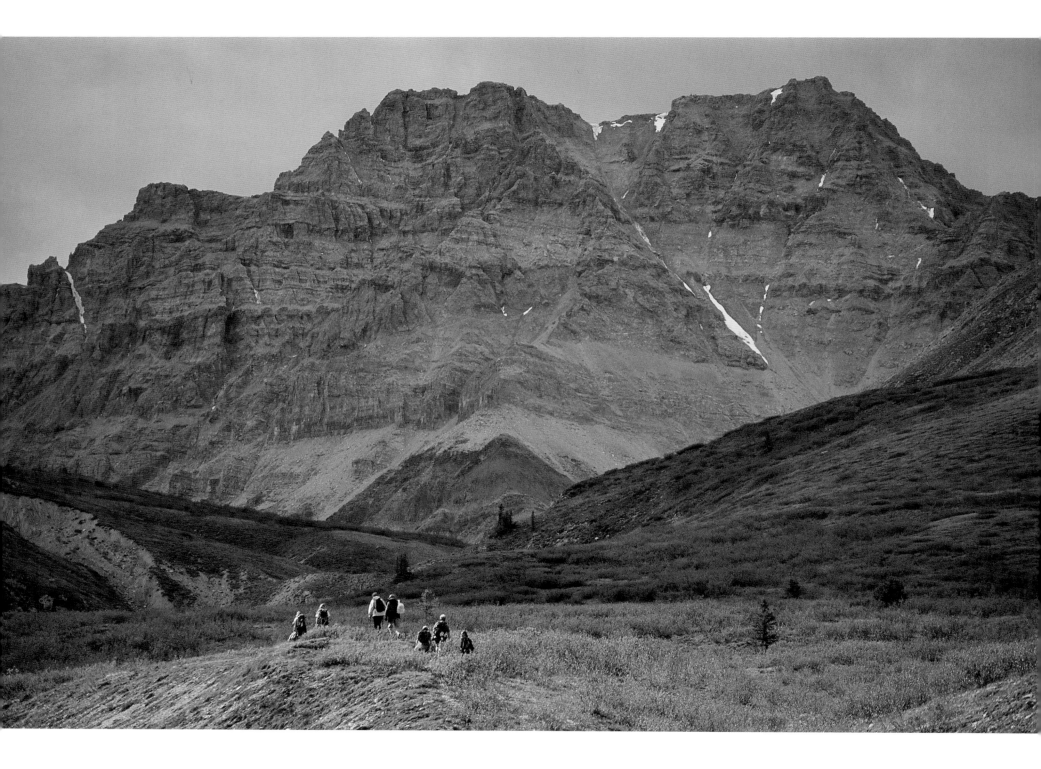

saying that a bear can hear you thinking bad thoughts about him. If you don't let those thoughts come into your mind, you are less afraid."

But Liz seemed entirely unafraid as she meandered through willow thickets. Her shoulders hunched, she walked with a bit of a list. I feared for her balance until it became clear her uneven gait was more suited to the lumpy terrain than our own purposeful striding. She stopped frequently to pick blueberries and crowberries and comment on the surprising array of food that seemed to grow in every thicket.

"I'll tell you what wilderness is," she said at last. "Wilderness is our store. These days, you might say it's our boutique since it appears to be getting smaller. Everything in it is premium quality—the game, the fish, the water, the air. And it's free. That's why we don't want people coming in here and messing it up the way they have down south where you come from," she said, looking at me. "How many places like this do you have left?"

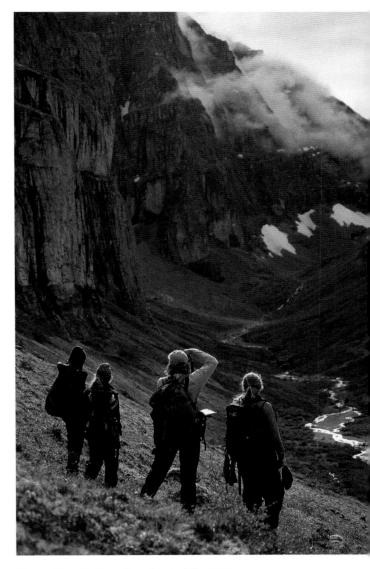

We spent two days in the shadow of Mount MacDonald, getting to know each other better and enjoying the brief respite from our hod carrier's routine of loading and unloading heavy packs and food barrels from the rafts and canoes. We ate blueberries for breakfast and dinner in scones and pancakes and impromptu sauces. We caught grayling below a small set of rapids, and when the fishing hole played out, Liz brought out a packet of smoked whitefish and inconnu she had brought with her from Inuvik.

We tried to take advantage of the brief interludes between rain squalls to dry out wet clothes, but it was a futile chore, made more so by a marauding fox that carried off the smaller bits of laundry. The morning we broke camp we could see our breath, and there was snow on nearby hillsides.

Below Mount MacDonald the river deepens as streams pour in from the east and west. We didn't have to worry anymore about running aground, but a more voluminous river presented new hazards. Shallow, stair-step rapids that had been a delight for the canoeists were replaced by spinning eddies and standing waves that billowed out from cliff sides. Safe passage often meant skirting big waves on one side of a channel while avoiding dead trees or "sweepers" stretching into the river from the opposite shore.

To make up time, we took advantage of the long northern days and paddled into the endless twilight. But fatigue and glare took a toll. Late one evening a wrong turn by one of the more experienced canoeists, Gladys Netro, led to a collision with a sweeper, and she and her paddling partner were pinned between their canoe and the downed tree for several minutes. Even when

Above: Hikers in the valley of waterfalls at Mt. MacDonald.

Opposite: A group of hikers on their way towards Mt. MacDonald, at 2740 m the highest peak in the Peel Watershed.

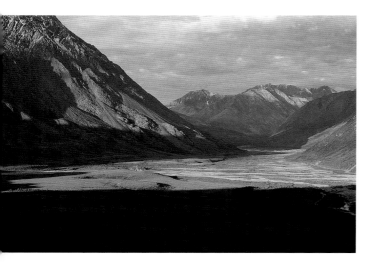

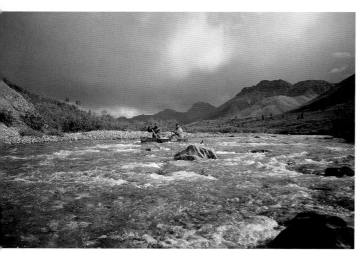

Top: The Snake's broad U-shaped valley was gouged out by glaciers.

Bottom: Paddlers negotiate the shallow rapids of the upper Snake River.

one of the rafts showed up, the current made a water rescue impossible. So, while people on the raft took hold of the canoe, others on shore used a rope to make their way down a steep embankment to the nearly horizontal tree trunk and pull the canoeists to safety.

Later, during a campfire discussion Liz reminded us that we had neglected to say a prayer that morning before embarking. "Our ancestors knew these rivers were dangerous, and they didn't travel for the fun of it," she said, speaking of the time when the Gwich'in made their way down the Peel and its tributaries in moosehide boats. "The women always walked because the boats were too full of game. If one of the boats sprung a leak, they'd stick a needle and thread in a dog's collar. The men would call to the dog and it would swim over to the leaky boat. If the moosehide boats didn't capsize in the rapids or if nobody drowned, people on the shore would shout and fire their guns. It was a life full of danger, but they talked about it as if it gave them great pleasure."

It was two days later that we pulled up beside "Second-to-Last Rapids." The Snake churns with rapids for most of its length, but there are only two major sets, and unless they are expert paddlers, canoeists should walk around both of them. Competent rafters usually make their way past both stretches without much trouble. On this occasion Jill Pangman, a guide who had run the Snake once before, went first, rowing the raft that carried most of our food and supplies, and made the passage look easy.

Kate Moylan blamed herself for what happened next. She and Jill had just switched rafts. All morning Kate had been at the helm of the one with two oars, relying on her skill to lever around tight corners. Now she was sitting in the paddle raft, which had to be manoeuvred by teamwork rather than a single oarsman. The skipper sits in the stern, sets the course, tells the paddlers to pull left or right, and uses her own paddle mainly as a rudder.

The rapids here dogleg sharply through a narrow canyon. Kate said later she had not gauged the force of the water pulling the raft toward the canyon wall on the right and failed to give the paddle-left command soon enough. When the raft began climbing the wall and she realized it was going to flip, she said her greatest fear was of hypothermia, a debilitating reaction to cold that can render people helpless in frigid water.

However, no one was exposed for long. The overturned raft floated smoothly through the rapids, its passengers clinging to the sides, and avoided the one remaining obstacle, a large boulder in the middle of the river at the mouth of the canyon. Two people were briefly caught under the raft, but they resurfaced. Onlookers hurled ropes from shore and helped move the raft into shallow water and safety.

Little was lost and no one injured. Still, the rafters sat quietly by a campfire for the better part of an hour, warming up and slowly emerging from the private abyss where close calls can take you. Those of us who had not been on the raft sat slightly removed from them. We had

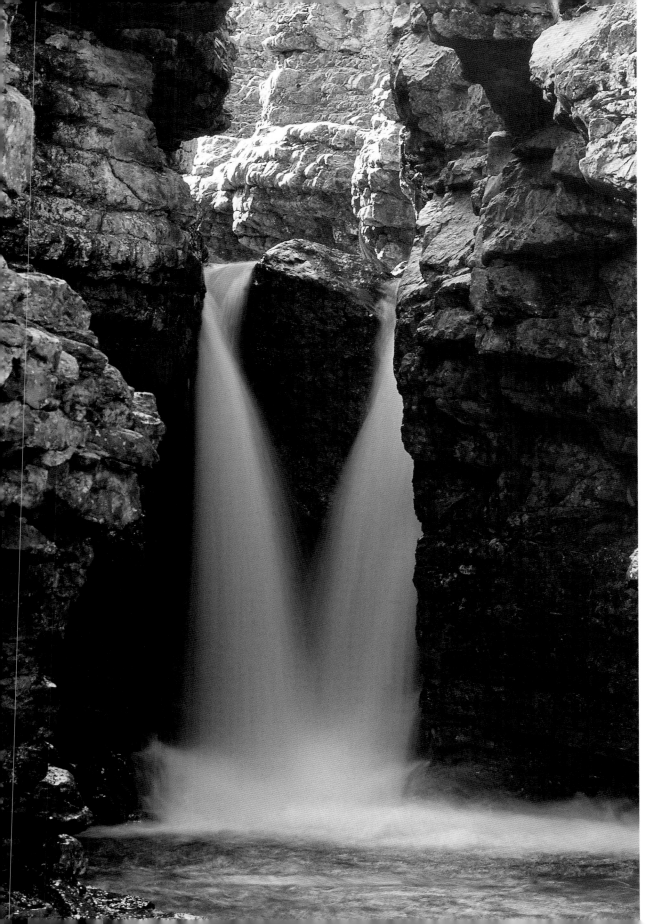

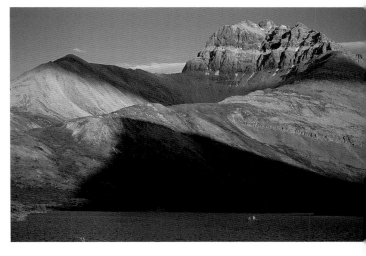

Above: A quiet evening paddle nurtures the spirit.

Left: A placid pool forms beneath a roaring cascade on a side creek of the Snake River.

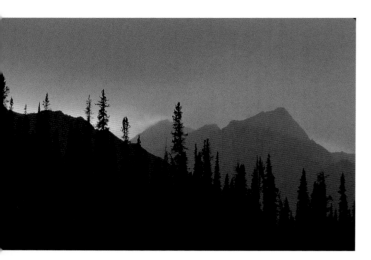

Top: Fading light silhouettes white spruce on a Snake River skyline.

Bottom: Pasque flower, once the Yukon's territorial flower, is often the first species to bloom on south-facing slopes.

missed the big spill and were feeling both relieved at our good fortune and slightly the lesser for it. There had been a fork in the trip. Half of us had been lost in the wilderness—if briefly. Half not. But when a vote was taken whether to return to the river or call it quits for the day, the majority opted to keep going.

That night, José Mansilla-Miranda, one of the artists who had been aboard the raft that flipped, came to the evening campfire carrying a guitar. A native of a mountain village in Chile, he now lives in Ottawa. He spoke English haltingly and had kept to himself for much of the trip, often setting up his tent apart from the rest of us. On this evening he was unusually animated, first struggling to express his reaction to the day's events in words, then producing the guitar. He played fiercely and faultlessly and sang equally well in a high, hoarse vibrato, serenading us in Spanish with a medley of folk tunes. "Until today I had no idea how strong this place was," he said afterwards. "It teaches you in one moment that your life is worth nothing and worth everything."

The next day we easily navigated the last set of big rapids, a 50-metre stretch of waves and boils that required little manoeuvring. After that, the Snake was a different river, a gently rolling, deep green carpet of water that passed between high earthen cliffs and dense forest. Nature's beauty, at last, consumed our attention. Tufts of cotton from balsam trees drifted over the river. A pair of peregrine falcons screamed at us and strafed our canoes as we paddled beneath their cliffside nest. Though peregrine numbers are dropping across much of the Yukon, there is no sign of a population crash along the lower Snake, which, like the rest of the river, is still safe from most man-made perils. A mile downriver from the falcon aerie, a grizzly stood on the shore, still as a rock, and watched us pass, its blond fur flashing gold in the slanting light.

Late on our thirteenth day on the river, just ahead of another storm, we arrived at the confluence of the Snake and the Peel and the encampment of Liz's people. There we gathered under the canvas top of a shelter that resembled a small circus tent. Our hosts included members of the Canadian parliament and the territorial legislature and several chiefs and mayors of First Nations communities in the Yukon and Northwest Territories. Their speeches echoed sentiments we had heard often from Liz and Gladys—fears that industry would despoil the region, driving out the wild herds and fouling the water. "If this wilderness is industrialized and the caribou and the other wildlife driven away," said Larry Bagnell, the Yukon's lone Member of Parliament, "a lot of the people in the eighteen [aboriginal] villages would vanish and their culture with them."

Nicholas Luard, writing about the African desert, had also addressed the cultural costs of destroying wild places. Wilderness, he said, is "the reference library of our past." Everything in it—lions, antelope, grizzly bears, falcons—"carries within itself a quantity of unique information . . . acquired over millions of years in circumstances that can never be duplicated." Kill off a species or destroy a habitat, Luard wrote, and you tear out a chapter of man's cultural history. Yet for most of us wilderness and culture are mutually exclusive concepts, the one implying an absence of human presence, the other an abundance of it. After our two-week immersion in the wilds, we had come out awed but shaken, still not sure about the proper role of humans, if any, in the ancient world from which we had sprung.

Our Gwich'in hosts were raucously celebrating their own sense of belonging, devouring platefuls of barbecued moose meat and reminiscing about life in the bush, when Liz tapped me on the shoulder. She wanted to introduce me to a friend, Eileen Koe, who lived near Fort McPherson. Eileen had a story to tell me about the winter thirty years earlier that she had spent on the Snake. "We travelled for days with dogs, trapping marten and wolverine," she began. "We made camp after camp in the bitter cold and snow. It was the most painful, lonely period of my life, but I learned to survive." She said that her brother had committed suicide shortly before, and she had hoped to find a refuge from her sorrow in the bush. "That land sustained me," she said, pointing toward the river we had just come down.

Liz passed me a plate of meat. "Moose heart," she said. "Eat it before it's all gone."

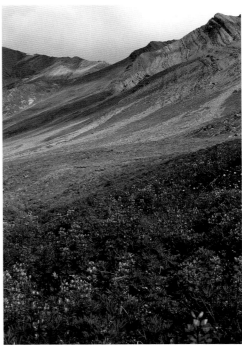

Top: Many species of groundsel are found along streams and wet places in the Three Rivers region.

Bottom: Arctic lupine blooms profusely in alpine meadows.

Adapted from a story that appeared in the *Los Angeles Times*, 2003.

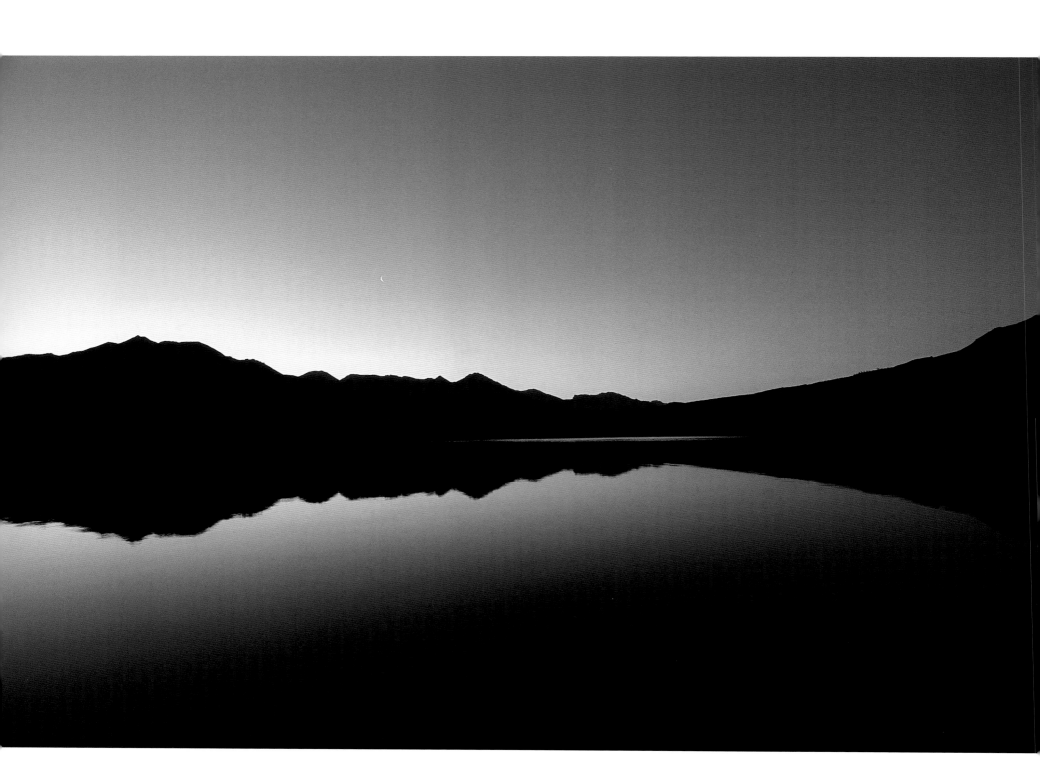

IMAGINING THE WHOLE

by John Ralston Saul

(While visiting the Yukon in 2001, John Ralston Saul went canoeing for a day with Yukoner Bob Jickling. That outing sparked plans for a major trip, and in 2003 Saul returned for a sixteen day trip on the Snake River. After this journey he spoke with Dave White of CBC Yukon; the following is adapted from that interview.)

Those sixteen days were a fabulous time—just the eight of us and nobody else except the animals. On the last day alone we saw five peregrine falcons. And we had wonderful encounters with caribou. Once they ran along the riverbank beside us and then at the last moment ran ahead and crossed right in front of us—just 20 feet in front of us. We saw four grizzlies, one just at the edge of the river, and it looked and we looked and it was off! We didn't see a road, we didn't see people; we saw the country as it is, in its real sense. I remember Bob saying that when you first go into places like the Snake River, you just gawk. You are like the tourist staring at the Eiffel Tower, saying "Isn't it beautiful!" Then after a couple of days, you stop gawking. You start feeling like part of nature. You move from a kind of urban rational admiration to a kind of harmony, part of the whole. And it is interesting just how fast that happens.

Bob had insisted that we have a little training session before we went out on the Snake, but I thought we could do that on the first day on the water. But on that river, from the moment you put the canoe in the water, you are faced with boulders everywhere, so I told Bob to give me my orders very fast—loud, clear and very authoritatively—if he wanted me to do what I was supposed to do.

In the city, your work, family, phone calls and what-have-you compete for your time and energy. But if you are in a canoe going down a very fast river with rocks and snags, it is not about competition, it is not about beating it. You have to figure out how to go with it, to go with it in a way that allows you to go through it. To cut a line through the river, in a sense, though it is rarely a straight line. In fact, much of that "going" is extremely precise, and the consequences are serious if you make a mistake.

My most vivid memory of the trip is a specific rapid over which we stood for about an hour, looking and calculating. "You will do this and do that, and you will do two of those," Bob said. So we got in and he was in the stern. Our canoe went first and we did everything right. Only we had not seen that around the corner there was a 4-foot jagged rock sticking straight out of the water. It looked like the end of Bob's canoe—and a few other things. Suddenly it came to me that I had exactly three strokes to get from that spot to that other spot. I acted instinctively,

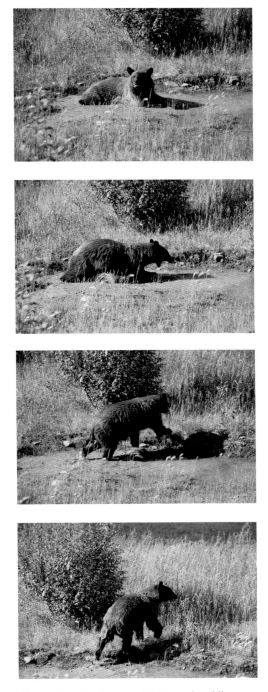

Above: A resting bear vacates its mud puddle near the Peel River.

Opposite: The peace and solitude of a northern evening is rarely equalled in today's world.

ARCTIC HUMMINGBIRD
By Brian Brett

"…I wither slowly in thine arms,
Here at the quiet limit of the world."
 Alfred Lord Tennyson, "Tithonus"

We were at camp
 beneath the bluff breathing flowers;
 meadow at an angle, the hill
full-fruited with the Yukon's secret treasures –

 crowberry
 cranberry soapberry raspberry
 blueberry juniper berry bearberry
blackcurrant prickly rose redcurrant
 buffalo berry red berry
 cloudberry

Then we were attacked.

It flew past a man's ponytail, turned,
and dived again, and he said:
"Did you see that?"

No one had seen it.

None of us understood,
until the little warrior returned,
rocketing by all of us,
a thousand miles too far north,
brave as Samuel Hearne,
and the Gwich'in guide who led the way
to the bodies of the lost patrol.

Hummingbird,
so far from home,
yet home everywhere.

Life leaping up from the tropics,
riding the northward-creeping thermals
 coming off the smokestacks,
the rivers of SUVs, the burning of Brazil,
the unquenchable need for plastic packaging,
the hunger for chocolate, and the vulcanized sneaker
promoted by that basketball player nobody will remember
a hundred years from now when the scavengers
 pick their boots
 out of the dumps of the world.

Ruby-throated warrior, leader of the advance squad,
 sentry and survivor, avian helicopter,
reaching,
 reaching,
 reaching for the near
 end of the world.

like an animal, and we missed the rock by about two inches. This kind of thing demolishes you. It gets rid of all of that geocentricism and rational intelligence and the way you want to dominate things, and you suddenly realize you are just hanging on by the skin of your teeth.

We are two things at once. There is this animistic whole and we are part of that whole. We are animals. We come out of that lineage, so to speak, and most of what we do is very like what animals do. And then we have this other part that is consciousness and rationality, the ability to step back and look and reflect. So on our trip down the Snake River, there was something of the human, the purely human, but in fact most of what we were doing was trying to relearn how to be an animal. I would say that after those sixteen days on the river I had a better sense of how those two equilibriums of animal and human must fit together.

In our cities we are very good at pretending that where we are is all that matters. I am not decrying that life; we all benefit from it. But in Canada this is a particularly surreal pretense because 95 percent of this country is not inside the cities, even though 85 percent of the people are. In this country we have this very real tension, a living tension, between the people and the place because there is such a dichotomy between where the people are and the reality of the place. That reality is not a romantic dream of pure nature; it is the clarity of the water and the presence of the wild animals. But when we are in our cities, we pretend that we do not need that tension, though it is the source of everything that we do. It is the source of our unconsciousness, of our imagination, of the way we live. But it's very difficult for most Canadians to feed into that.

This is not a country that can continue to insist that it is just about the people. And you cannot run Canada as though it existed only where the people are because most of it is in the North, and the balance between the people and the place has to be right. And if we do not imagine our civilization as being fed by and feeding the North, then the country will fail and it will fail fast. We have to find ways of imagining this whole country in order for it to exist.

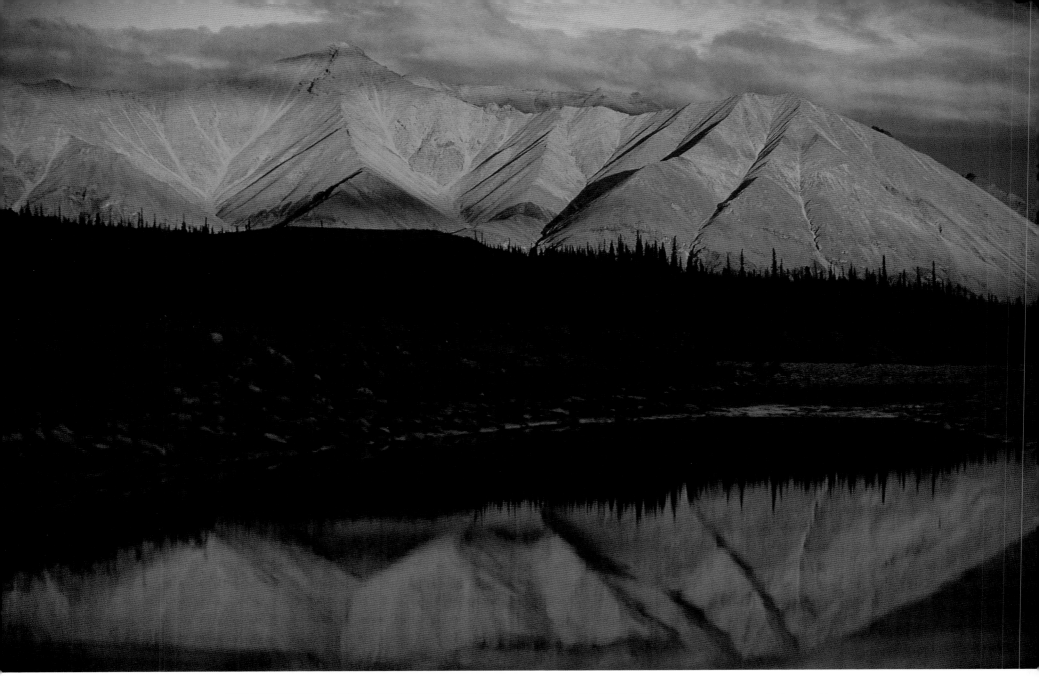

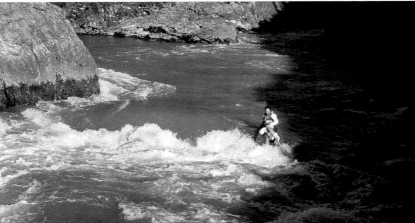

Above: "We have to find ways of imagining the whole country in order for it to exist" – John Ralston Saul, commenting on the North.

Left: Running the canyon drop on the Snake River.

COMING DOWN THE SNAKE

By Peter Lesniak

"Boy, I really enjoyed coming down that Snake River," Jimmy Johnny, a member of the Nacho Nyak Dun First Nation, told me shortly after completing one of his lifelong goals. "Now I've seen the whole thing" from near its headwaters high in the Wernecke Mountains, where it runs clear as glass, to its confluence with the Peel River.

One morning over coffee and cigarettes he told me about the first time he saw this Shangri-La of a valley. It was 1962, he was thirteen and working as a wrangler for an outfitter who guided hunters to trophy-sized moose, sheep and grizzly bear in the Peel Watershed. But he shot his first moose when he was just nine. "It took five horses to pack out the meat," he tells me.

Johnny favours denim and wool over Gore-Tex and polypropylene and, since he never learned to swim, prefers horses over canoes and rafts. He still works for an outfitter each year between August 1 and September 30, and he plans to continue doing so "until I'm ninety-nine," though nowadays he describes himself as almost "too old to shoe horses." Right after this trip ended in his hometown of Mayo, he led a string of packhorses back into the region his ancestors have known for millennia. These days, though, he's just as likely to be pointing a camera or camcorder at the scenery and wildlife as a spotting scope or hunting rifle.

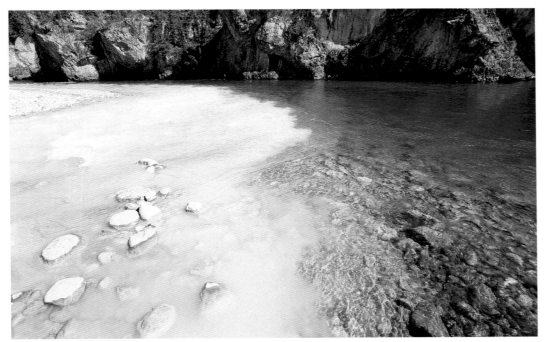

Top: Rock gendarmes, carved by glacial ice, shine in the moonlight above the Snake River.

Left: Glacial waters flow into the Snake River from a tributary.

Opposite: Long-time hunting guide Jimmy Johnny strikes up a tune.

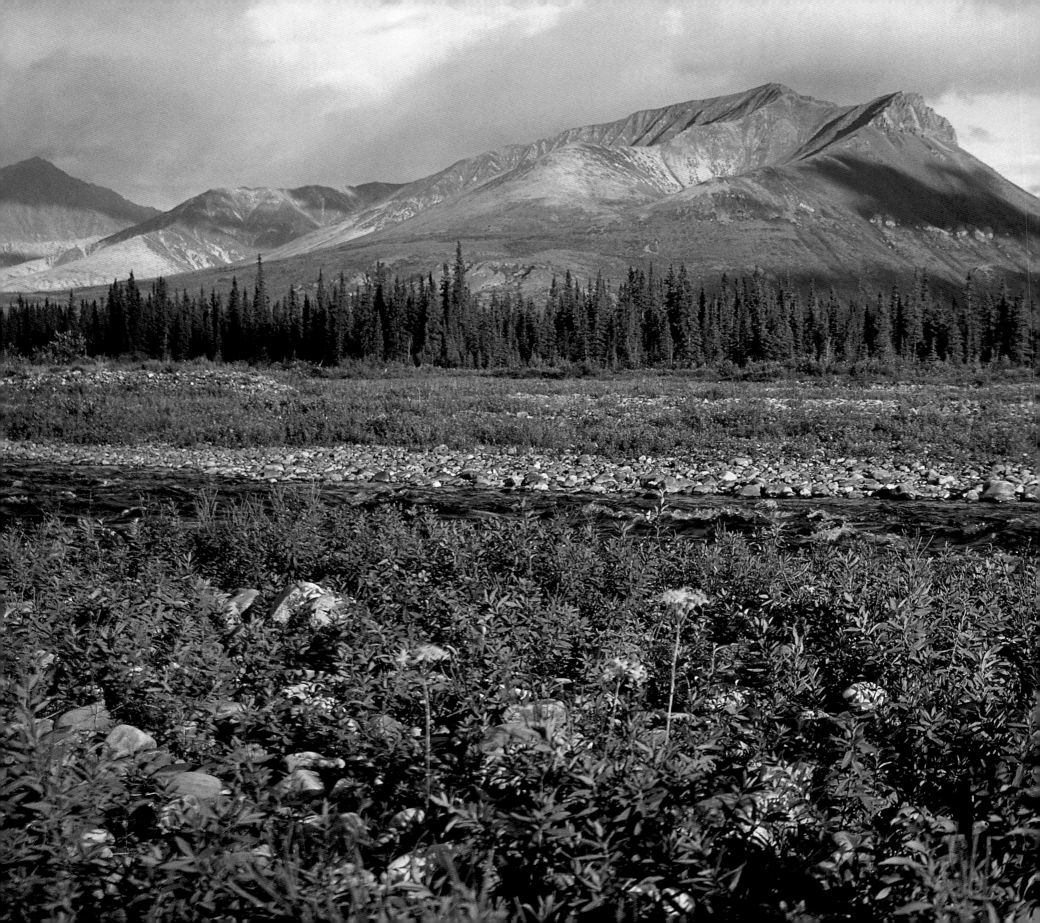

THE BONNET PLUME RIVER

O ne of Canada's premier whitewater canoeing rivers, the Bonnet Plume is famed for its long and turbulent canyons, powerful falls and rocky portages. Although known to the Gwich'in as *Tsaih Tlak Njik*, Ochre-Sparkling River, it was later named after a Gwich'in man, Andrew Flett Bonnetplume, the main translator for the Klondike stampeders who travelled up the Peel and Wind rivers on their way to Dawson City.

Near the headwaters of the river, Bonnet Plume Lake is set among sharp peaks and steep alpine meadows. Its aquamarine waters empty into the river through the apron of a massive rockslide before entering a valley of deep green spruce and feather moss forests that sweep away to the mountain slopes. In its lower reaches the braided river flows through plateaus dotted with wetlands as it rushes toward the Peel River canyon.

PEREGRINES AND PINGUICULAS

By Sarah Locke

On our last hike along the Bonnet Plume River, we wander up a bluff at the outside edge of the Wernecke Mountains. A line of spruce snakes down the slope to the river, but otherwise it is open and dry, perfect for rambling. On this warm August day, there is no hint of subarctic chill, no reason to hurry. Our goal is a band of cliffs where golden eagles, peregrine falcons, and gyrfalcons have all nested over the years. Birds of prey are fiercely

Left: Though officially designated a Canadian Heritage River, the magnificent Bonnet Plume is not protected from development.

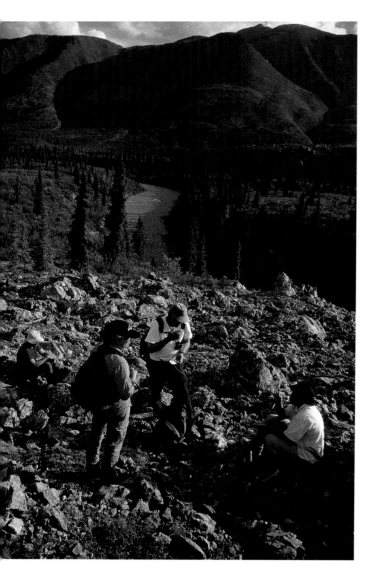

Above: Hikers explore the major landslide that once filled the Bonnet Plume valley.

Opposite: The Bonnet Plume is famed for its long and turbulent canyons.

territorial and seem as likely as rival gang members to share turf, but this spectacular aerie apparently encourages cooperation.

Earlier, while I was scanning with my binoculars, a peregrine falcon slashed across my field of vision, dead-set on its trajectory, flying with such concentrated force and purpose that it must have been hunting. It was headed for the labyrinth of bogs, lakes, and small ponds that surrounds us on three sides, offering an endless smorgasbord of waterfowl and shorebirds. These wetlands, stretching 60 kilometres north to the Peel River, are part of the Peel Gap, a natural flight path between the mountains. In spring and autumn, this corridor reverberates with song as ducks, geese, and swans migrate between their breeding grounds in the northern Yukon and Alaska and their winter homes farther south. A northern pintail could take off from one of these ponds, fly east along the Peel to the Mackenzie, and continue south all the way to the Mississippi Delta without ever crossing a mountain. A lesser yellowlegs, one of the peregrine's favourite foods, could branch off this flyway to a winter home on the Atlantic, the Pacific or the Gulf of Mexico.

Our group wants to check whether any young peregrines are in the nest above us, but there are many diversions along the way. Jane Isakson grazes on alpine blueberries, others peer at wildflowers and photograph lichens. I need regular breaks just to take in the horizons, which have been in short supply for the last ten days. Below us, the teal-coloured Bonnet Plume meanders through a maze of sandbars as though—for once—it cannot decide which way to go. And like the river, we are all taking a rest today, welcoming the chance to slow down and daydream after ten days of navigating whitewater on the steep stretches of the upper river.

Our journey began in Mayo, Yukon, nestled in the deep green of the boreal forest. From there we flew over a sea of peaks and river valleys to Bonnet Plume Lake, high among the bald sweeps of the Wernecke Mountains. The eighty-minute flight transported us to a world of glacier-carved peaks, serrated ridges and bowl-shaped cirques where rock glaciers bulldoze down the mountainsides and stunted white spruce trees cling to the valley floor, subdued by elevation and latitude. We explored this alpine region for a day, climbing up hillsides upholstered with mosses and lichens and pushing through chest-high willow and birch shrubs to reach the wildflower meadows above. Thick with arctic lupines, arnicas, wild sweet pea, and goldenrod, these flower gardens are nurtured by the almost endless summer days.

The next day, after paddling out of the lake's calm waters and joining the quickening flow of the current, we were faced with evidence of the Bonnet Plume's resolve. Ages ago, a massive rockslide scoured the side of a mountain, filling the valley with huge limestone blocks; the river has incised a route through this debris. In narrow canyons such as this, the world shrinks: cliffs form the horizons, and we could see little but the water immediately downstream of the canoe, looking two—hopefully three—boulders ahead. Life became very simple: our only goals were

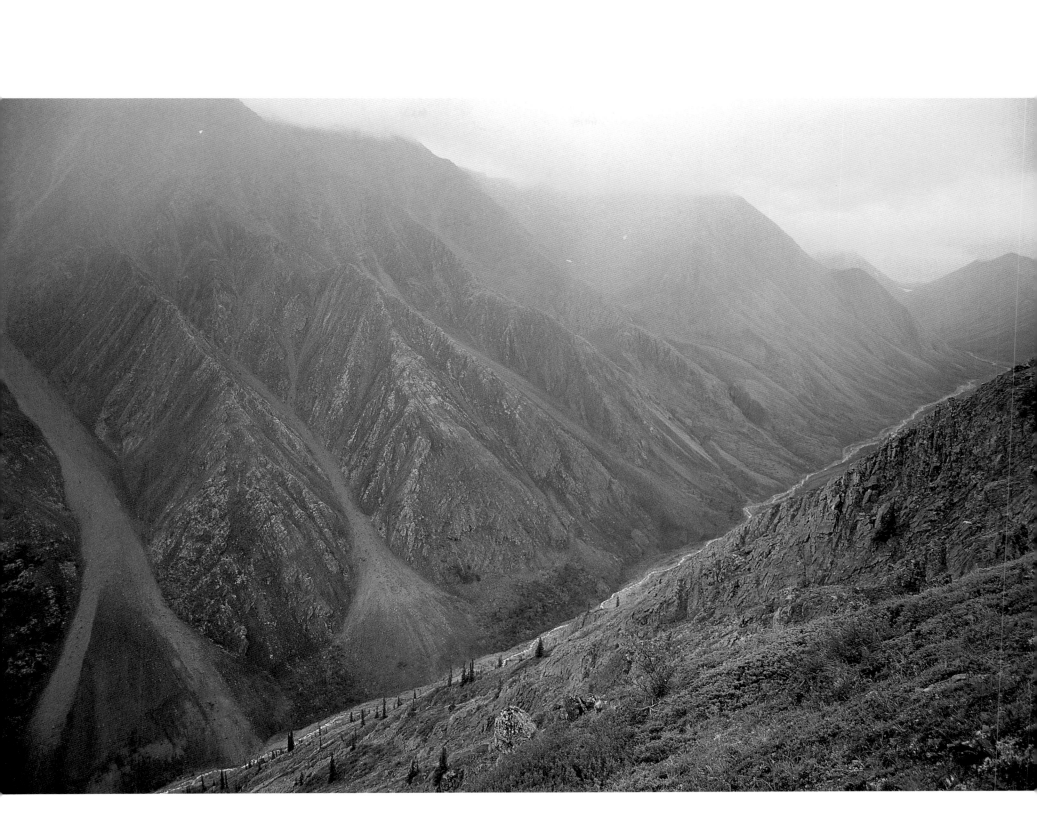

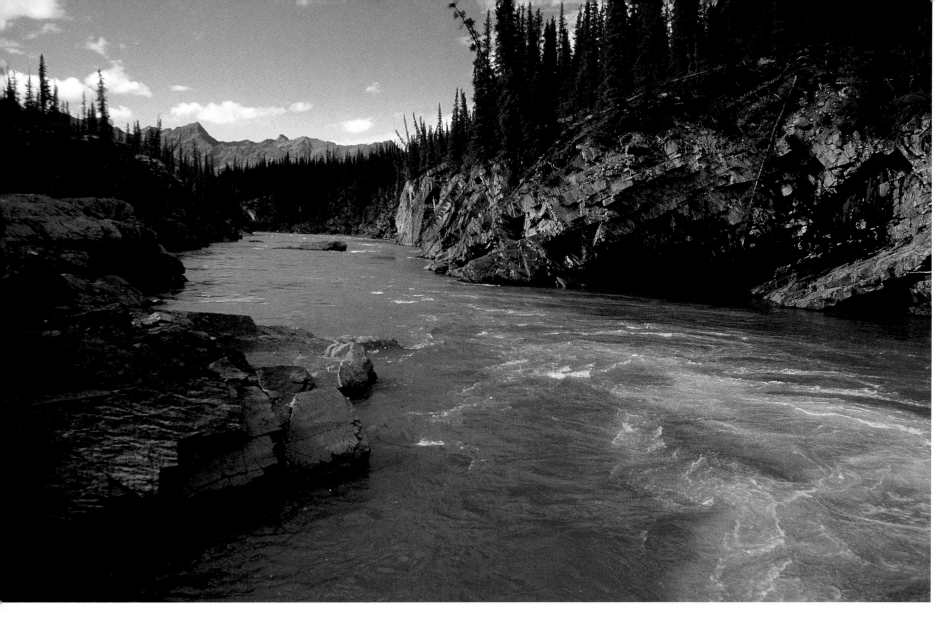

Above: The Bonnet Plume plunges through numerous canyons in its upper reaches.

Right: Jane Isakson and Peter Sandiford thread a route through the turbulent waters of a Bonnet Plume canyon.

Opposite: Rafters scramble to the "high side" when their raft broaches on a rock during a tense moment on the Bonnet Plume.

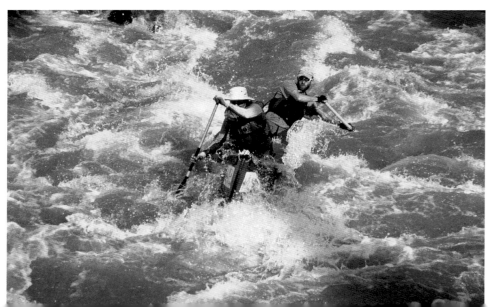

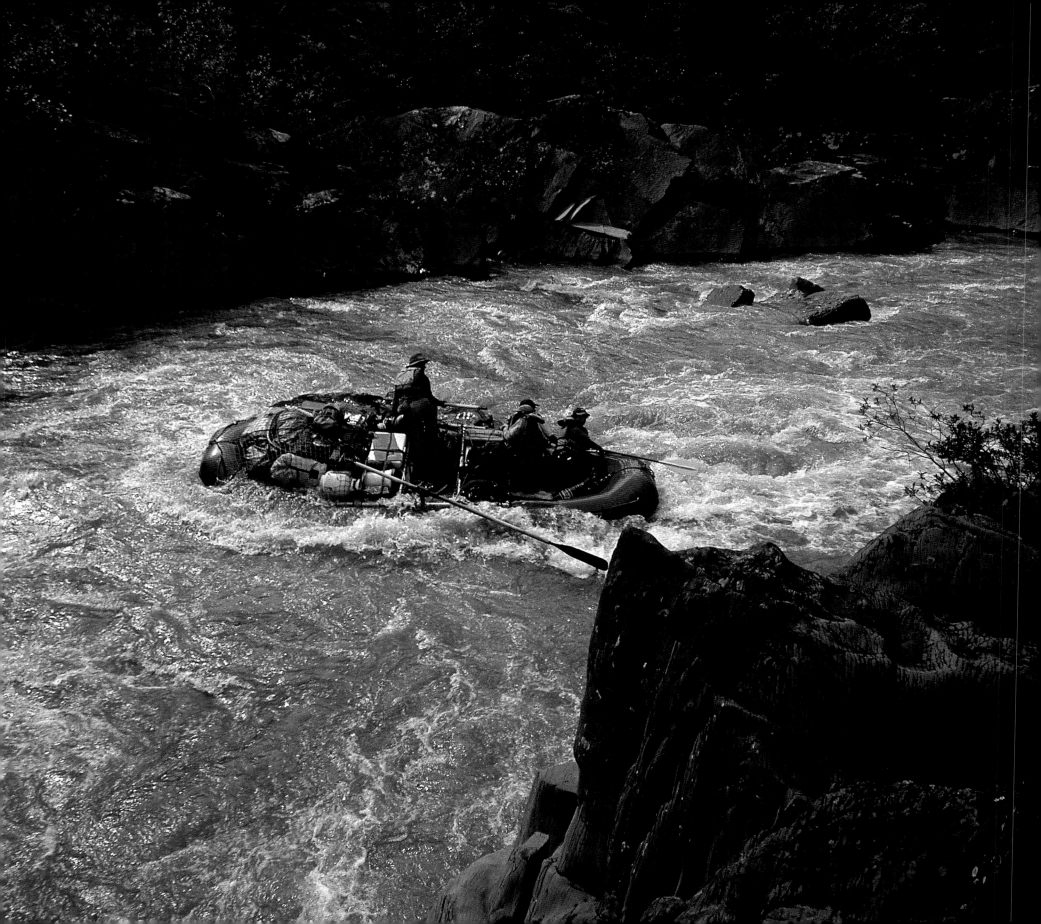

anticipating the river's demands, reading its mind, staying in its good graces.

The Bonnet Plume deserves its whitewater reputation, but it is defined by the mountain wilderness through which it flows. Along the upper river, we hiked into the mountains as often as we could, always on unnamed peaks. Wishing we had more time to explore, we looked up side valleys so huge they could swallow whole many large parks. Every day we drank straight from the river—cup to mouth.

Now, with the major rapids and the mountains behind us, the Bonnet Plume has flushed us out of one all-engrossing world and into another. We started near the southern edge of the Peel River Watershed; 165 kilometres of hard travel later we are somewhere near its middle. To say this is big country, wild country, profoundly understates the space here.

Above: Guides Kathy Elliot and George Saure make supper plans over the campfire.

Below: Fishing for lake trout on Bonnet Plume Lake.

Opposite: The midnight sun eventually dips below the horizon on the lower Bonnet Plume.

On the slope above me, Dave Mossop booms out "Ho ho! What have we here?" and my landscape reverie ends; I am back in the world of biological detail and small-scale wonders. Dave has worked in the Yukon as a biologist for more than three decades and can tell you something about nearly every living object out here. We do not have to wait long for him to answer his own question.

"A little pinguicula in bloom! That's pretty, hey?" Pretty yes, but this violet-coloured *Pinguicula vulgaris* is no innocent little flower like the sweet-scented dwarf rhododendron we saw earlier. Commonly known as butterwort, the pinguicula is one of the Yukon's few carnivorous plants. "There are little hairs on the surface of the leaf," Dave explains, "and when

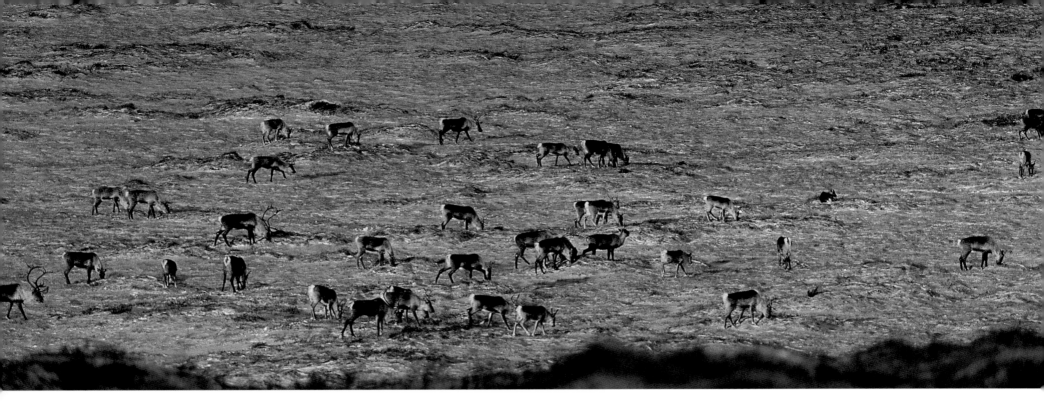

Top: Thick carpets of lichen sustain the Bonnet Plume woodland caribou through the long winters.

Bottom: The carnivorous pinguicula traps insects with its sticky leaves.

flies and things get embedded in them, they are just digested in place." Pinguiculas don't make a clean kill. When insects that are stuck to the leaves start struggling, the movement stimulates the leaves to secrete an acidic goo, full of enzymes, that dissolves the insect's soft parts; the pinguicula absorbs this liquid directly into its glands.

Unlike the toothless pinguiculas, peregrines have a decisive killing strategy. Falling out of the sky in one of their spectacular stoops, they can reach speeds of well over 200 kilometres per hour; no other animal attains such velocities. One wonders if their prey can hear the sound of air being cleaved in two, or if the end is so quick they never know what hit them. Only three decades ago, it was feared that peregrines might vanish off the face of the planet, victims of pesticide poisoning. But even in the darkest days when they had disappeared from most of their habitat, a few of them always returned to the cliffs of the Peel Watershed. Now about fifty pairs—one-quarter of the Yukon's total population—nest along the Peel and its tributaries every year.

Reaching a vantage point, we can see a massive golden eagle nest on the right side of the cliff, but no one is home. Adding layer upon layer of twigs and sticks, eagles sometimes reuse such nests for centuries. Their strata can be read like growth rings or analyzed as an archaeological site, deducing what the eagles ate in different years.

Gyrfalcons, the largest falcons in the world, will take over an eagle's nest instead of building their own or lay their eggs directly on a ledge. When hunting, they swoop along low

to the ground, silently chasing down their prey, making the kill once they've closed the gap. Their preferred food is ptarmigan, and gyrfalcons will stay in the North year-round if they have enough to eat. But like many of the animals in the northern boreal forest, the number of gyrfalcons and ptarmigan rise and fall in roughly ten-year cycles. When ptarmigan populations start to slide, fewer gyrfalcons are able to breed. But decade after decade, their numbers rebound, and gyrfalcons have never been listed as threatened or endangered in Canada. About 750 pairs breed in the Yukon, supplementing their summer diets with ground squirrels and water birds as well as ptarmigan.

⁂

From the top of the bluff, we can see far across the Peel River to the Richardson Mountains, pinched between a layer of flat-bottomed clouds and a shimmer of wetlands. These rounded sedimentary mountains drop down to the coastal plain of the Beaufort Sea, and in a few short months arctic gales will blow through the darkness, scouring their summits ever smoother. On a warm summer day it's easy to forget that winter rules here. Everything, from plants to animals to insects, has figured out a way to survive the winter lockdown, the eight months of snow and cold during which temperatures can plummet to minus-fifty degrees Celsius. Wood frogs crawl underneath leaf litter and freeze solid, while ptarmigan burrow into the snow to sleep overnight; bears take to their dens, tiny red-backed voles tunnel beneath the snow, and porcupines resort to gnawing on bark. Caribou—no longer tormented by the insects of summer—come into their own.

Chionophiles or snow lovers, caribou are superbly prepared for the severe cold. Hollow chambers in their guard hairs provide insulation, and their large hooves act as snowshoes. In winter their footpads harden, giving them better traction on ice. Their bodies are compact, their muzzles furred, their ears reduced, but one of their most important adaptations cannot be seen: caribou are the only large mammals that can subsist on lichens. The specialized bacteria in their guts break apart the chemical bonds in these nutrient-poor organisms, allowing them to be digested. Caribou have lived in the North for almost two million years, so they have had plenty of time to develop this ability; without it, vast herds of caribou could not exist across the North.

Woodland caribou, slightly larger than their barren ground cousins, roam the valleys and slopes of the Peel Watershed year-round and are often seen along these rivers. Earlier today we watched two of them trot along a gravel bar beside the river. Their erratic weaving course—first towards us, then away—displayed the very essence of caribou spirit. Curiosity trumping caution. Such scenes were once common on riverbanks, mountain slopes and valley bottoms across Canada, but no more. Classified as a threatened species in most regions, woodland

Fireweed is the Yukon's territorial flower.

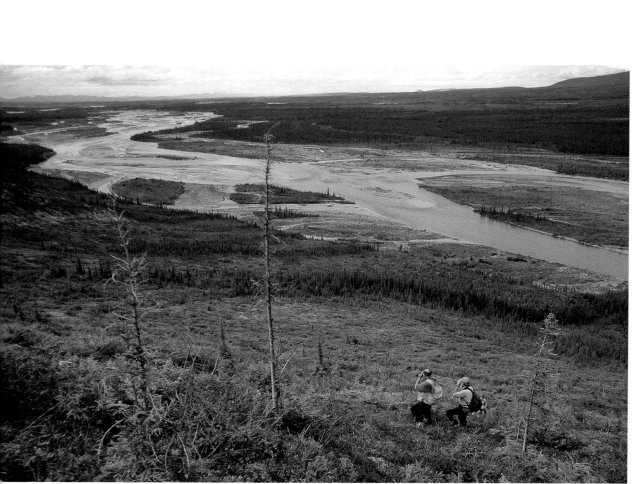

Above: Hikers scan for raptors along the lower
Bonnet Plume.

Right: Woodland caribou from the Bonnet Plume
herd, one of the Yukon's largest, are often seen
along rivers of the Peel Watershed.

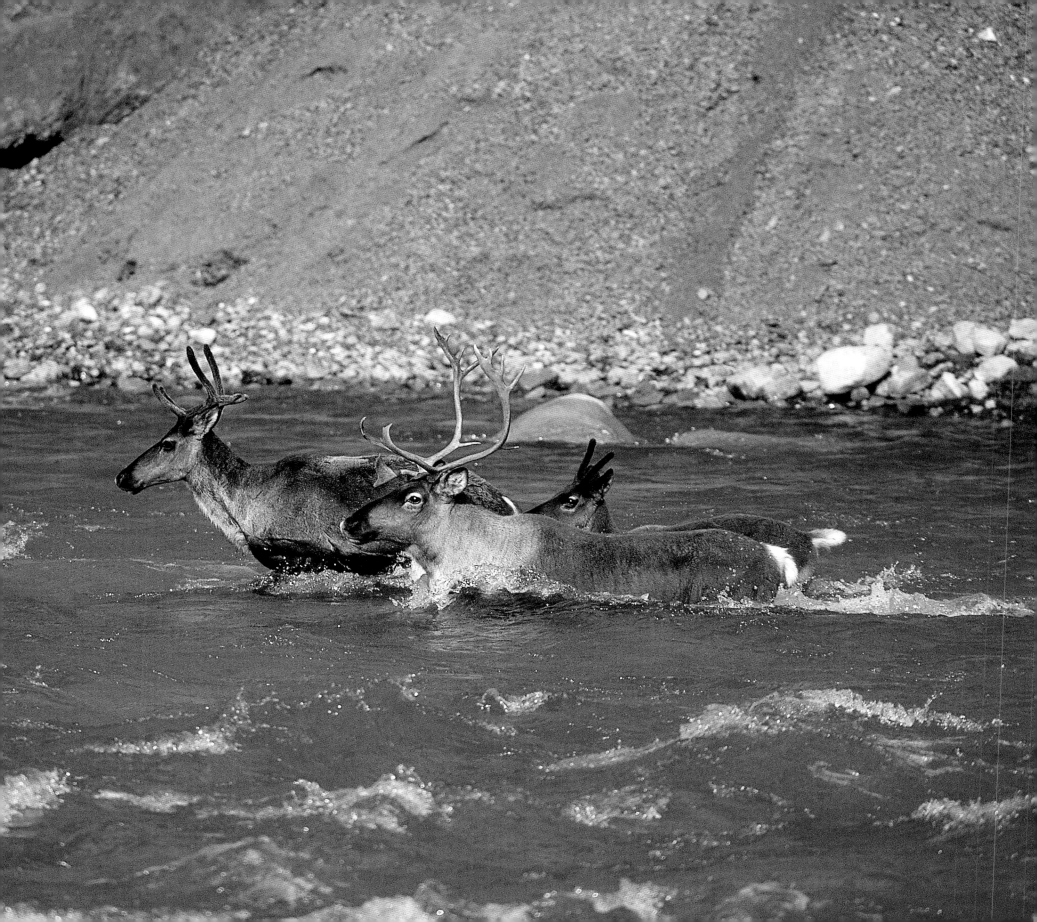

Above: Marten, which spend much of their lives in trees, are increasingly scarce in disturbed forests to the south, but abound in the boreal.

Opposite: Solitary and territorial in winter, red foxes often forage around ponds while searching for mice, shrews and other prey.

Following pages: The placid waters of Fairchild Lake, east of the Bonnet Plume River, mirror the forested slopes of surrounding hills.

caribou live on a mere 50 percent of their historic range. Extremely sensitive to disturbance, their survival depends on access to large expanses of mature boreal forest with thick mats of lichen, but as industrial development moves farther and farther north, roads are fragmenting the frontier forests they need. Some biologists have used the term "extinction in slow motion" to describe the decline of this species.

Even in the Yukon, where overall populations are generally healthy, desperate measures have been taken to save woodland caribou. But biologists do not spend much time worrying about the Bonnet Plume woodland caribou, which might well form the largest woodland herd in the Yukon. When its size was last estimated in 1982, biologists put the number at about 5,000 animals and moved on to more pressing problems.

Walking single file, escorted by wolves and ravens, barren ground caribou from the Porcupine herd also thread their way into the Peel country some winters, probably when snow is deep farther west. Numbering about 123,000 animals, they form the largest of the caribou herds in this part of the world. More than 80 percent of the cows calve in the hotly disputed area known as the "1002 lands" in the Arctic National Wildlife Refuge, which has been under pressure from oil and gas interests for decades. As a result, the Porcupine herd is arguably the most thoroughly studied group of caribou in the world. In the Peel Watershed, predators and prey still have the space that they need to work things out on their own, no management needed. The Bonnet Plume herd courses across these mountains and valleys year after year— uncounted, unstudied, unsurveyed—as are the wolves that hunt them and the golden eagles and bears that prey on their newborn calves.

An estimated 6,500 grizzly bears, one-quarter of the Canadian population, live in the Yukon. They have one of the lowest reproduction rates of all North American mammals, breeding late in life and not very often. After studying grizzly habitat in the watershed, researchers determined that the bears here eat immense quantities of plants—mainly horsetails, the roots of alpine hedysarum and berries—helping to explain why male bears living this far north require more than 1,500 kilometres of home range. Conservation biologists estimate that top carnivores and the prey on which they depend need 25,000 to 50,000 square kilometres of unfragmented, undisturbed land to survive in the long term without interference from humans. The Peel Watershed, at the very edge of the boreal forest, is one of the few places where grizzlies, caribou, sheep, wolves and other species still have the room they need to manage their own lives.

That evening, diffuse northern light sets fire to the mountains across the river, igniting them with shades of apricot, salmon and blood red. From our camp by the river, we watch thinhorn

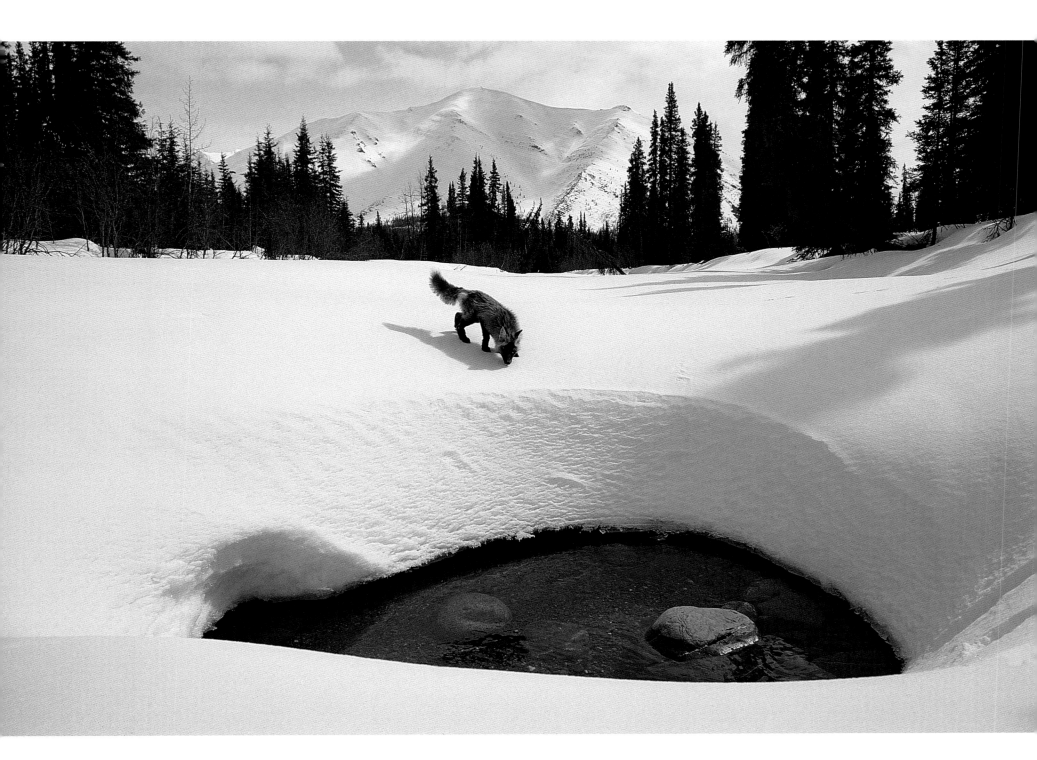

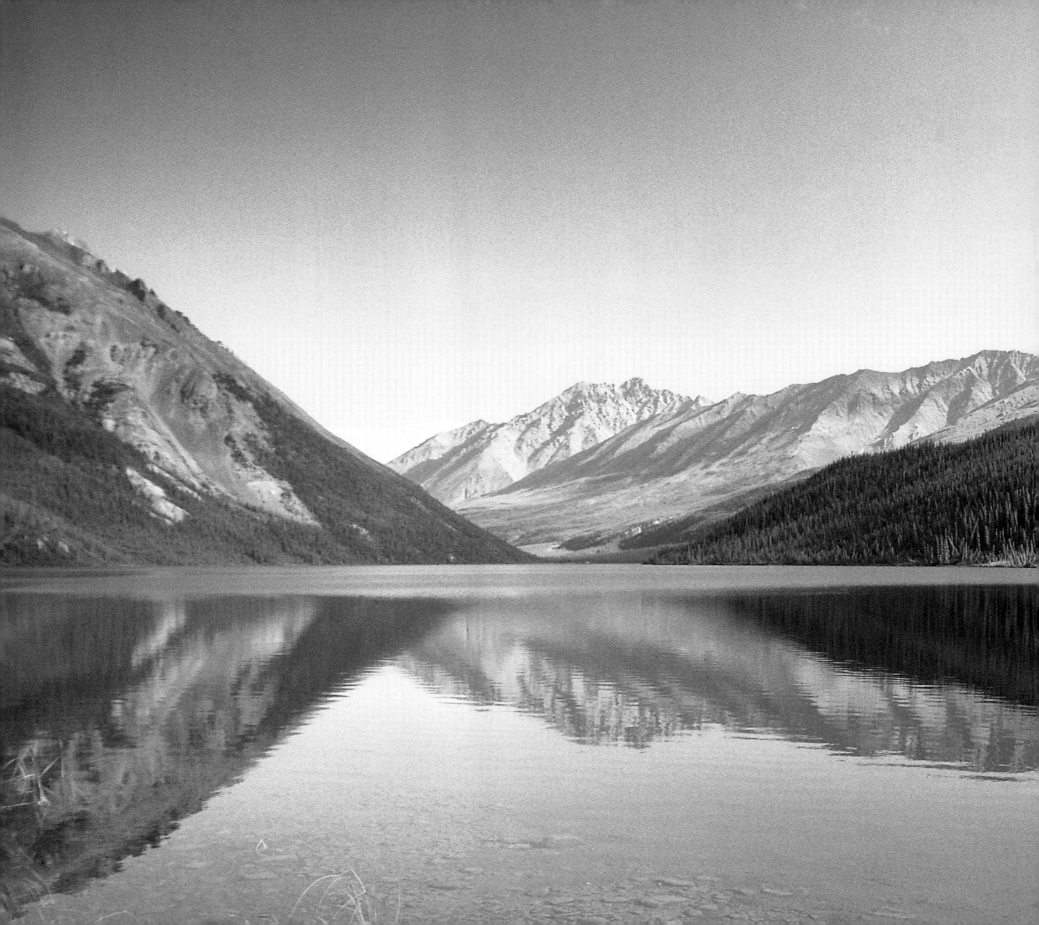

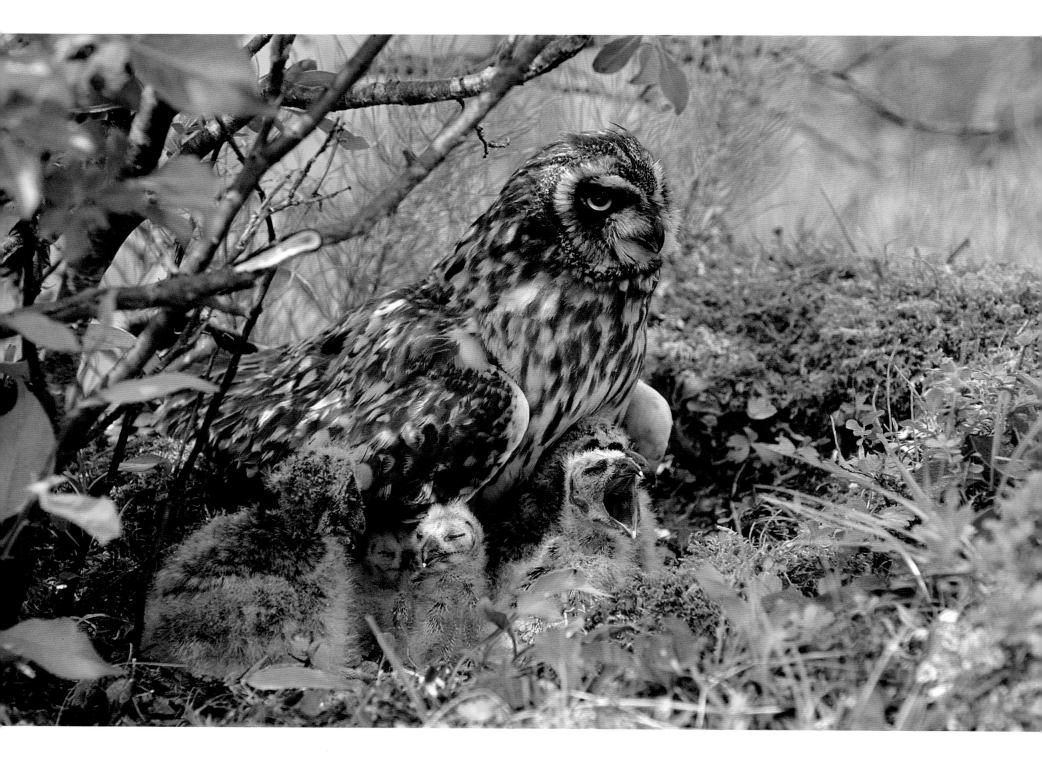

Dall sheep pick their way across a hillside to the southeast. On shale slopes these graceful animals stand out as brilliant points of light against the dark rock; as dazzling as arctic snow, they are the only wild, white sheep in the world. Along with caribou, they evolved in Beringia, which served as a refuge—and a centre for evolution—during the last ice age.

Margaret Lake lies across the river from our camp. Lake whitefish, the descendants of other ice age survivors, still swim in its waters. During the last glacial period, a giant lake connected the Yukon and Peel river systems, and for 8,000 years fish swam back and forth in its waters. When the glaciers retreated and the ice-dammed lake disappeared, fish originally from the Yukon River were stranded in the Peel Watershed. Six of these relict species still swim in the Peel and Mackenzie rivers.

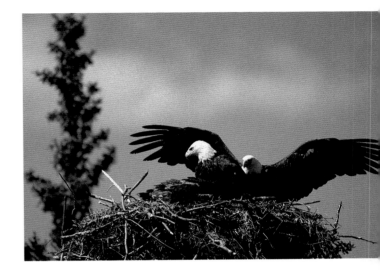

⌒⌒

The next morning, we break camp and head downstream towards the Peel, the broad river at the heart of this watershed. With the Werneckes receding behind us, the true north of the Arctic seems that much closer; only the Richardson Mountains separate us from the Beaufort Sea. If we stayed on the water, following first the Peel and then the Mackenzie rivers, we could paddle to the Arctic Ocean in another week or two.

No longer hemmed in by mountains, the taiga, the northern edge of the boreal forest, sprawls away from both sides of the river. It's the classic "land of little sticks" where stunted black spruce vie for purchase in the permafrost-rich soils, and a mosaic of ponds and wetlands glint under the northern sun. This land has its own distinct wealth, different from the mountain world with its ethereal rivers but still knit together by the tracks of caribou and the shrill cries of peregrines. Most importantly, it's still whole, which seems almost a miracle at this point in time.

We have another 180 kilometres of river to travel before this journey ends, so we'll spend long days in the boats, watching the country go by. In the canyons along the upper Peel we'll pass islands dense with balsam poplar and willows and watch for bald eagles nesting in snags and black bears traversing the slopes. In two days, we'll enter one of the North's great sacred places, the Peel River Canyon. But that world is still to come; the Bonnet Plume is not done with us yet. Before the confluence, the river explodes into a wild confusion of braids as it cuts through an open plain of unconsolidated sand and gravel, left behind by the retreating glaciers. Many rivers meander through their deltas but not this one. This disorganized rock presents a challenge, and the Bonnet Plume picks up speed again, intent on cutting new channels, and once again we fly along on its surface.

Top: Bald eagles, versatile hunters of fish, waterfowl and small mammals, are abundant along the lower Peel River.

Bottom: Most falcon nests are on cliff ledges, and both gyrfalcons and peregrine falcons often adopt the stick nests of other large birds such as eagles, hawks or ravens.

Opposite: The uncommon short-eared owl is not as nocturnal as other owl species.

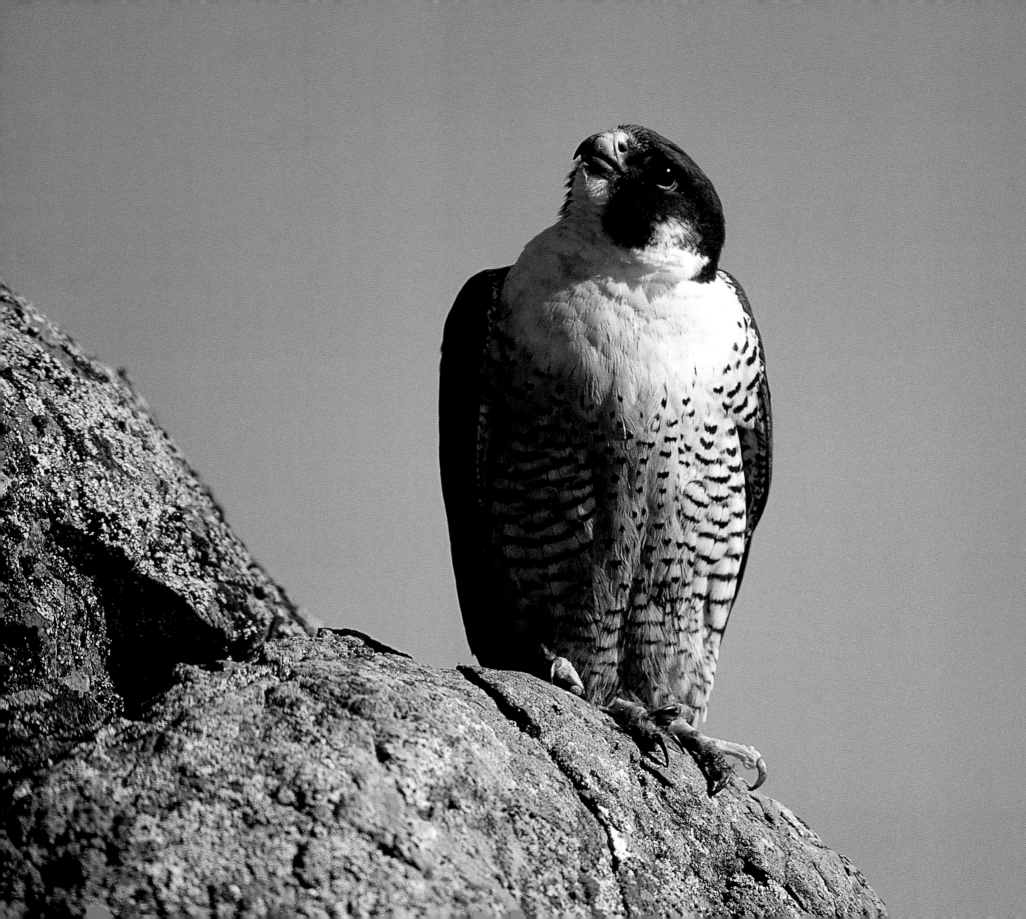

FOSTERING THE PEREGRINES

By Paul McKay

Veteran Yukon biologist Dave Mossop winces and quickly deflects any suggestion that he has played a key role in bringing the elegant peregrine falcon back from the edge of extinction, but the facts prove he has. In the 1970s peregrine populations plummeted because the birds were being poisoned with pesticides during their winter migrations in the south and the eggs they were producing could not hatch. Since that time Mossop has mapped some two hundred peregrine nests in the Yukon, scaling steep river cliffs and jagged peaks to band thousands of fledglings, then tracking their migration patterns and breeding progress.

Now, though approaching sixty years and busy teaching environmental science at Yukon College, every summer Dave Mossop's passionate heart and sturdy legs keep him in a canoe, tent, and wooden Yukon River pack boat, still searching for new peregrine and gyrfalcon nests and scanning familiar cliffs for offspring who are now parents. If the timing is right, he will don his hockey helmet, climb up to the nests and carefully place numbered legs bands on youngsters still too featherless to fly, while enraged parents screech and dive-bomb him. The leg bands, used to track survival and migratory patterns, form the core of a national database updated every five years. As well, Mossop often collects and collates blood and DNA samples to help pinpoint breeding patterns and population health.

Despite his sometimes gruff manner and his reputation for battling bureaucrats who seem to perpetually delay or deny funding for his peregrine protection programs, Dave Mossop exudes joy when he's on the hunt for new nests and for signs that his revered gyrfalcons and peregrines are breeding. He freely imitates dozens of Yukon songbirds while paddling whitewater canyons, tramping alpine meadows, and leaning into aeries on ledges, always with the grin of a kid who's just scored a goal in road hockey.

At the peregrines' darkest hour, he recalls, the once-prolific Yukon River population of fifty nests was down to a single pair of birds. As they could not produce viable eggs, the burly Mossop became a kind of interspecies foster parent. He and a few committed colleagues set up a special breeding facility in Alberta that produced captive-bred eggs from formerly wild (often injured) peregrine adults. Their eggs were then placed in wild nests in a long-shot gamble that the eggs would be incubated there and the chicks would grow up to be productive parents. He watched the near miracle happen before his eyes.

"The bird has a great deal of public charisma, and in the sixties it was clear that it was going towards extinction. It was already gone in most of North America, and the remnants were up here. So this was the fallback position, where their ecosystem was still intact and healthy. But it was a hopeless, hopeless kind of a feeling—to be going out annually and finding fewer and

Top: Populations of lesser yellowlegs—a main prey species for peregrine falcons—seem to have declined sharply in the Yukon.

Bottom: The willow ptarmigan juvenile pictured here will turn all white in winter.

Opposite: Sleek peregrine falcons can hit speeds over 200 kilometres per hour in their stoops.

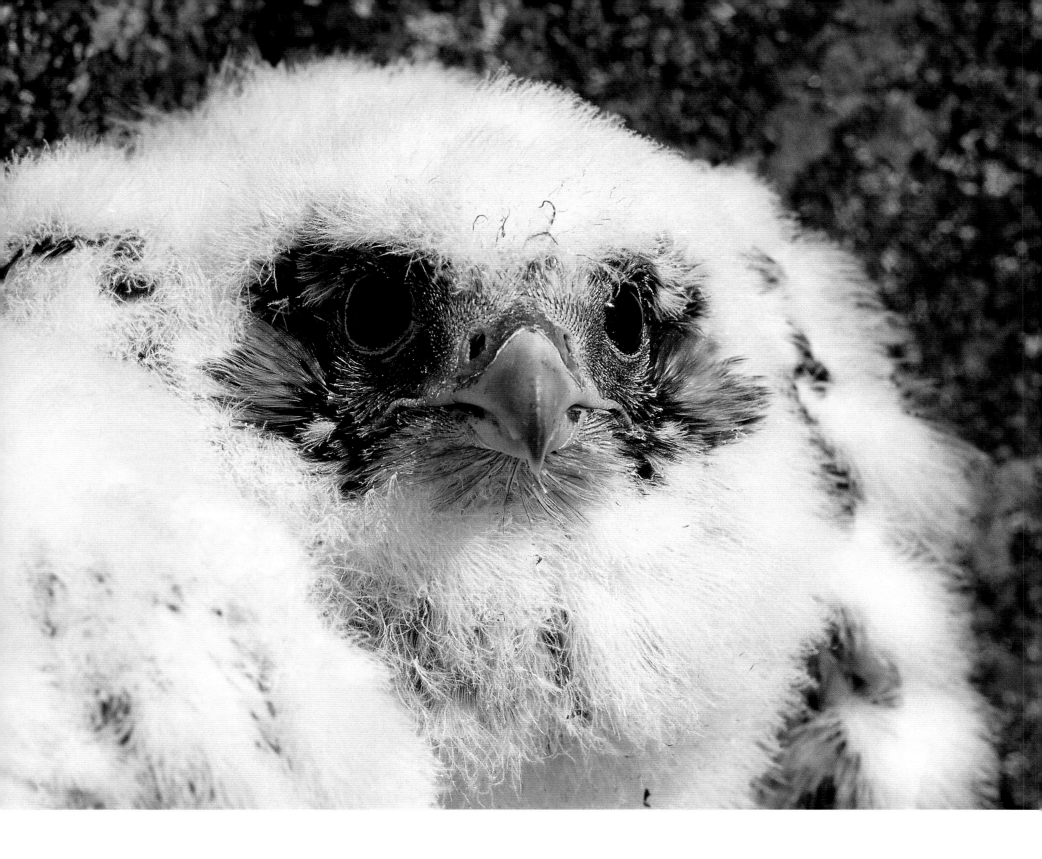

Above: True to their name, willow ptarmigan inhabit willow shrub tundra in the summer and valley bottom willow thickets in winter.

Opposite: Occupying nests on cliff ledges, gyrfalcon chicks are fed ptarmigan and other large birds.

The medium-sized hawk owl hunts during the day, usually from perches on treetops.

fewer birds. I remember going out to the last nest I knew of up on the Arctic coast, banding the last three youngsters, and thinking that could be the end of them. They disappeared."

There was, however, one more avenue to explore. "We did take some of the last ones from other nests, hoping they would breed in captivity. Thank goodness we did, because it was the only way to save the [anatum peregrine] gene pool and begin restocking nests. That started to bear fruit in the late 1970s. The Yukon still had a remnant population that was trying to breed—but they couldn't. The eggs just would not hatch because they were still carrying this heavy load of pesticides.

"We had no idea if it would work, but we took this pair's [non-viable] eggs away and replaced them with a captive-bred youngster that was twenty days old. It was kind of hilarious—and traumatic. They did not know what to do or what it was. I watched through my spotting scope as the mother tried to drive and scare this baby from the nest. Hours later, the youngster started begging for food. Suddenly the male flew off and came back with prey. Then the female took it and plucked it, but she still didn't seem to know what to do. Then the fledgling started begging out loud again, and the mom flew down to the ledge and began feeding it as if she had been doing it all her life. Instinct kicked in. It was quite thrilling." For years afterward, that same pair raised captive-bred young placed in the nest by Mossop, who had by this time also become a bizarre but beneficial stork to dozens of additional pairs.

Right: Northern harrier on her nest.

Opposite: Flying low on their long buoyant wings, northern harriers hunt small birds and mammals.

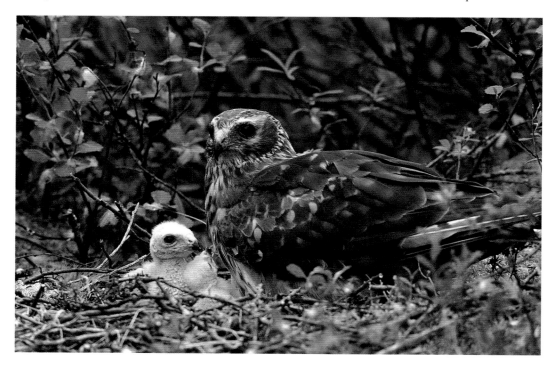

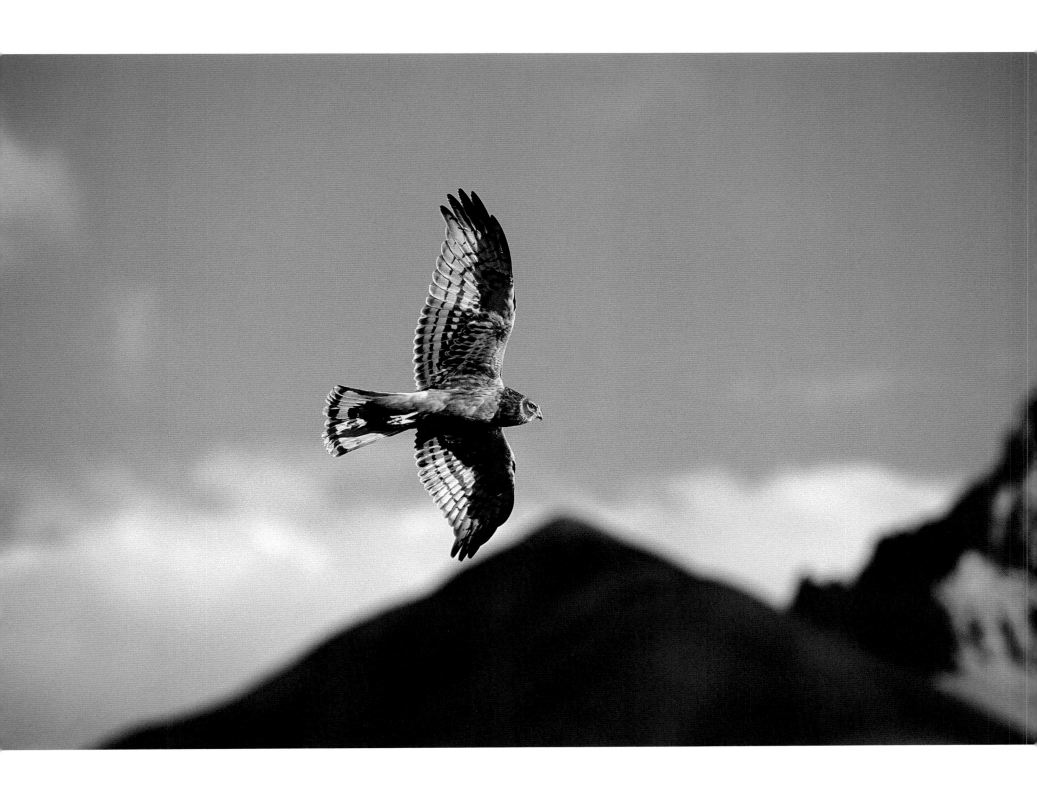

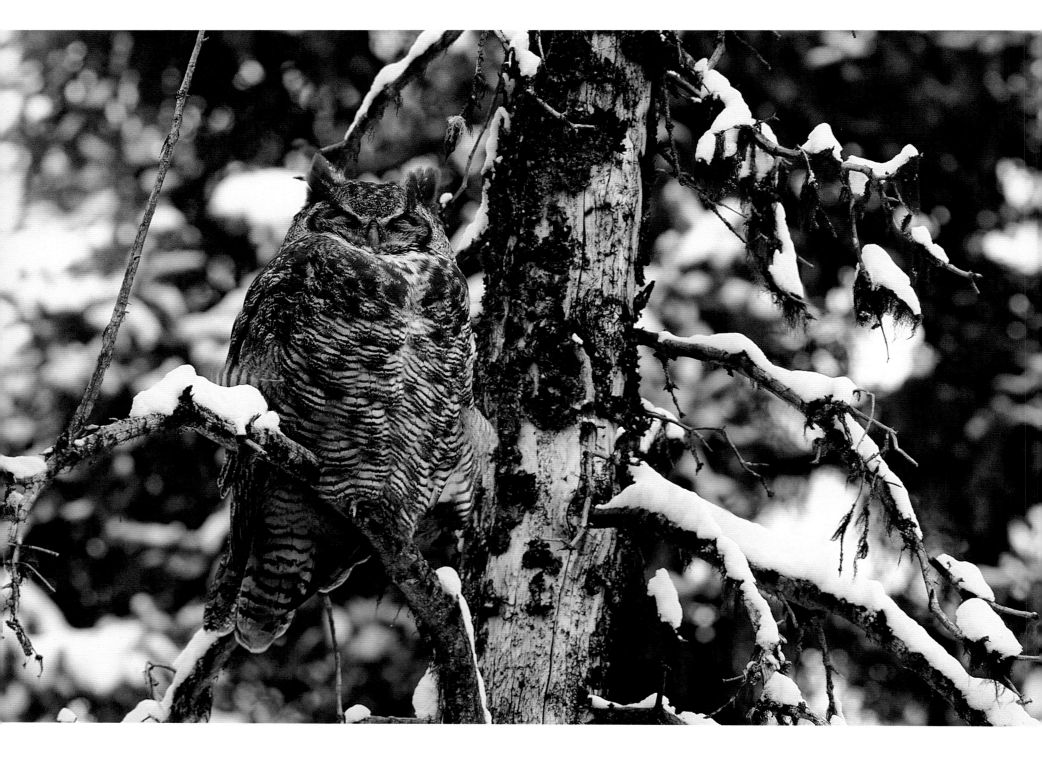

Meanwhile, peregrine populations were rebounding because several implicated pesticides had been banned, captive-breeding programs were bringing restocked birds even to urban areas like Ottawa and Toronto, and the peregrines had received top priority under a national endangered species program. By 1992 peregrine populations in the Yukon had returned to historic levels. However, their productivity rates have since fallen sharply. In recent years about 60 percent of the nests Mr. Mossop has been tracking for the last twenty-five years have been bereft of peregrine fledglings. During a 340-kilometre paddle down the Bonnet Plume and Peel rivers in August 2003, only one nest of young peregrines was detected instead of nearly a dozen he has tracked in the past. Only three adult pairs were spotted.

The trend has him deeply worried. And there are added signs that a widespread ecological upheaval is taking place even in Canada's most remote, pristine regions. The Yukon peregrine's chief food—a shore bird called the lesser yellowlegs—has almost disappeared in many parts of the territory, including the Bonnet Plume and Yukon rivers. Another food source, the scoter

Above: Four hungry raven chicks clamour for the first serving.

Below: White-crowned sparrows live throughout the forests of the Canadian boreal.

Opposite: Populations of great horned owl rise and fall along with the ten-year cycle of its main prey, the snowshoe hare.

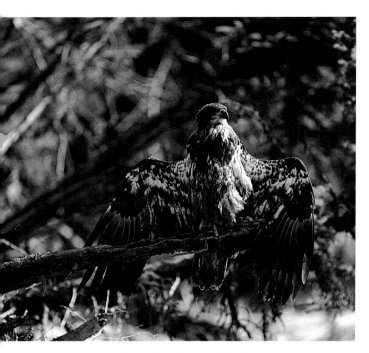

A juvenile bald eagle dries its wings.

duck, has declined 58 percent across the continent—from 1.8 million to 700,000. And smaller raptors such as the kestrel are rarely seen where once they were prolific. Only one kestrel was spotted during two weeks on the Bonnet Plume—despite constant scanning with binoculars. Similar declines in peregrine populations have been reported in Labrador, northern Alberta and Alaska.

Even those Yukon peregrine nests which are producing youngsters contain ominous clues that the food source has changed dramatically. This summer, Mossop found nests filled with remnants of short-eared owls, an unheard of prey species for peregrines because it takes a great amount of skill and energy to catch an owl compared to the formerly plentiful shorebirds.

As a result, says Dave Mossop, proposals by BC-based Promithian Inc. to start a coal mine and steel smelter and drill for coal-bed methane are the wrong projects at the wrong place at the wrong time. He points out that the Bonnet Plume's densest avian habitat, at Chappie Lake, is less than 20 kilometres downwind from the proposed mine and mill complex. "I have helped do the biodiversity inventories at Chappie Lake. Over thirty species of waterfowl, shore and songbirds breed there, including tundra swans, sandhill cranes, geese, and ducks. Peregrines and bald eagles are in there hunting all the time from nests on the Bonnet Plume and Wind rivers. It's a kind of grocery store for these creatures. I can't believe anybody would think that's a viable location for that kind of operation."

Sombrely he says, "The peregrines are giving us biological clues. They are like the canary in the mine, telling us in advance that something is very wrong or that all is well. Right now, I can't make out those clues. It could just be periodic swings in ecological cycles. It could be new pesticides building up in their eggs—the chemical industry never sleeps. It could be global warming. . . . Whatever it is, we need to get out there and find the cause before we risk losing a species we almost lost to extinction once before."

Excerpt from original story that appeared in the *Ottawa Citizen* in 2003.

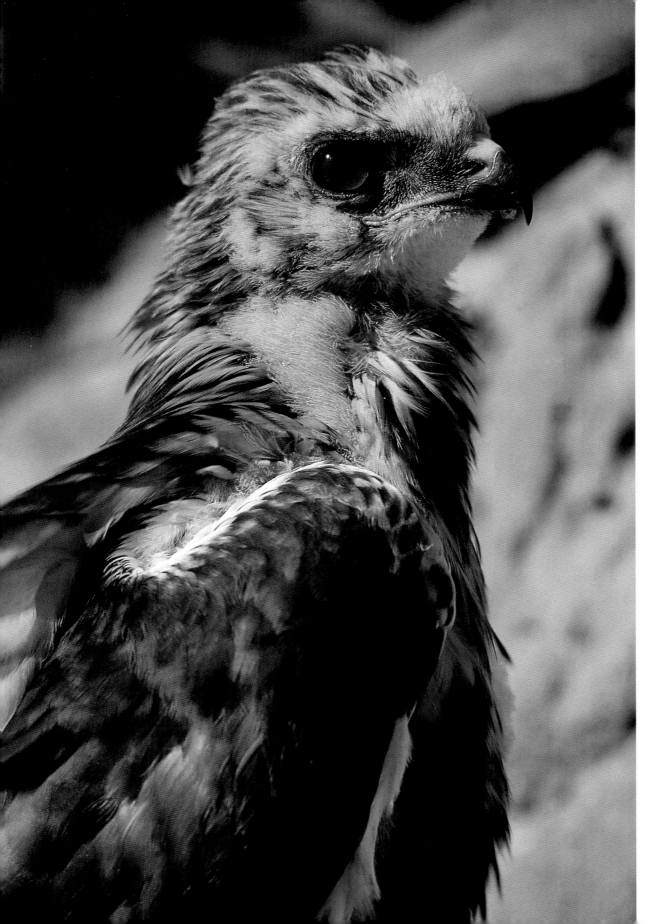

Above: Usually solitary, some Yukon bald eagles are known to congregate in Haines, Alaska during salmon spawning.

Left: Juvenile rough-legged hawk.

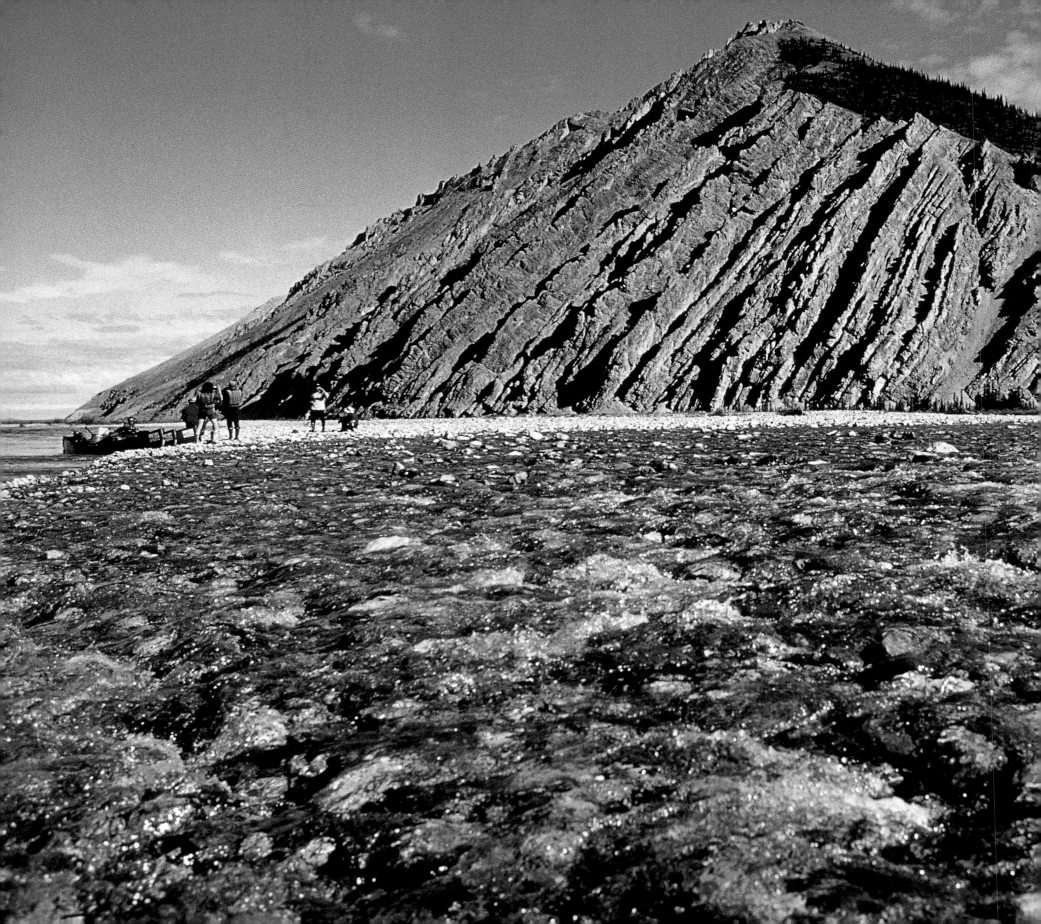

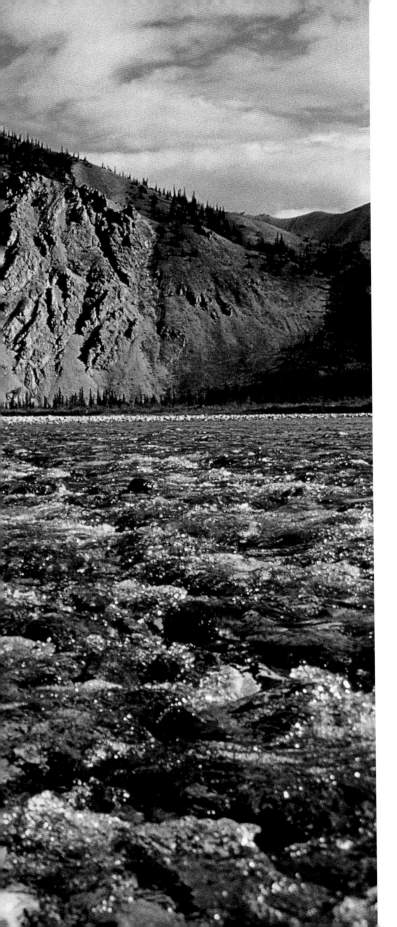

THE WIND RIVER

Even in a land of clear-flowing rivers, the translucent blue-green waters of the Wind stand out. Flowing over a never-ending carpet of cobble rocks and sand, the Wind River passes between gnarled limestone ridges intersected by twisted creek canyons which beckon hikers and slides past huge alluvial fans and dryas meadows offering idyllic camping. Dall sheep can be seen at the mineral licks next to the river.

The Gwich'in regularly travelled the Wind and knew it as *Tr'inlintr'ali Njik*, "always blowing creek." In 1899 they helped a group of gold rushers headed for the Klondike who spent a winter on the banks of the lower river. The ill-fated Lost Patrol of the Royal Northwest Mounted Police came to grief in this country.

WOLVES OF THE WIND RIVER

By Brian Brett

The wolf looked at me.

I was driving north to Dawson City during breakup. A meandering creek had cut new channels through a large meadow-swamp—empty except for this creature near the highway.

I steered my car onto the road's shoulder. The wolf was straddling a brook, staring at the water with a palpable intensity. It was the gaze of a hunter—the wolf so focused it didn't notice my car barely 30 feet away. Then it looked up at me.

Left: Limestone ridges along the Wind River.

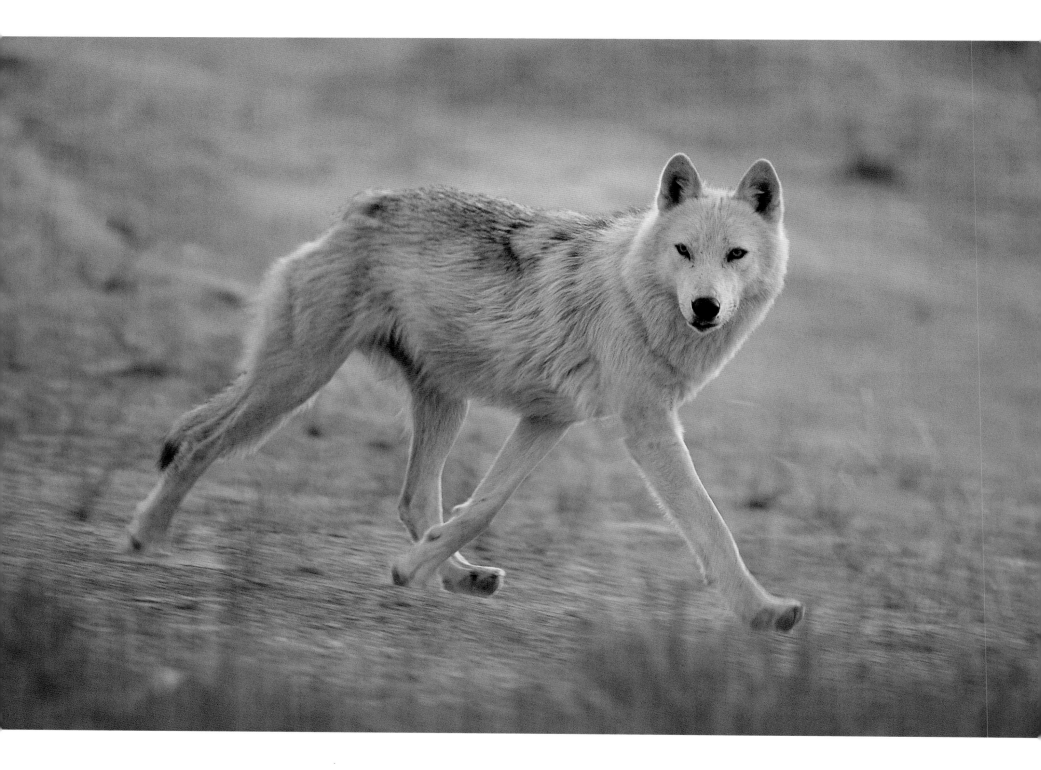

I was paralyzed by the power of that gaze. The wolf is born with blue eyes which later change to gold—though some may have a greenish or brown tinge. This wolf had the golden, uncompromising knowledge of the owl's eternal question in the lost hours of the night. "Who are you?"

Finally, I broke away from its stare and nodded ironically, like one jaded hunter to another. Feeling intrusive, I put the car into gear and pulled away from this alien power straddling a rivulet and, I suspect, the grayling trapped there.

That brief episode was one of the instructions of my life. I knew instantly I would never understand total attention. The art of "being there." An art most animals inherit naturally, one we discarded when we discovered language and consciousness.

Five years later I found myself on the Wind River expedition organized by CPAWS. At present it's a wild river. There aren't many left. One day we discovered an old campsite on a bluff near the river. Inside the stone fire ring was a lump of wolf scat, as obvious an opinion as you can get.

Later we arrived at a huge tundra plain ringed by coloured mountains flanked with rubble. Ferocious creeks raged between the mountains, channels thick with marble and uranium. In the afternoon various parties from our expedition disappeared into the mountains, to a salt lick at their base, and to the creeks. While tundra is flat to the eye, the constant freeze and thaw of the land creates a lumpy surface, often too rough for a spoiled camper's Therm-a-Rest mattress. After fiddling with the precise locating of my tent on the flattest turf on a frost-heaved hill, I found myself alone and decided to set out after the others. I was less than a mile from camp when I noticed something moving on the tundra.

Wolves.

There were four of them—three of them mottled, one black—leaping, lunging over each other, displaying all the wonderful gestures of pack behaviour. The ambush, the chase, the fake defeat, the bowing. It was right out of the textbooks: the flattened ears, the grins, the glance over the shoulder before the lunge at the pack mate.

I was enthralled.

The wolf speaks with every muscle in its flesh, as do most other creatures living beyond the sense-deadening statistical overload we mistake for knowledge, which for us has become a way of avoiding knowledge. Our speech has become Michael Jackson marginalia and shallow political sound bites. Real knowledge lives all around us—in the smell of protein in a blade of grass, in the way moss grows on trees, in how spruce gum will heal wounds, inside the eye of the wolf. The wolf uses gesture the way we use our mouths. Its entire body is a tongue, a voice that can tell stories we are too shallow to learn, a voice that speaks the stories we have lost. We have yet to understand the "simple" complexities of how to speak wolf.

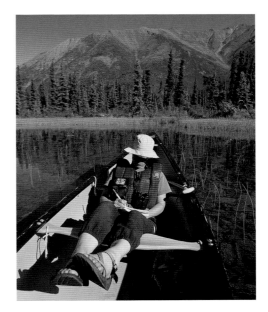

Top: Teresa Earle takes a break away from the mosquitoes on McClusky Lake.

Bottom: An endless variety of stones carpets the banks of the Three Rivers.

Opposite: Long-legged grey wolves can traverse huge expanses of wild country, and typically hunt over a 100-square-kilometre area.

Top: Fringed grass of Parnassus is a common flower of meadows and stream banks.

Below: Authors Peter Lesniak and Brian Brett out for a leisurely paddle on McClusky Lake.

As their play fights continued, the wolves were coming towards me. But now they shifted into hunting mode, stalking something, yet sporadically—none of them could resist a rollover or a snap at a tail. I wondered what they were hunting on this huge plain.

Then I realized the wolves were hunting me.

Despite my pretensions to a wilderness history, I am such an ignorant urbanite that it was several seconds before I understood I was the prey. This upset me. Wolves are not supposed to hunt people. It goes against all I have read. As far as I know, there are no recorded wolf attacks on humans, though Native people say that in unrecorded times they were hunted by wolves.

The wolves spread out, playing, stalking. Weird. Is this the way they hunt? Is the kill a form of play? I watched them quarter, regather, move closer.

My mind started opening all its files on wolves. *Of Wolves and Men*, a classic text by Barry Lopez—my favourite book about wolves. Farley Mowat's benevolent mouse-eaters. Jack London's mythical beasts ripping the lungs out of Yukon trappers. Werewolf stories. *Loup-garou*. The Native claims of pack attacks that might merely be a storied variation on all the Wild West tales of cowboys defending themselves with their trusty Winchesters.

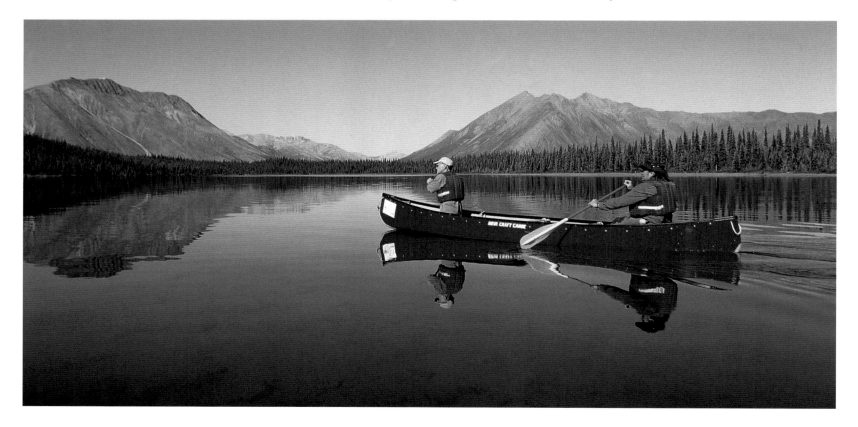

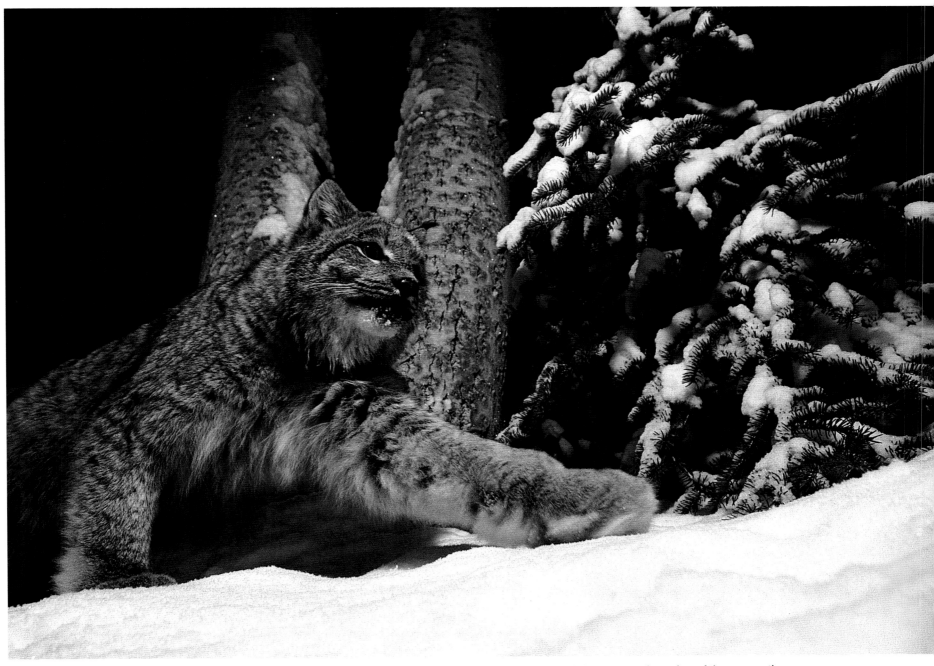

Huge paws help lynx stay on the surface of the snow as they pursue hares and other prey in nocturnal hunts.

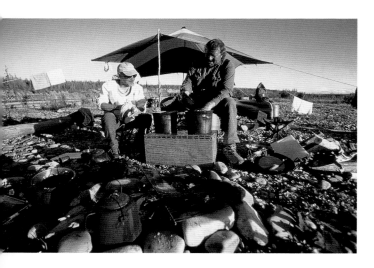

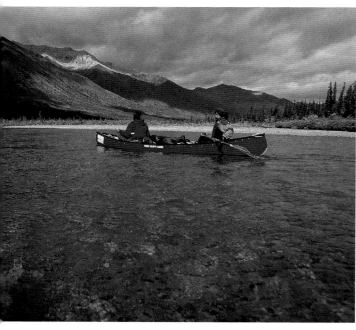

Top: Peter Lesniak and Brian Brett wash the dishes.

Bottom: Elaine Alexie and Michael Belmore paddle the iridescent waters of the Wind River.

Opposite: Photographer Fritz Mueller catches the evening light on Mt. Royal.

I suddenly understood the many vicious attempts to exterminate the wolf across North America and in Europe. The first recorded extermination of wolves was in 1750 in the Scottish Highlands where a clan chieftain, Lochiel, hunted them down because "they preyed on the red deer of the Grampians." No mention was made of who else was preying on the red deer. One can only assume it was Lochiel.

The tundra plain was so vast it was hard to calculate distance. But they were coming fast. "I'm going to be attacked."

The saner part of me insisted: "Wolves don't attack people, especially in the afternoon on the naked tundra." They kept coming, bounding over each other, snapping at ears, huddling together, then spreading out, slinking, stalking, leaping into the air.

These were the goofiest wolves. If this is how they hunt, it's a miracle they hadn't starved to death before now.

Our awareness of wolves goes back to earliest history. Twenty-thousand-year-old cave paintings in southern Europe contain images of wolves. A wolf is mentioned in *The Epic of Gilgamesh*, the earliest recorded poem. During Aztec burial rites the bone of a wolf was used to prick a man's chest. Wade Davis recently wrote about a Native's gift of a sacred (to him) bone tool used for skinning out the eyelids of wolves.

This made me remember the stories of wolf hunters from the era when myths thrived about wolves devouring too many wild game and livestock. Ernest Thompson Seton was led to his destiny as an animal lover when he tracked the legendary Currumpaw wolf, Lobo. This wolf was so smart he gathered Seton's widely-spread and obsessively-disguised poisoned baits into a pile and shat upon them. Then, when his mate, Blanca, was killed, he walked right up to the ranch house where her body was being kept and stepped into four traps. Seton chained him up and left him for the night. The next morning, though unharmed physically, he was dead, and Seton laid his body alongside his mate. He'd learned a lot from that wolf.

Aldo Leopold was inspired to write *A Sand Country Almanac* after he shot a female wolf among her pups. "We reached the old wolf in time to watch a fierce green fire dying in her eyes." That green fire changed his life, as he wrote in "Thinking Like A Mountain," the article that outlined how the extermination of wolves was changing the ecology of North America for the worse. It was one of those great short works of contemplation that altered how we think about the world.

The wolves drew closer.

The plains tribes hated wolf poisoners because the dying slobber of the wolves would dry on the grass and prove poisonous to ponies and wild game "months or even years later." The tribes were so angered by this brutal mistreatment they often retaliated with war parties. That never stopped the bounty hunters, ranchers, and government agents who poisoned, clubbed,

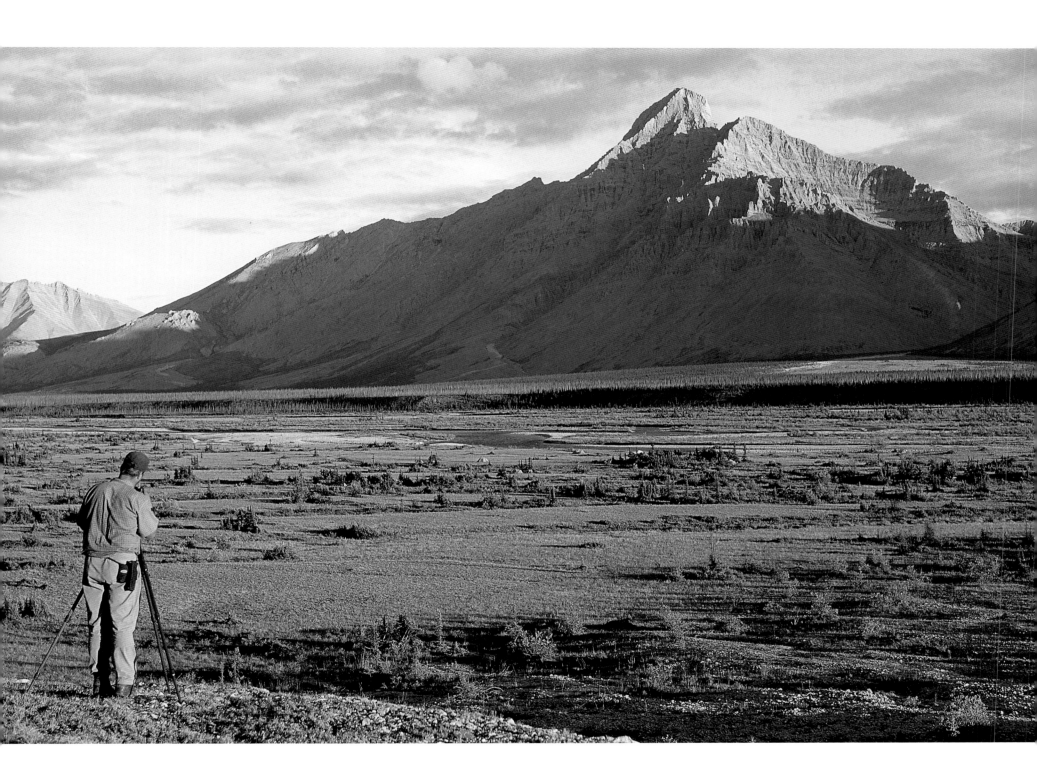

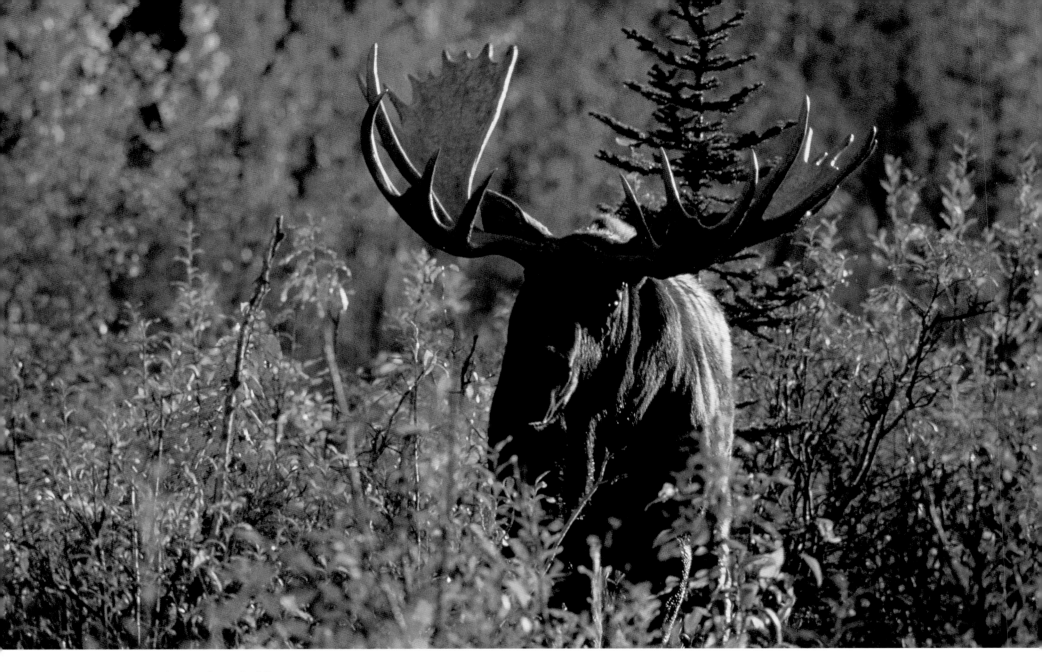

Above: Bull moose during the fall rutting season.

Right: Black bears mainly frequent the lower plateau country of the Three Rivers, leaving the high mountains to the grizzly bears.

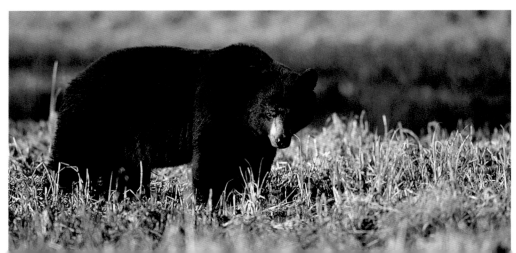

set on fire, trapped—even inoculated with mange—hundreds of thousands of wolves in North America. In Montana alone, during one twenty-five-year period more than 80,000 wolves were slaughtered.

A wolf can cover 125 miles in a day and sprint at 45 miles per hour, which is just about what these wolves were doing on the tundra. The Pawnee claimed long ago that they moved like liquid and their hearing was so good that they listened to clouds passing overhead. Their ears have the range of porpoises and bats. It's believed they can hear mice under snow. No wonder they are good hunters and so admired by the many Native tribes who adopted them as spirit symbols. The Kwakwaka'wakw believe their people were wolves before they became men and women. The Arikara claim the Wolf-Man created the Great Plains for them.

The wolves rushed forward. I saw a stick lying on the ground, a rotten branch, but it was a weapon. A weapon! I bent down and picked it up.

They stopped in their tracks. I had broken the trance. The wolves stared at me, wondering about this tree-clutching, two-legged caribou. Then they turned back. Cravenly, I also backed away, returning to camp, unsure, looking over my shoulder at the fleeing wolves. The spell was over.

Above: These red-fruited cup lichens show the rich diversity of the boreal forest floor.

Left: Woodland caribou forage on reindeer lichens year-round.

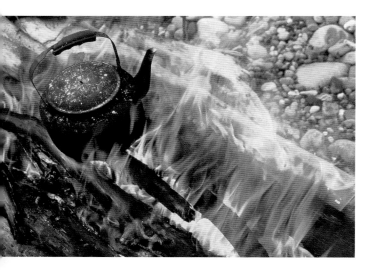

Top: Cowboy coffee boiling hard.

Bottom: Dempster Colin, from Ft. McPherson, scans for wildlife grazing in the alpine.

Opposite: The Wind River valley is known for its broad grassy terraces and huge alluvial fans.

It turned out they were just pups, not fully grown, at most twelve weeks old, parked at a rendezvous point by the hunting pack. I hadn't been able to tell their size because of the expansive tundra. I learned later that Jimmy Johnny and Fritz Mueller, members of our expedition, had filmed the entire silly encounter from a hiding place on the hill above the salt lick.

Barry Lopez talks of sheep kills and moose kills in *Of Wolves and Men*, of how species of animals live apart yet hold a magnificent conversation among themselves. He talks of the spiritual, biological nature of the hunt in the wild and how when a wolf falls upon sheep it is surprised by their idiot panic. "The wolf has initiated a sacred ritual and met with ignorance." Startle a flock of sheep, then startle a herd of antelope, and you will see the difference. We've bred the wilderness out of the sheep and left behind only a shopping mall mentality. The sheep fail to communicate "resistance, mutual respect, appropriateness—to the wolf." And so the wolves react madly to the madness they encounter among livestock.

I had just turned into a sheep. I knew as soon as I picked up my stick I'd done something wrong. And the guilt accompanied me back to camp, reminding me that we no longer live in the wilderness any more, we only go to the wilderness. I was an alien here.

Sure, I'd wanted to tell the others about the wolves—some members of the expedition who'd been up the river had undoubtedly returned to our base by then—but in reality I was insecure, clutching my pathetic, wooden sword that merely proved I could never pay attention. I had been driven back to my fire by a pack of ferocious ankle-biters.

A night later I heard howls on the tundra, waking me in the dark. The adults had returned. The next day there was no sign of the cubs. The parents must have realized that we'd invaded their rendezvous and hustled their offspring away.

This got me thinking about the wolf scat in the old fire pit, and Seton's defiled bait. The contempt.

We don't know the wolf, but the wolf knows us.

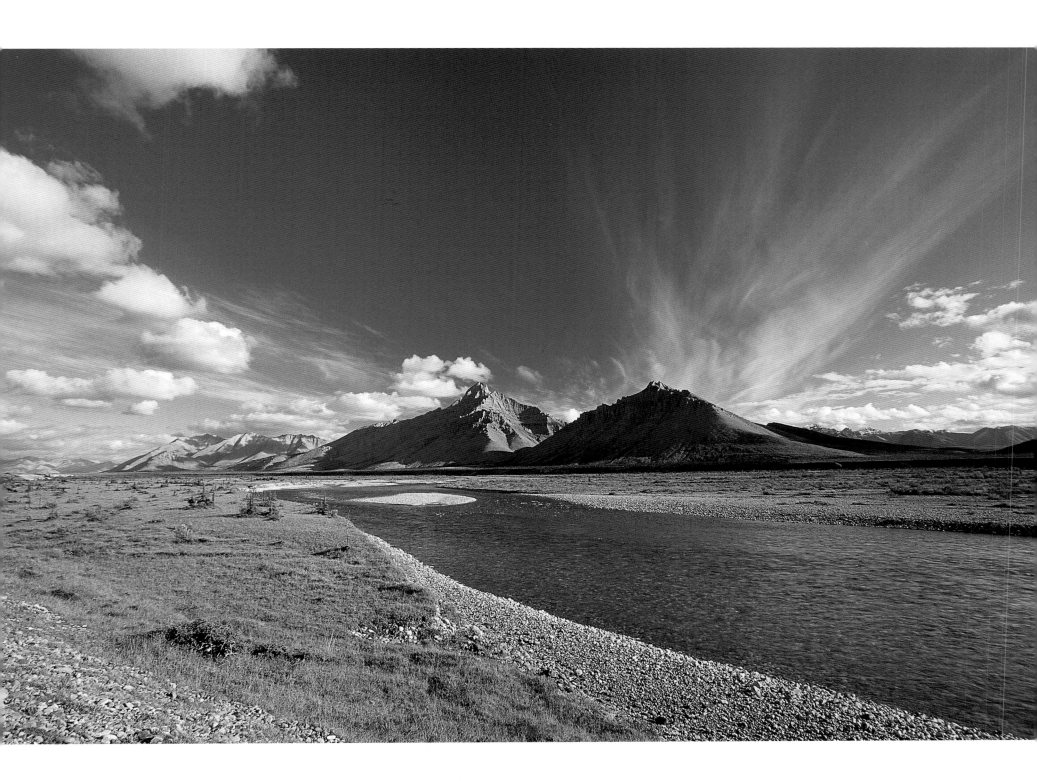

Above: Gwich'in activist Elaine Alexie with a grayling.

Opposite: December sun at noon in the northern boreal.

MY COMMUNITY, MY PEOPLE

By Peter Lesniak

With her tattoos and piercings, Elaine Alexie may look like any other modern twenty-four-year-old, but this staunch environmentalist has one foot firmly planted in her aboriginal past. Unlike many of her southern contemporaries, she much prefers whitefish and caribou to pasta and tofu and says meat is essential to her well-being, as it was for her Tetl'it Gwich'in forbears. On our canoe trip down the Wind River, she packed along a generous stash of dried fish and meat for emergency snacks; the rest of us made do with energy bars.

Born and raised in Fort McPherson, Alexie has travelled around the world to spread the twin gospels of sustainability and biodiversity. As a member of the Gwich'in Steering Committee, she has lobbied politicians in Ottawa and Washington to protect the Alaskan calving grounds of the Porcupine caribou herd from oil drilling. In 2003 she was the only Canadian youth at the World Summit on Sustainable Development held in South Africa.

At the two-day elders' gathering, held on a sandbar at the confluence of the Snake and Peel rivers at the end of the Three Rivers Journey, Alexie helped present a youth declaration which opposed any industrial development that might threaten the lands and waters of the Peel Watershed. "We oppose the actions of government agencies and corporations which promote the idea that the land is to be exploited to supply a global continental energy demand using non-sustainable practices that contaminate or destroy the natural world, species and habitats, sacred sites and our communities and homes," she said.

Because her people have used this watershed for thousands of years—it is dotted with their sacred and burial sites—she insists that they must participate fully in any policy decisions affecting their traditional lands. After all, they have the most to lose if changes destroy their way of life, which still relies heavily on subsistence hunting, fishing and gathering. "Our culture, our identity, our ideology as a people comes from the land. It's who we are," she says, adding that her people's ability to live off the land is fundamental to their physical and mental health. "They say the land is a healer; you go out and you come back a totally different person. It gives you perspective and you're rejuvenated."

One of Alexie's latest projects is the Dene Youth Alliance, a grassroots network of aboriginal youth across the Northwest Territories that is working closely with the worldwide Indigenous Environmental Network. The group's issues include the proposed Mackenzie gas pipeline and industrial projects such as diamond mining and forestry. "If you go into the communities, all you see is the one-sided perspective that industry is showing to our people," she said. This is the land of her ancestors, she emphasizes, and most of her people aren't about to relinquish control without putting up a fight. As a sovereign nation, the Tetl'it Gwich'in people have an inherent

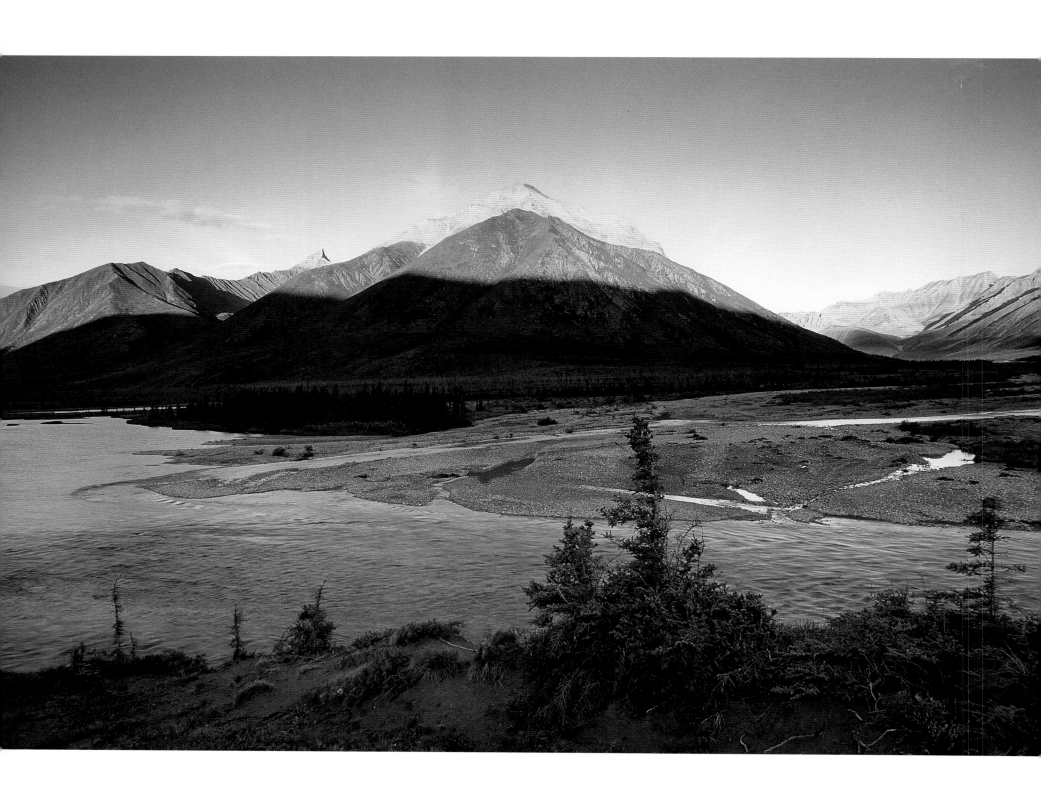

right to self-determination as guaranteed in their treaties and land-claim agreements. "We must be consulted regarding any and all appropriation, commercial use and/or intrusion onto our lands, ecosystems, waters and natural resources. We reserve the right to say no.

"I've learned that what I'm doing now is what I'm supposed to do in my life," says Alexie. "This is the role I have to play in my community, with my people."

Adapted from an article which appeared in the *Yukon News*, 2003.

REMEMBERING THE WIND

By Peter Lesniak

Ghosts haunt the 200-kilometre-long swath of mountains, tundra and taiga that is bisected by the opalescent-blue waters of the Wind River. Listen hard and you can hear them whispering from the canyons, cliffs and beaches as you paddle down this tributary of the fabled Peel: Native people hunting for fish, game and furs; European explorers seeking the Northwest Passage; stampeders heading for the Klondike; Mounties praying for deliverance from hunger and cold; big-game hunters stalking trophies; modern-day prospectors hoping to hit the motherlode.

May Andre, 58, one of three Fort McPherson people in our group, hears ghosts as she stands for the first time at the confluence of the Wind and Little Wind rivers, thinking about her father, John Robert. "He was born around this area, more than likely, and lived here year-round with his parents, brothers and sisters, hunting and trapping," she says. As a young man, he built a tiny cabin in the bush and lived there alone during the trapping season, only going to Fort McPherson or occasionally Dawson City to sell his furs or buy supplies.

He never went to school and spoke little English, but Andre says he travelled all over this land by dog team and on foot. "He loved the clear water and the land, but especially the clear water. He was really healthy and strong. Though it was a tough life, he didn't complain." After marrying he spent more and more time in Fort McPherson, but she remembers fondly, as a girl of eight or nine, listening to him talk about the Little Wind, where life was less complicated than in the community with all its frustrations and temptations. He was not a perfect man by any means, says Andre, "but he was a really hard worker and a good provider." He died when he was "ninety-something," four or five years ago.

May Andre still spends as much time as she can at a fish camp on the Peel, where she smokes and dries fish for her relatives and friends, and she brought along a big bag of her fish for us to

Above: May Andre heard her father tell many stories about trapping on the Wind and Little Wind rivers.

Opposite: Bond Creek, a major tributary of the Wind River, is named after the first trophy hunter to visit the Peel Watershed.

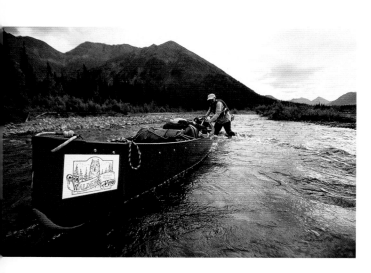

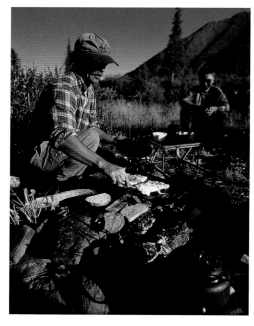

Top: Author Peter Lesniak walks a canoe down the shallows at the start of the Wind River.

Bottom: Guide Blaine Walden cooks eggs and toast as Peter Lesniak looks on.

Opposite: The Peel Watershed can catch the brunt of arctic fronts headed south.

try. She marvels at the Wind's beauty and how clear and wild it still is, even though prospectors have scoured its peaks and slopes since the 1920s. "It's unbelievable," says Andre. "We have something here that money can't buy and it should be protected—not only this river but the other two as well."

⁓

Adapted from an article that appeared in the *Yukon News*, 2003.

WALDEN'S WILDERNESS WAYS

By Peter Lesniak

I think I know why Blaine Walden, our lead guide, always seems so inordinately cheerful; he spends most of his time doing what he loves best, canoeing and dog-mushing. I don't know how he lost his middle finger, but I vow to find out before our trip is over.

With an enviable knack for making everything from cooking to packing look easy, Walden cannot see himself doing anything other than guiding until he gets too old and feeble to paddle a canoe or drive a dogsled anymore. He has been taking small groups of paddlers down the Wind River for a dozen years. The keeper of its secrets and treasures, he knows the best camping spots, where the dangers lurk and the grayling bite, and where shell fossils, quartz crystals and blueberries can be found in abundance. He is on such intimate terms with this landscape you almost expect him to have pet names for the grizzlies, wolves, moose, caribou and sheep.

His clients travel from around the world to experience an increasingly precious commodity—wilderness—the real deal, not some gentrified park version with its vigilant wardens, designated campsites, and marked trails. "We can go down the Wind River and not even see an old campfire ring anywhere. Generally, you don't even see any other groups," he says. "To have those opportunities to travel through an area for days or for weeks and not see a town, a bridge, or any type of man-made structures. . . to see the environment the way it probably always has been, you know, the way all of the North used to be. . . it's kind of like stepping back in time."

Walden has also worked in British Columbia and Alaska during his twenty-two years of professional guiding. He says even America's least-violated state has "gone beyond what we have in these valleys now. . . whether it's tourism or homesteads, they've just been developed so much more."

To help ensure that the same thing does not happen here, he helped found the Wilderness Tourism Association of the Yukon in 1993, a non-profit group that deals with the host of issues

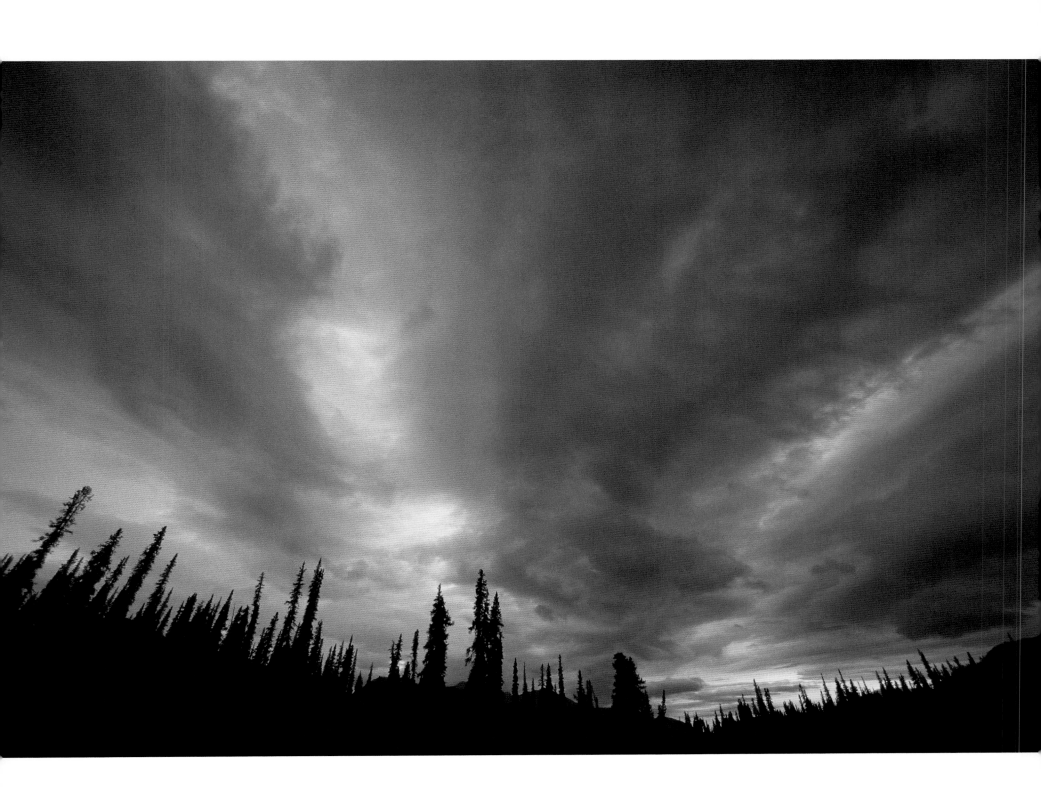

Above: "Rainbow of a river in one colour" are the words poet Brian Brett used to describe the endlessly shifting tones of the Wind's azure waters.

Right: The capitate valerian, with its ball-shaped cluster of flowers, is found in moist mountain meadows.

facing the rapidly expanding wilderness-tourism sector of the territory's economy. Though mining has been up and down, tourism has been a steady Yukon industry for many years, accounting for more than $160 million in yearly revenues. Wilderness tourism makes up a big part of this total, directly employing about 400 people. "It's probably always been the biggest private sector employer. And it's probably going to be that way in the future," he says.

Walden is not advocating against any development in the Peel Watershed; he just wants careful planning so that the area's immense recreational potential is not destroyed. He sees the rivers in the Peel Watershed as "a long-lasting, sustainable economic generator," if they can be maintained as they are now. "The remote rivers are really our ace in the hole, and it's really critical that we maintain them for our industry. . . . I think the average Yukoner just doesn't quite understand that at this point. Everybody wants sustainability. And tourism really is sustainable. Mines provide huge benefits over the short term, but in a matter of years they're gone, whereas tourism—when done properly—can allow things to remain relatively the same. But we've got to really watch we don't grow so big that we lose what we have."

Wilderness tourism has enormous potential both for the North's First Nations, who can establish guiding companies in their traditional lands, and for any neophyte entrepreneurs without a lot of money. They can start small and grow slowly, as Walden did with his own company. If he has a dream, it is this: "I don't have any children, but wouldn't it be wonderful, when I get too old to go down those rivers, if I could turn over my paddle to some twenty-year-old kid and he can go down those rivers and they will be exactly the same as when I made a living off them?"

And the story of the missing finger? He likes to tell that one when a client has complained once too often about the weather or the bugs.

It happened more than two decades ago in a remote corner of northern British Columbia during a rafting trip that went terribly wrong. He and his girlfriend at the time were left stranded with only a sleeping bag and no food for nearly a month. He cut off the finger himself to halt the spread of gangrene, using just a pocketknife. No anaesthetic. Not even an antibiotic. But you'll have to get the full story from him yourself. Besides, he tells it much better than I ever could, especially after he's had another great day on the water or the trail, deep in the wilderness he loves more than anything—despite the fact it almost claimed him forever.

Adapted from an article that appeared in the *Yukon News*, 2003.

WIND RIVER BLUES
By Brian Brett

Blue that I don't understand,
river I will never know.

what are the words for you?

Rainbow of a river in one colour.

azure blue cobalt
 ultramarine sapphire
cerulean indigo aquamarine
 turquoise lavender

All the colours you are moving
through dawn and darkness.

A tongue of water lapping
against the cinnamon shoreline.

Blue of a robin's egg,
 blue like the sky,
 midnight blue,
 cold blue,
 blue-eyed water,
 Mediterranean blue,
 navy blue,
 blue like Picasso's blue dancer,
blue as the boy baby's basket

There is no way to describe blue water that's
 clean,
 clear,
 uncorrupted.

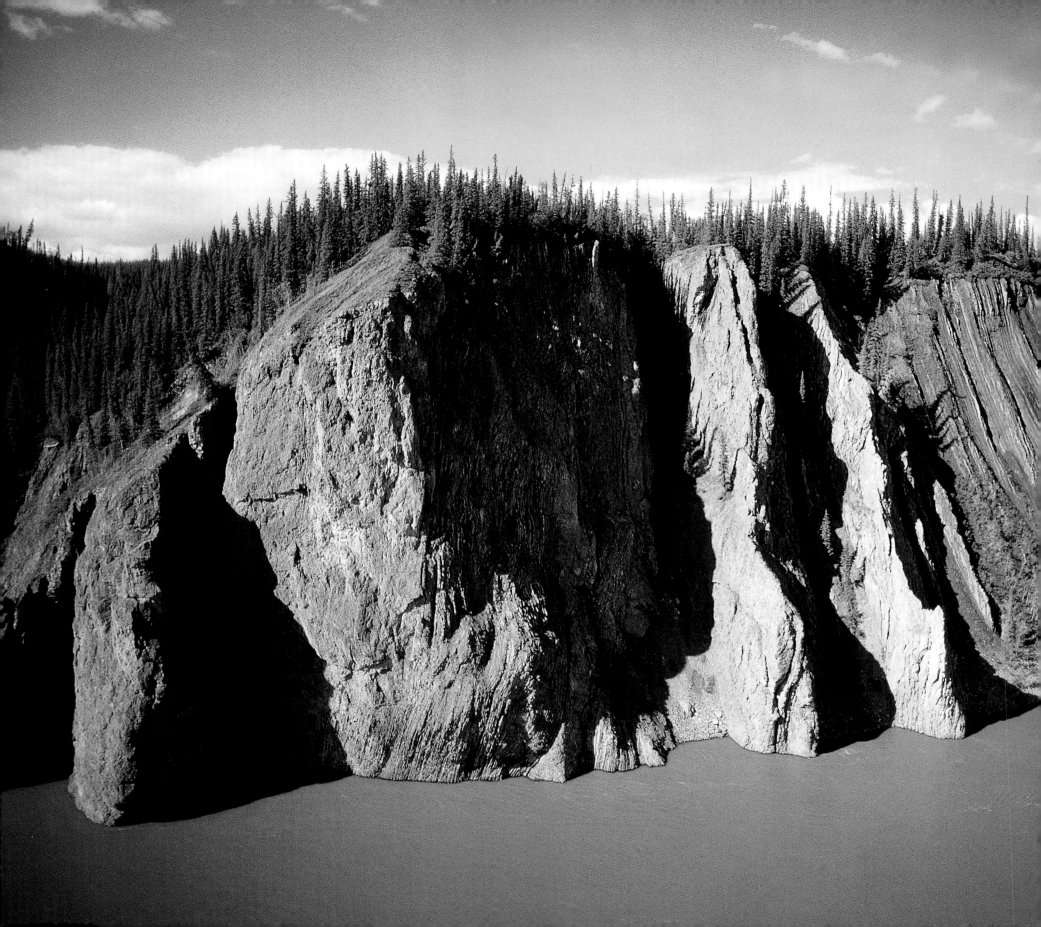

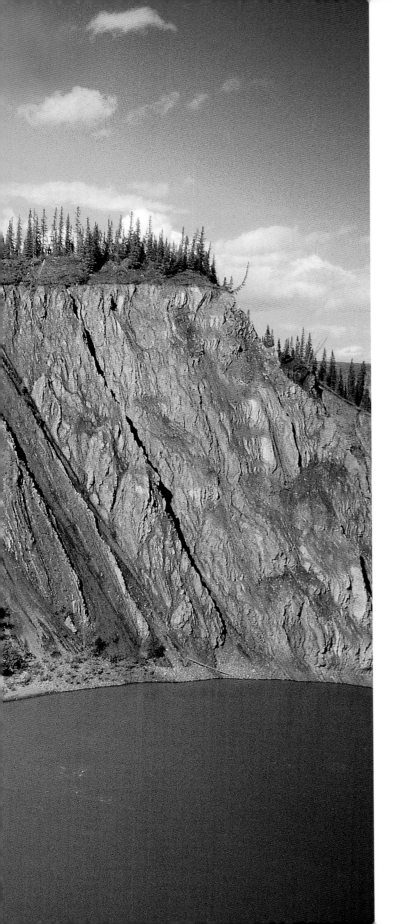

THE GATHERING

By Sarah Locke

On August 6, 2003, as our crew of Bonnet Plume paddlers sets up camp on a gravel bar in the Peel Canyon, six red canoes float around a corner, dwarfed by the tall cliffs. It's a bittersweet moment, watching the Wind River group paddle towards us. While happy to see old friends and meet new ones, we can no longer deny that our journey will soon end. For the last two weeks, each party has been floating through this wild land enclosed in its own bright convivial bubble, self-contained pods skimming down the rivers. Only this morning our group was weaving through the delta of the Bonnet Plume, engrossed in the search for clear channels. Now it is time for convergence.

Our greetings, echoing between the canyon walls, seem a slight breach of manners, verging on the unruly. Hushed voices might be more appropriate in this sanctuary, where geology has been transformed into art. Across the river, crushed and crumpled rock bends back upon itself, forming a dark whorl of shale. Fins of rock, standing straight up on end, are painted with sinuous curves and slashes of black, grey, and cream. Hemmed in, confined, the river's dark water swirls in eddies and erupts in boils, demanding attention when one wants only to succumb to the spell of these walls.

Left: The storied Peel Canyon is a major landmark for the Tetl'it Gwich'in.

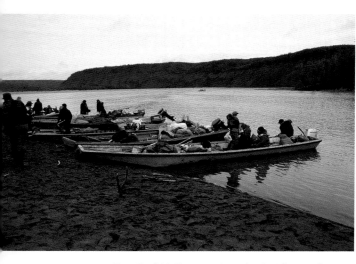

Top: Paul McKay rows into the Gwich'in gathering on the Peel River.

Bottom: A party of Gwich'in and Nacho Nyak Dun ran flat-bottomed river boats 200 kilometres up the Peel for the gathering with members of the Three Rivers Expedition.

Opposite: The Wind River crew at the Peel Canyon camp.

For me, memories from previous trips add more layers to this stark, enchanted beauty: climbing out of the canyon to the screams of peregrine falcons, nesting across the river; our young son's tears when told he must portage the Peel's last rapid instead of riding in the canoe with his parents; the vibrant stories of Gwich'in elder Neil Colin during last year's trip.

This year's drama has been building in the skies all day, and by evening an arctic front is upon us, its strength magnified in the confines of the canyon. Together with the Wind River crew, we keep watch on the rising water levels, pull the boats higher on the beaches and batten down our tents more securely, but mainly we huddle together under a network of tarps, trying our best to stay warm and dry.

Only the young Gwich'in members of the party, Robert Mantla and Elaine Alexie, venture out into the wind and rain for any length of time that night. Their ember-red jackets billowing like sails, they fish from a rocky point of land where they are exposed to the blast of the storm, throwing Elaine's homemade fishing reel—a Kool-Aid can with string wrapped around it— time and time again into the now invisible waters of the Peel.

Their ancestors lived in a world full of challenges, and this canyon was the very symbol of danger for them. At high water, a powerful eddy line crosses the river from one rocky promontory to another, dividing the river into two giant whirlpools. The Gwich'in called this canyon *Tshuu tr'adaojìich'uu*, rough hateful water.

But the water is not high now, and the next morning, we paddle easily out of the canyon to discover that last night's storm has dusted the hills with snow. Now cold rain soaks us. This does not bode well for the elders' gathering, which is supposed to mark the end of the Three Rivers Journey, and we continually debate the odds. What are the chances that the Gwich'in will leave their warm homes in Fort McPherson, pack up their boats, and travel 200 kilometres up the Peel to meet us? Even if a few make the trip, will any elders come along?

A day later, as the Peel's confluence with the Snake River comes into view, we have our answer: we had too little faith. The Gwich'in were not about to stay home. Joined by visitors from Mayo and a few northern politicians, more than sixty people made the journey in a fleet of large, flat-bottomed scows, spending anywhere from eight to sixteen hours working their way upriver to meet us.

Some have brought their rifles, and they welcome us with a volley of gunshots, the traditional greeting in this part of the world. "Hoo-hoo! Gwich'in welcome!" calls out Jimmy Johnny, who is shooting video, documenting our arrival at the symbolic end of the Three Rivers Journey. In the old days, protocol would have demanded firing a return salute, but no rifle is handy, so we wave for the camera instead.

Cowboy hat planted on his head, Jimmy has trained his camera lens on Debbie Buyck, forty-one, a Nacho Nyak Dun, who is pulling at the oars in our raft, manoeuvring it across the eddy

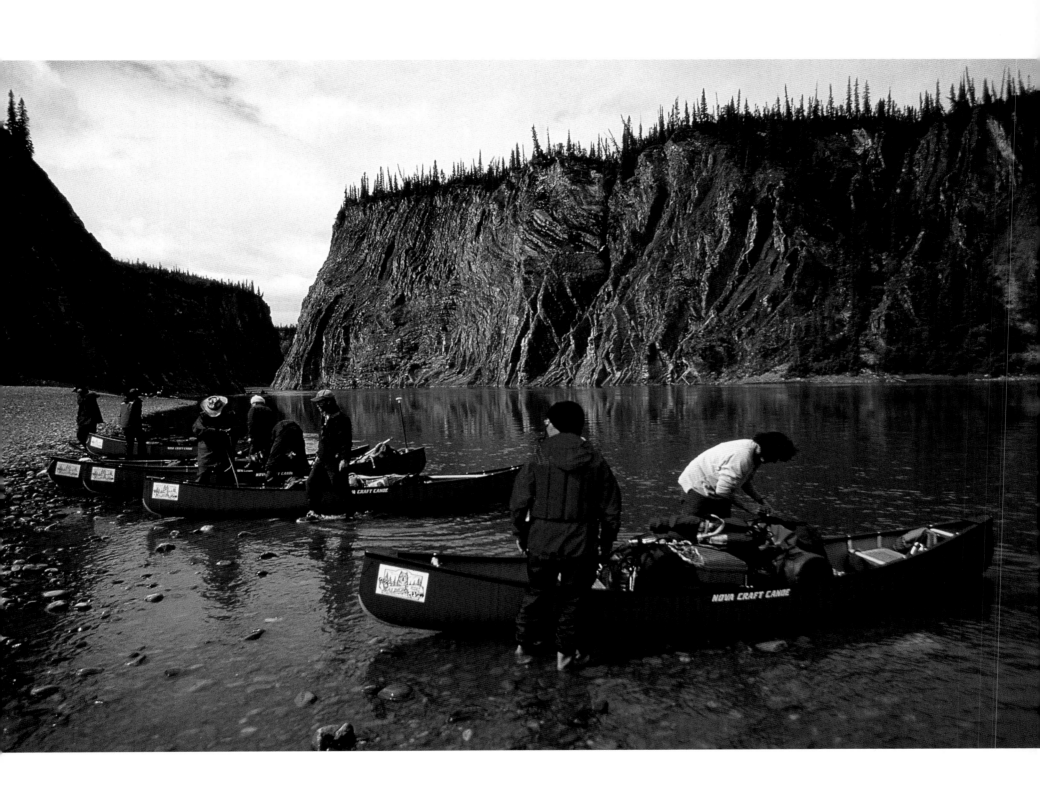

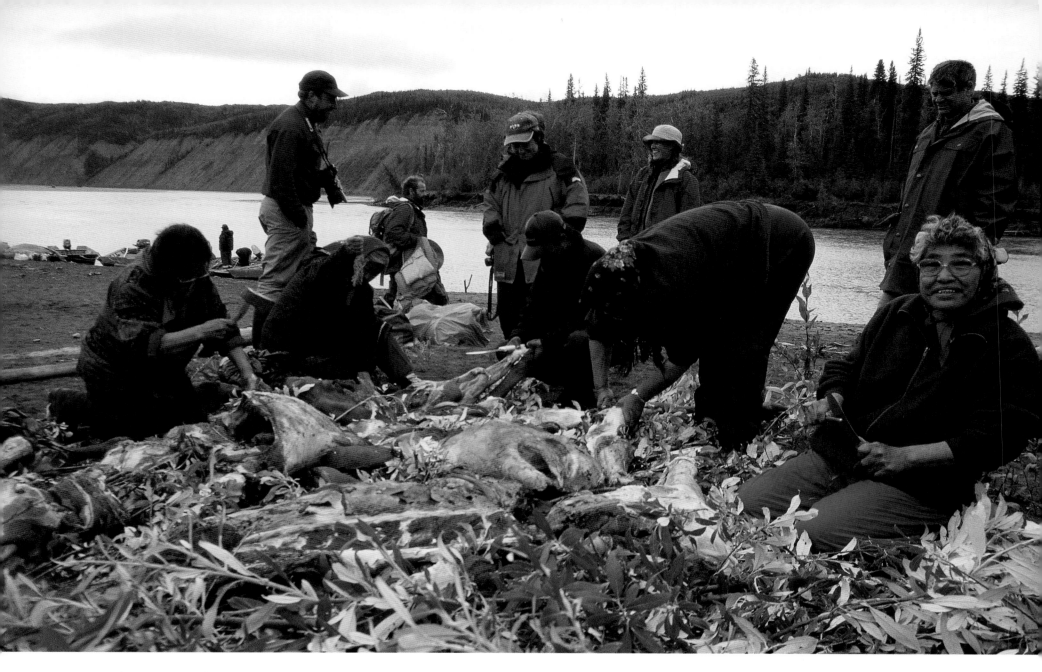

Above: Gwich'in elders prepare the moose meat on a bed of willow boughs. Hannah Alexie on the right.

Right: Pots of moose meat stewing at the elders' gathering.

line separating the Peel from the Snake River to join the tangle of boats pulled up on the gravel bar. Debbie is ending her first trip into the traditional territory she has always heard about and cannot wait to join the making of a feast out on the land.

The willow-fringed sandbar hums with activity as people set up frames of spruce poles for canvas-wall tents and haul firewood out of the forest. Soon coffee is boiling hard on the fire, white bread is stacked on crates, and dried duck, whitefish, beaver, and other country foods are laid out on tablecloths of spruce boughs.

Elders in rickrack-trimmed Delta parkas are perched side by side on logs, sipping tea and visiting. Eunice Mitchell arrived yesterday by float plane; it was her eighty-third birthday. She cheerfully recounts how she slept comfortably in her "parkie" last night as her sleeping bag had not arrived. Isaac Kunnizzi, so frail he never emerges from his tent, still entertains visitors with stories of trapping in this area.

Soon a crew of hunters returns from a successful foray up the Snake River, bringing back two moose they shot upstream. The men quickly skin the animals in the forest, hack the carcasses into manageable chunks with axes, and lay these pieces on a mat of branches. Several Gwich'in women set to work on the meat, knives and hatchets flashing, bright kerchiefs fluttering in the wind. For the next two days elder Mary Teya seems never to leave this job. Born in the Mackenzie Delta, raised 100 kilometres downstream on the Peel, she travelled this way once as a small child and remembers peeping out between blankets from her nest in the dogsled. Her grandparents lived their whole lives in the Three Rivers country, and their stories have made it as familiar as a collection of family photos. "You can talk about any place up here, and I know what you are talking about," she says.

Towards the end of the afternoon, another volley of gunshots rings out, and the crowd cheers as the Snake River crew arrives, paddles raised ceremonially in the air. We're all here now, safe and sound, and many hands help relay their river bags to shore. By the time we're done, the first vat of boiled moose meat is ready, and the feast is well underway.

The paddlers on the Three Rivers have been travelling in parallel worlds, each one full of adventure, comradeship, and inspiration. Now the Gwich'in have opened the door on another world altogether, one full of the joy of belonging. They have infused this already remarkable experience with heart and soul, allowing us a glimpse of life in an ancestral homeland. As they now live far downstream of these mountains, among the wetlands of the Peel Plateau, many of them have never been this far up the Peel. But this country still informs their lives, and they all know the traditional tales about stalking sheep among the rugged peaks of the Werneckes and intercepting great herds of caribou with fences made of brush.

In the old days, once the rivers were free of ice, small family groups made their way down from the mountains and met on this sandbar. Swapping tales, they celebrated the end of winter

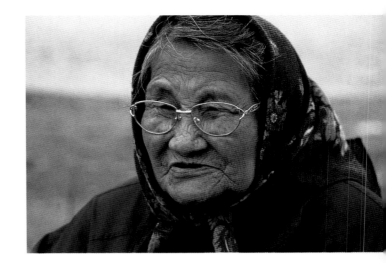

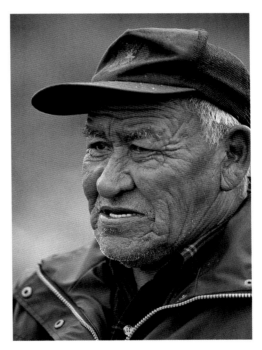

Top: Gwich'in elder Eunice Mitchell celebrated her 83rd birthday at the elders' gathering.

Bottom: Gwich'in elder Amos Francis.

HOW TO COOK A GRAYLING
By Brian Brett

You can gut it, light a fire,
 torch the dry wood,
witness shadows in the flames,
the same shadows seen for six million years.
 A cast-iron frying pan,
butter, a little garlic, some lemon.
 Bread it with hope.
Then sizzle until a flame-tongued sunset
sends everyone running up the hill,
 abandoning the fish,
for a view of the continuous world.
 The gift of the river
 wasted.

Or you can cook it Gwich'in style.
 Throw it on the rim of the fire
and yank it out, bones and guts and all,
 and enjoy....
 When you eat a grayling,
 the grayling is the sunset,
and the running is what the others do.

Grayling from the Wind River.

and built mooseskin boats for descending the Peel. Now once again the sounds of laugher and high-spirited voices carry across the river.

Towards evening, everyone crowds together under large tarps as one speaker after another talks about the importance of the Peel River Watershed. The wind has picked up again and is trying to hurl these strips of nylon up into the skies. People hang onto the bucking edges of the tarps, which are snapping in the wind, competing with the soft voices of the Gwich'in speakers. The meaning of their words carries easily over the storm; a myriad of ways to say "my land," "my country," "we have to protect it." "We can do it!" exclaims Mary Teya.

The morning after the elders' gathering the camp bustles with commotion as everyone packs to leave. Most of the visiting paddlers are flying back to Mayo, though a few are travelling with the Gwich'in to Fort McPherson. Robert Alexie Sr. organizes the flotilla of Gwich'in boats, encouraging people to stay together and watch out for sandbars. He grew up at the mouth of the Trail River, about 120 kilometres upstream of Fort McPherson, and still spends as much time as he can at the family camp there. Taking a break from loading his boat, he talks with pride about the work of his daughter Elaine, who has lobbied on environmental issues concerning her people everywhere from the halls of Washington to the United Nations. While he is happy to let her lead on political issues now, he still expresses his own deep concern about the Peel River and its future. "I care about my country," he says. "I was brought up here and I want to drink that water until the day ends with me. I care about this river more than any place in the world."

People linger over the final goodbyes, but eventually everyone settles into one of the boats, and the Gwich'in fire up their outboard motors and start the long trip back to Fort McPherson. At first those of us left on shore talk quietly, but soon we fall silent as we watch the long line of Gwich'in boats grow smaller and smaller against a smooth curve of high bluffs, eventually rounding the corner and disappearing from sight.

Opposite top: More than 60 Tetl'it Gwich'in and Nacho Nyak Dun joined the 37 Three Rivers paddlers for the elders' gathering on the banks of the Peel.

Opposite left: Three Rivers travellers share their stories.

Opposite right: Gwich'in elder Neil Colin welcomes paddlers to the gathering.

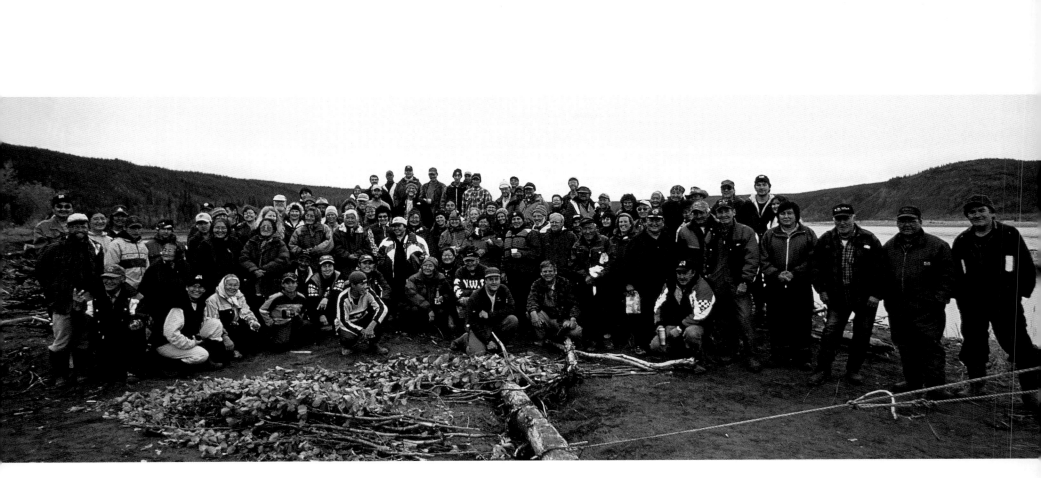

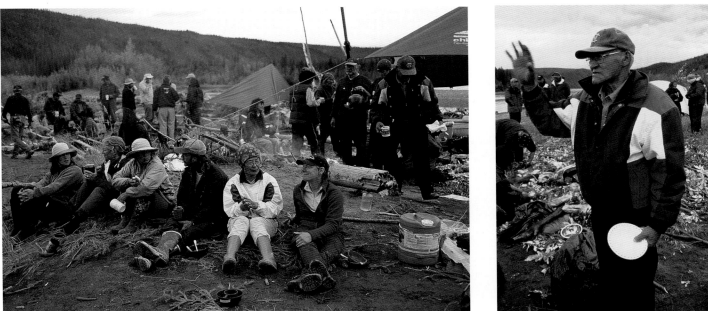

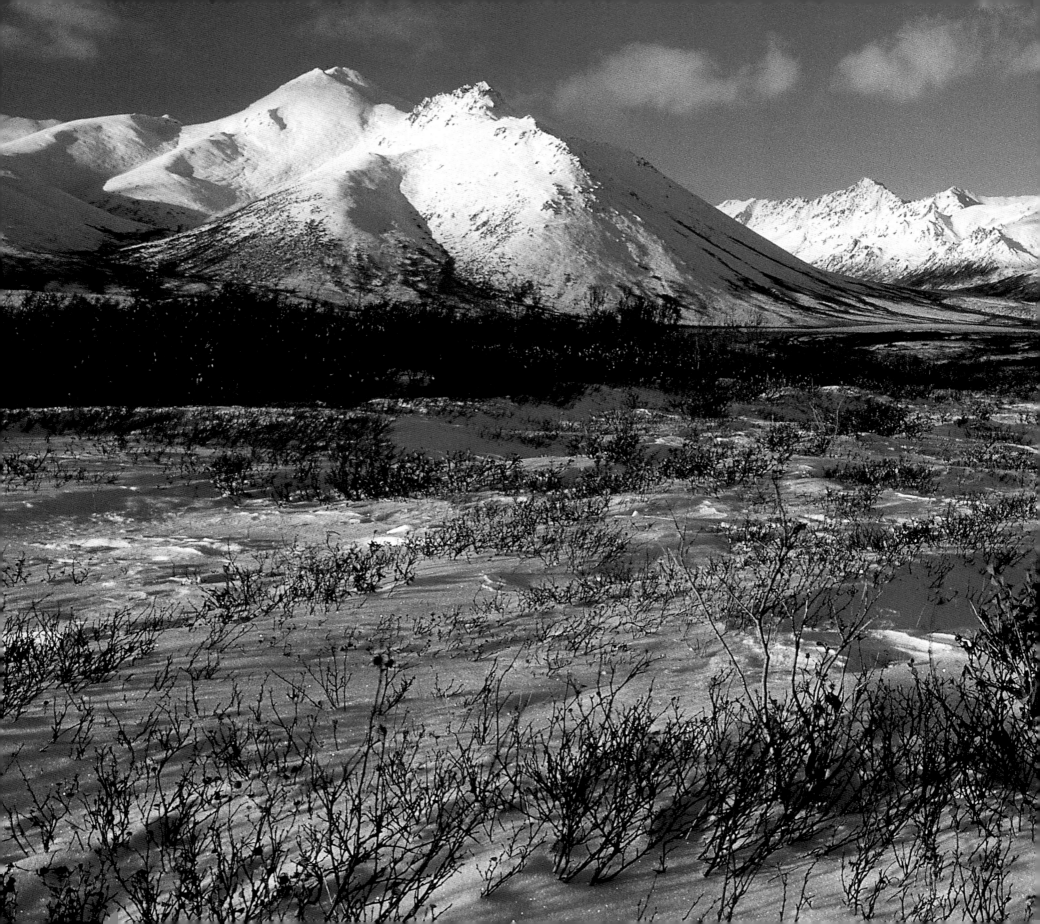

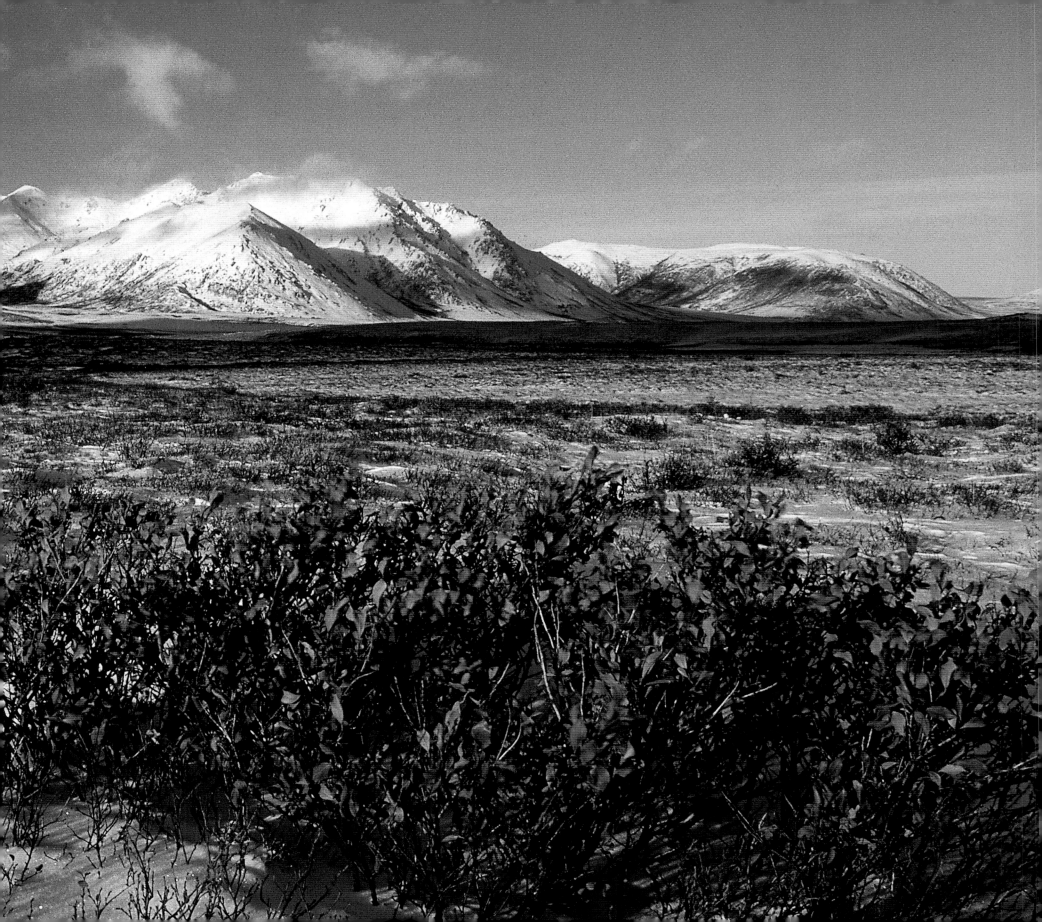

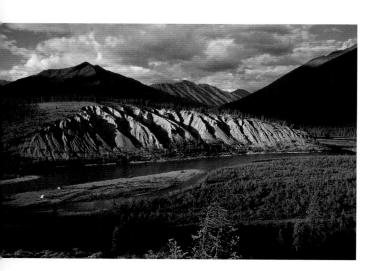

At various times during the past 20 years,
First Nations, territorial governments, local
renewable resource councils and non-government
organizations such as CPAWS have made a
powerful case for a network of protected areas in
the Peel Watershed.

AFTERWORD

By Juri Peepre

When the oil industry cast its gaze northward in the late 1960s and early 1970s Chief
Justice Thomas Berger understood what was at stake. During his public hearings on
the proposed Mackenzie Valley natural gas pipeline, he broke new ground by saying that
conservation areas should be set aside at the same time as any decisions to permit big resource
development projects were made. He reasoned these protected areas would help compensate
for loss of wildlife habitat and the diminished arena for aboriginal people to sustain their
traditional economy. For the North, Berger recommended a new type of wilderness park, one
that would preserve wildlife and natural landscapes but include continued aboriginal hunting
and fishing. Years later, partly as a result of Berger's work, Ivvavik and Vuntut national parks
were established through First Nations final agreements, protecting key Porcupine caribou herd
range and the bounty of arctic and subarctic life found in the northern Yukon. Now, farther
south, the Peel River Watershed offers one of Canada's and the Yukon's best remaining chances
for conservation that is worthy of international recognition to protect its mountain boreal
forests, intact large mammal ecosystems, pristine rivers and unbounded wilderness.

In the days when the people of four northern First Nations—the Nacho Nyak Dun, the
Tetl'it Gwich'in, the Tr'on dek Hwech'in, and the Vuntut Gwich'in—travelled throughout the
greater Peel Watershed, making their living from the wildlife and fish and trading goods with
their neighbours, boundaries had no meaning. Now all four peoples have settled land claims
in their traditional territories, though hammering out these agreements was not easy; it took
decades of Canadian judicial rulings, hearings, broken promises, hundreds of hours in meeting
rooms, and many, many lawyers.

In their 1992 land claim settlement, the Nacho Nyak Dun people, reflecting their desire to
honour and conserve an important part of the Peel River Basin, nominated the Bonnet Plume
watershed as a Canadian Heritage River. Unfortunately, Heritage River designation proved
to be purely symbolic, offering no legal protection. Tetl'it Gwich'in land plans also call for
conservation in the Peel Watershed. In historic times they travelled throughout this watershed,
but now the Yukon border bisects their traditional territory. They live downstream on the Peel
River in the Northwest Territories but still own 600 square kilometres of land in the Yukon and
have been forceful about their right to maintain the abundant clean water of the Peel River that
flows into their territory.

The Tr'on dek Hwech'in territory includes another Peel River tributary, the upper
Blackstone River, west of the Ogilvie Mountains. The Vuntut Gwich'in, based in Old Crow,
Yukon, are part of the Gwich'in Nation spread across the western subarctic. All four First

Nations participate in a regional land use planning commission that began setting a course for the future of the Peel Watershed in 2005.

At various times during the past twenty years, First Nations, territorial governments, local renewable resource councils, and non-government organizations such as the Canadian Parks and Wilderness Society (CPAWS) have made a powerful case for a network of protected areas in the Peel Watershed. Based on the results of mapping and research and motivated by the compelling reasons behind the Canada-wide effort to protect the boreal forest, CPAWS-Yukon is calling for a strong focus on wilderness conservation within this entire watershed. Taken as a whole, it is an exceptional, globally important candidate for a "biosphere reserve," a place where conservation, communities and people can build a lasting economy that respects the way of life and is sustained by an intact ecosystem. CPAWS recommends roadless wildland areas in the watersheds of the Wind and Bonnet Plume rivers and territorial park protection for the Snake River drainage.

During the clamour to build pipelines and drill for natural gas or coal-bed methane, it would be easy to overlook the grizzly bear and wolverine as they retreat to shrinking islands of intact high country. It would be convenient to argue merely for careful management of the Bonnet Plume woodland caribou herd while seismic lines, roads and drill pads decimate its habitat, a fate faced by many dwindling mountain caribou herds in Alberta and British Columbia. But we must be aware that, north of the Peel Watershed, there is no other mountain wilderness over the horizon, no other place to say, "This is our last chance. We'll make our stand for our heritage here."

The people of the North will need courage to decide which of the many competing values and perspectives are most important—for it is not a question they can leave to others. Nevertheless, all Canadians can help by reminding northerners of their stewardship responsibility and the far-reaching contribution these boreal wildlands make to the health of earth. The future of the Three Rivers and the Peel Watershed will be set during the next few years; whatever the outcome, conservation demands our continued vigilance.

✑

To stay informed or take action on the Three Rivers Project, conservation in the Peel Watershed, or boreal forest work throughout the Yukon, send an e-mail to info@cpawsyukon.org and ask to be put on the CPAWS electronic mailing list.

Visit our website at www.cpawsyukon.org and click on Three Rivers to learn more and see how you can help.

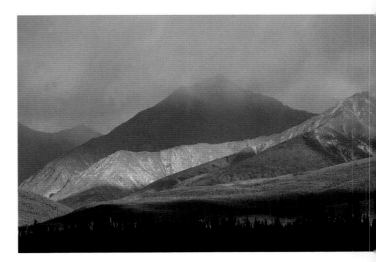

Top: Skies are constantly putting on a show in Three Rivers country.

Bottom: The boreal forest performs a key role in keeping the world's atmosphere healthy—but now this vast circumpolar ecosystem is threatened by increasing resource development.

Contributing Authors

Margaret Atwood

Margaret Atwood is the author of more than thirty acclaimed books of fiction, poetry and critical essays. *The Blind Assassin* won the 2000 Booker Prize. Her other novels include *Alias Grace*—which won the Giller Prize in Canada and the Premio Mondello in Italy—*Oryx and Crake, The Robber Bride, Cat's Eye,* and *The Handmaid's Tale. Moving Targets*, published in 2004, is Atwood's latest collection of non-fiction. Margaret Atwood grew up in the woods of Canada, and has been a lifelong defender of our environment. She lives in Toronto.

Brian Brett

Brian Brett is a poet, novelist, and journalist who lives on Salt Spring Island, BC. He is the author of ten books of fiction and poetry, and has appeared in numerous, poetry, fiction, natural history, and poetry anthologies. Shortlisted for the BC Book Prize for poetry and a renowned performer on stage, he has just released a CD of his "talking songs" titled *Night Directions For The Lost*. His "ethical thriller" *Coyote*, a novel dealing with environmentalism, ecoterrorism, and morality was published in October 2003. *Uproar's Your Only Music*—a memoir in poetry—appeared in the fall of 2004.

Frank Clifford

Frank Clifford is a *Los Angeles Times* environment editor who joined the Three Rivers Journey in 2003. After receiving one of journalism's most sought-after fellowships from the Alicia Patterson Foundation, Clifford wrote *The Backbone of the World: A Portrait of the Vanishing West Along the Continental Divide*, an arresting exploration of America's longest wilderness corridor. Before moving to California, he wrote about the American West for newspapers in Santa Fe, Tucson, and Dallas. A native of Minnesota, he now lives in Los Angeles.

John K. Grande

John K. Grande is an art critic who writes widely on the themes of Canadian art and nature.

Peter Lesniak

Peter Lesniak is senior editor of the *Yukon News*, an award-winning newspaper in Whitehorse. The Canadian Community Newspaper Association and the British Columbia and Yukon Community Newspaper Association have consistently judged the paper one of the best in its class for its design, articles and photos. He has won numerous awards over the years for his writing, including two for editorial writing from the International Society of Weekly Newspaper Editors. Before moving to Whitehorse in 1990, he worked for The Native Press in Yellowknife, The Canadian Press in Toronto and Thomson Newspapers in Toronto, Barrie and Orillia, in Ontario.

Sarah Locke

Sarah Locke is a writer and freelance journalist living in Whitehorse. After moving to the Yukon, she produced a CBC North daily radio show, and contributed feature documentaries for *Ideas* and *Sunday Morning*. Her recent work focuses on nature and science writing, including *Yukon's Tombstone Range* and *Blackstone Uplands – A Traveller's Guide*, and the environment column for the *Yukon News*, yourYukon. She was a featured writer in *Alaska Geographic*'s issue on the Yukon Territory and a contributing writer for *Yukon Wild – Natural Regions of the Yukon*.

Paul McKay

Paul McKay is an award-winning journalist, playwright and feature writer with the *Ottawa Citizen*/CanWest. He has written widely on environment, energy, corporate and social issues, and has authored three books, including *The Pilgrim and the Cowboy,* an investigation into the alleged illegal trade in endangered peregrine falcons in the Yukon. McKay is also a prolific songsmith who has penned more than one hundred jazz ballads, swing tunes, film theme songs, roots country, Celtic, classical, ragtime and children's compositions. His songs have been recorded with Canadian Juno Award winners Colleen Peterson and Willie P. Bennett, and Juno nominee Georgette Fry. Paul composed and recorded songs based on his experiences on the Bonnet Plume River.

Richard Nelson

Richard Nelson is an award-winning writer, cultural anthropologist, and broadcaster who lives in Sitka, Alaska. He is the author of *The Island Within* for which he won the John Burroughs Medal for outstanding natural history writing. His other books include *Make Prayers to the Raven: A Koyukon View of the Northern Forest* and *Heart and Blood: Living with Deer in America*. He was awarded the distinction of being the first Alaska State Writer.

Juri Peepre

Juri Peepre is a long-time conservationist and wilderness advocate living in Whitehorse. He coordinated the Three Rivers Project and was CPAWS-Yukon's Executive Director until 2004. Juri led the Yukon's Endangered Spaces campaign, part of a national conservation effort. He has authored numerous conservation articles and contributed essays and photographs for books on the Yukon environment, including *Yukon Wild* and various guidebooks. He was a contributing author to *Parks and Protected Areas in Canada, Protecting Canada's Endangered Spaces* and *Unimpaired for Future Generations: Conserving Ecological Integrity with Canada's National Parks*.

Contributing Authors

Patricia Robertson

Patricia Robertson is a fiction writer, poet, journalist, and editor. Her first short story collection, *City of Orphans*, was nominated for the Ethel Wilson Fiction Prize. A respected creative writing instructor in Whitehorse, she is also co-editor of *Writing North: An Anthology of Contemporary Yukon Writers*, the first such anthology of Yukon literature. Her work has appeared most recently in the spring issue of *The Malahat Review* and is forthcoming in a special poetry issue of *The New Quarterly*. Her second fiction collection will be released in 2006.

John Ralston Saul

John Ralston Saul is an award-winning essayist and novelist. He is the author of *On Equilibrium* and *Reflections of a Siamese Twin*, in which he presents ideas on the nature of Canada. His book *The Unconscious Civilization* won the 1996 Governor General's Literary Award for Non-Fiction and the Gordon Montador Award for the best Canadian non-fiction book on social issues. It was the concluding book of a major philosophical trilogy, the first two volumes being *Voltaire's Bastards – The Dictatorship of Reason in the West* and *The Doubter's Companion – A Dictionary of Aggressive Common Sense*. His novels include *The Birds of Prey* and *De si bons Américains*, both published first in French, and *The Field Trilogy*. The last volume of this trilogy, *The Paradise Eater*, won the prestigious Italian Premio Letterario Internazionale.

Principal Photographers

Marten Berkman

Marten Berkman is a well-known northern photographer and videographer with submissions in *Canadian Geographic* magazine, *Up Here, Extreme, Outdoor Canada, Western Living, Sea Kayaker, Canadian Journal of Environmental Education* and *Yukon Wild*. He has produced works for a wide range of clients including the Canadian Parks and Wilderness Society, Yukon Film Commission, the Government of Yukon's departments of Tourism and Environment, and Yukon Quest (official photographer). Marten is the author of the photographic book, *Chasms of Silence*, a limited edition portfolio of high arctic landscape photographs. He directed the *Three Rivers: wild waters, sacred places* art gallery film for CPAWS.

Peter Mather

Peter Mather is a Whitehorse photographer and writer who is also engaged in the Caribou Commons Project, a Yukon organization working to protect the Arctic National Wildlife Refuge and Porcupine Caribou Herd.

Courtney Milne

Courtney Milne's photographic and writing career has taken him on a global journey spanning all seven continents. His twelve books of photography include *The Sacred Earth, Spirit of the Land, W.O. Mitchell Country*, and *Emily Carr Country*, each portraying the theme of landscape as a powerful influence on the human condition. His multimedia shows have thrilled audiences worldwide and his prints have been exhibited in more than 200 exhibitions across Canada and internationally. Milne has received two Agfa Special Achievement Awards, the Gold Medal from the Canadian Association for Photographic Art, and was nominated for a 2004 Governor General's Award in Visual and Media Arts. In June 2005 Milne received an Honorary Doctor of Laws conferred by the University of Regina.

Fritz Mueller

Fritz Mueller has worked in northern Canada since the 1980s as a field researcher, government biologist, and in recent years as a wildlife and landscape photographer. Fritz's images are published internationally (*National Wildlife, Nature's Best, Ranger Rick, Natural History, Canadian Geographic, Up Here, Defenders, The Globe and Mail*), and his photographs feature prominently in Yukon tourism campaigns. Fritz is an award-winning photographer; his photograph of Tombstone Mountain at the western headwaters of the Peel Watershed won the Banff Mountain Photography Competition Grand Prize.

Jannik Schou

Jannik Schou is a wildlife and nature photographer based out of Denmark, who has completed many long journeys in the Yukon's wilderness. He has a passion for wildlife photography and has spent several seasons in the Peel River Watershed. Schou and his partner Jill Cracknell give photographic presentations on the Yukon to a wide range of European audiences.

All Is Absorbed Into One: Eight Visions Of The Three Rivers

By Patricia Robertson, with notes from John K. Grande

Wild places were once home to us all. Perhaps that is why the Canadian wilderness has inspired artists for more than a century and why contemporary artists continue to explore and celebrate "wild" space and our place within it, while also documenting the world's vanishing wildlands and endangered species. Today much of the strongest artwork is grounded in a holistic view of the planet.

In 2003, more than 200 Canadian artists from coast to coast entered the competition to join the Three Rivers Journey and exhibition. Proposals were judged by a jury, including members from the Banff Centre for Fine Arts, and the Yukon Arts Centre Public Art Gallery. The selected artists included Joyce Majiski and Jane Isakson from the Yukon, Marlene Creates from Newfoundland, Haruko Okano and Gwen Curry from BC, and three Ontario artists: Ron Bolt, Ojibway artist Michael Belmore, and José Mansilla-Miranda.

The ensuing national group exhibition, *Three Rivers: wild waters, sacred places*, is an eclectic response to a sojourn in one of the world's wildest places. The eight artists produced works in a variety of media, including photography, installations, painting, and sculpture. This engaging show challenges the way we perceive the links between art and nature, and perhaps it will compel many to rethink their notions about conservation. As the Three Rivers exhibition tours across Canada and beyond, enthusiastic audiences are witnessing an important milestone in the evolution of art and conservation in the Yukon.

These eight artists deepen our understanding of pristine boreal wilderness, and underscore our need for such places. "As wild environments become increasingly encroached upon by development," says art critic John K. Grande, "they become even more significant, for they offer something to us in terms of understanding our place in nature and raise questions about our human identity that are often overlooked in urban centres. Art can play a leading role in guiding our society towards a regenerative, intuitive vision of the life process."

This essay was adapted from the Three Rivers: wild waters, sacred places *exhibition catalogue (Yukon Public Art Gallery and CPAWS-Yukon, 2004) Visit www.cpawsyukon.org to view the artworks.*

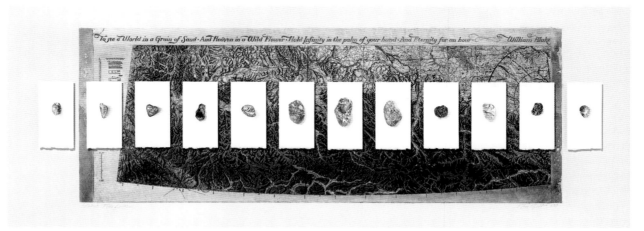

"Yukon Time Lines" by Ron Bolt

Participating Artists

Michael Belmore

Michael Belmore, of Ojibway heritage, is a sculptor and installation artist whose work has been exhibited in Canada and the United States. Michael's work explores the use of technology and how it has affected our relationship to nature. His work is represented in the permanent collections of several Canadian institutions as well as in numerous private collections. Belmore lives in the Haliburton Highlands in Ontario.

Ron Bolt

The work of Ron Bolt has been described as photo-realism; he explores the power and strangeness of nature by looking for relationships of patterns, colour, form and detail. Ron Bolt's career includes over sixty solo exhibitions from coast to coast and many group exhibitions in Canada and abroad. Numerous commissions include murals, books, a stamp, and a large work for Canada's Consulate in Sydney, Australia. He is a recipient of the Government of Canada 125 Medal (1992) and the Queen's Jubilee Medal (2003). He lives in Baltimore, Ontario.

Marlene Creates

Marlene Creates is a visual artist who lives in Newfoundland. For over twenty-five years her work has explored the relationship between human experience and the land, and the impact they have on each other. She has participated in over 200 solo and group exhibitions, both nationally and internationally, and has taught visual arts, worked in artist-run centres, and been a guest lecturer at over 100 institutions across Canada and abroad. Her work is in numerous public collections in Canada, including the National Gallery of Canada and the Canadian Museum of Contemporary Photography.

Gwen Curry

Gwen Curry is an installation artist whose work explores the environment as subject matter, with a special focus on flora and fauna, both living and extinct. The idea of "witnessing" has been an important aspect and has resulted in works in diverse media including printmaking, drawing, large mixed media works, sculpture and installations. She taught in the visual arts department of the University of Victoria from 1978-1994 and has participated in almost 100 group and solo exhibits in Canada, the United States and Europe. Her work is represented in many public, private and corporate collections. Gwen Curry lives in Brentwood Bay, near Victoria, BC.

Jane Isakson

Jane Isakson obtained a degree in fine arts after an athletic career during which she represented Canada in the biathalon event in two winter Olympics. Jane's current body of work has focused on the northern landscape and the migration patterns of wildlife throughout the region of the Yukon. Her paintings have been featured in solo and group exhibitions in the Yukon, the Northwest Territories and Alberta.

Continued

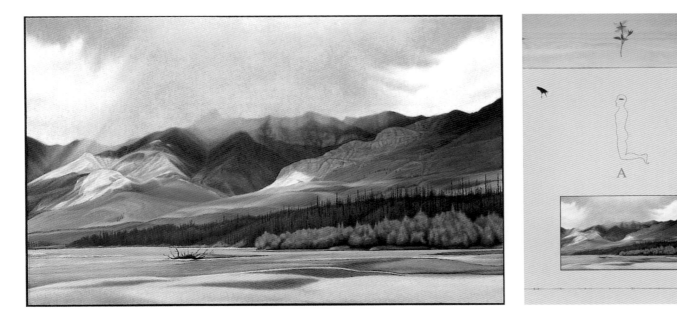

Expedition artist José Mansilla-Miranda's highly symbolic painting, "Lux," a triptych of panels titled "Alpha," "Omega" and "Spine" communicates messages about the human body and its relation to the living body of the land. Each image suggests the fragility of life, and the dialogue with animal and plant species in each. "This landscape of the Yukon is a territory of inspiration, peace, and spiritual power," says Mansilla-Miranda.

Participating Artists

Joyce Majiski

Joyce Majiski is a self-taught artist who started her career in wildlife biology and later worked as a hiking and rafting guide. She is a visual artist living in Whitehorse, Yukon, who draws on her connection to the natural world as the basis for her creative energy. Majiski makes use of several media including handmade paper, print and natural objects to recreate environments. Her work has been shown in solo exhibitions in Alaska, British Columbia, California and the Yukon.

José Mansilla-Miranda

José Mansilla-Miranda was born in Chile and came to Canada in 1979. José's work has dealt with his interest in reconnecting with his psychological and symbolic memory of the ancestral memory of the Americas, awakening and expanding his consciousness in harmony with nature and exploring his artistic creativity and cultural identity. Mansilla-Miranda's work has been featured in major solo and group exhibitions in Canada, China, Cuba, Mexico, South America and Europe. He lives in Ottawa, Ontario.

Haruko Okano

Haruko Okano is an installation artist whose work has been exhibited from the local to the international level. Her current work attempts to integrate her artistic practice and daily spiritual beliefs with her love of the land. Her installations are viewer-interactive and combine commercially produced natural products with organic detritus materials. Okano lives in Vancouver, BC.

Far left: "Flow" by Michael Belmore.

Left and below: "A River of Occurrences, Yukon 2003" by Marlene Creates.

Acknowledgements, Donors, Partners and Participants

This book showcases a long journey brought to life by the many individuals and organizations that have supported the Three Rivers Project from its inception in 2002. The book is the culmination of the Project, which began with the Three Rivers Journey and led to the touring national art exhibition *Three Rivers: wild waters, sacred places*.

We are indebted to the able Harbour Publishing team, notably Betty Keller for editing and Roger Handling for design. *Three Rivers: The Yukon's Great Boreal Wilderness* would not have been possible without the enthusiasm and shepherding of Brian Brett, who encouraged, advised, edited and cajoled us throughout the production.

We appreciate the generous contribution of essays, stories, poetry, photographs and art produced for the Three Rivers Project, including the thoughtful prose of Margaret Atwood and John Ralston Saul.

Many reviewers vetted portions of the book, including Debbie Buyck, Alejandra Duk-Rodkin, Ingrid Kritsch, Paul Matheus, Richard Nelson, Jim Pojar, Charlie Roots, Don Russell, Sharon Snowshoe and Mary Walden.

Enthusiastic community members, leaders, Renewable Resource Councils, and First Nations elders such as Jimmy Johnny, Neil Collins and Mary Teya; CPAWS board and staff; and many other Yukoners made invaluable contributions to the Three Rivers Project and this book. Gwich'in conservationists Gladys Netro and Elaine Alexie played vital roles throughout.

Three Rivers Journey and Gathering Participants

Wind River	Bonnet Plume River	Snake River
Elaine Alexie	Debbie Buyck	Marten Berkman
May Andre	Gwen Curry	Ron Bolt
Michael Belmore	Kathy Elliot	Frank Clifford
Joe Bishop	Jane Isakson	Marlene Creates
Brian Brett	Sarah Locke	Jennifer Goethals
Teresa Earle	Robert Mantla	Liz Hansen
Jimmy Johnny	Paul McKay	Scott Henderson
Peter Lesniak	Courtney Milne	José Mansilla-Miranda
Joyce Majiski	Dave Mossop	Kate Moylan
Fritz Mueller	Richard Nelson	Gladys Netro
Haruko Okano	Juri Peepre	Jill Pangman
Blaine Walden	Peter Sandiford	Bonnie Smith
	Georg Saure	

Gathering

We thank the more than sixty elders, leaders and community members from Fort McPherson and Mayo who travelled by boat to the Peel River gathering and offered their experiences and thoughts on the river's future.

Behind the Scenes

Charlene Alexander	Scott Marsden
Erica Heuer	Brenda Oziewicz
Mac Hislop	Kathryn Boivin
Lisa Mainer	Chris Dray

Major Donors and Partners

The Three Rivers Journey and related events were supported by:

Wilburforce Foundation
Canadian Boreal Initiative
Yukon Arts Centre Public Art Gallery
Wilderness Tourism Association of the Yukon
Canada Council for the Arts
The Banff Centre – Mountains as Water Towers Program
Yukon Conservation Society
Mountain Equipment Co-op
Tetl'it Gwich'in Council (Fort McPherson)
Sila Sojourns
Walden's Guiding and Outfitting
CPAWS Yukon Chapter
CPAWS – Boreal Rendezvous Project

Harbour Publishing
P.O. Box 219
Madeira Park, BC
V0N 2H0
www.harbourpublishing.com

Designed by Roger Handling, Terra Firma Digital Arts
Edited for the house by Betty Keller
Production management by Peter Read
Printed and bound through Prolong Press Limited, China.

Harbour Publishing acknowledges financial support from the Government of Canada, through the Book Publishing Industry Development Program and the Canada Council for the Arts, and from the Province of British Columbia through the British Columbia Arts Council and the Book Publisher's Tax Credit through the Ministry of Provincial Revenue.

Library and Archives Canada Cataloguing in Publication

Three Rrivers : the Yukon's great boreal wilderness / edited by Juri Peepre

ISBN 1-55017-365-0 / 978-1-55017-365-9

1. Taigas—Yukon Territory. 2. Rivers—Yukon Territory.

3. Natural history—Yukon Territory. 4. Wilderness areas—Yukon Territory. 5. Taiga ecology—Yukon Territory. 6. Yukon Territory-Description and travel. I. Peepre, Juri, 1952-

FC4012.T48 2005 917.19'1 C2005-903646-X

Printed on chlorine-free stock made with sustainably-harvested pulp.

ARTWORK CREDITS

Map on p. 6 adapted from Yukon Environment, Geographic Information System Section. Base data from National Topographic Data Base (NTDB).

Our thanks to the Paleontology Program, Department of Tourism and Culture, Government of the Yukon for permission to reproduce the painting Woolly mammoth, American Lion pride, by wildlife artist George Teichmann on page 47.

Native paintings on page 50 courtesy of Yukon Archives, Catherine McClelland collection.

Mooseskin boat on page 52 courtesy of the David Hager Collection, Yukon Archives.

Artwork on pages 16, 17, 48, 51-53, 65, and 144-146 photographed by Al Reid Studio, Cathie Archbould Photography, Marion M Bordier, Bob Matheson, and Trent Photographers.

PHOTO CREDITS

Cathie Archbould: p. 40 (bottom), p. 45 (top), p. 55, p. 57, p. 62, p. 79 (bottom), p. 120 (bottom), p. 136

Marten Berkman: pp. 4-5, pp. 10-11, p. 27 (bottom), p. 29 (bottom), p. 35 (bottom), p. 36 (bottom), p. 46, p. 63, p. 65 (top), pp. 66-67, p. 68 (top and bottom), p. 69, p. 70, p. 71, p. 73 (left and right), p. 76, p. 79 (top), p. 81 (top and bottom), p. 114 (top), p. 119 (right), p. 128 (right), p. 134 (bottom)

Teresa Earle: p. 117

Stephen Krasemann: p. 23 (top)

Ken Madsen: p. 35 (top), p. 118 (top)

Peter Mather: p. 15 (left), p. 26, p. 31, p. 32 (top), p. 33 (right), p. 34, p. 37, p. 38, p. 43 (top), p. 56 (top), p. 90 (top), p. 93, pp. 138-139

Courtney Milne: p. 7 (bottom), p. 14 (bottom), pp. 18-19, p. 25, p. 28 (top), p. 36 (top), p. 64, p. 77, p. 86 (bottom), p. 89 (top), p. 91 (bottom), p. 119 (left), p. 120 (top), p. 127, p. 128 (left top and bottom), p. 132 (top), p. 135 (top), p. 137 (bottom right), p. 141 (top and bottom)

Fritz Mueller: front cover, p. 1, pp. 12-13, p. 14 (top), p. 15 (right), p. 24 (bottom), p. 32 (bottom), p. 39 (top), p. 45 (bottom), p. 49, p. 54 (top and bottom), p. 80, pp. 110-111, p. 113 (top and bottom), p. 114 (bottom), p. 116 (top and bottom), p. 121, p. 122, p. 124, p. 125, p. 126 (top and bottom), p. 133, p. 135 (bottom), p. 137 (top), p. 137 (bottom left)

Paul Nicklen: p. 20, p. 22 (top and bottom), p. 30 (top), p. 100, p. 101 (top), p. 102, p. 107 (top and bottom), p. 109 (left), p. 112

Terry Parker: p. 99 (bottom)

Juri Peepre: pp. 2-3, p. 24 (top), p. 27 (top), p. 28 (bottom), p. 29 (top), p. 39 (bottom), p. 40 (top), p. 41 (top), p. 42, p. 43 (bottom), pp. 58-59, p. 60, p. 61, p. 72 (top and bottom), p. 74 (top and bottom), p. 75 (top and bottom), pp. 82-83, p. 84, p. 86 (top), p. 87, p. 88, p. 89 (bottom), p. 90 (bottom), p. 91 (top), p. 92 (left), pp. 96-97, p. 123, pp. 130-131, p. 132 (bottom), p. 134 (top), p. 140

Peter Sandiford: p. 33 (left), p. 85

Jannik Schou: p. 7 (top), p. 8, p. 9 (top and bottom), p. 21 (top and bottom), p. 23 (bottom), p. 30 (bottom), p. 41 (bottom), p. 56 (bottom), p. 94, p. 95, p. 98, p. 99 (top), p. 101 (bottom), p. 103, p. 104 (top and bottom), p. 105, p. 106, p. 108, p. 109 (right), p. 115, p. 118 (bottom)